I st art so m ething,

you finish it.

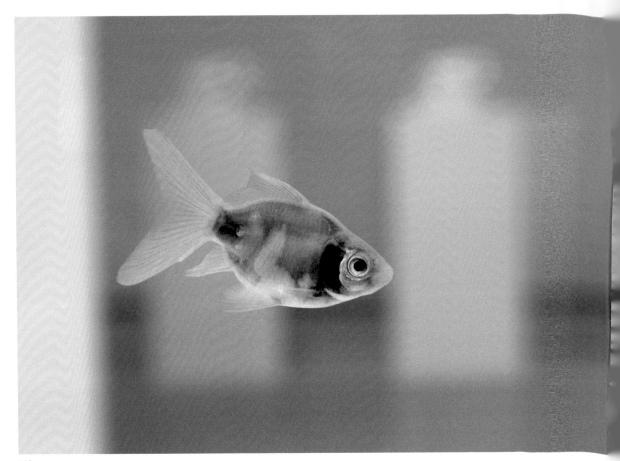

003

003
Sterile 2014
Goldfish
Dimensions variable
Installation view
Assemble Standard Minima
Schering Stiftung, Berlin, 2015

NOT WHAT I MEANT BUT ANYWAY

Revital Cohen

Tuur Van Balen

Columbia Books

on Architecture and the City

I see Pegasus containing one messier object
a number of dim galaxies
that can only be seen in large telescopes
green tent for a discrete destruction
mechanical angst for fall training
summer fur, highly pregnant
that can only be seen in the axial gallery.*

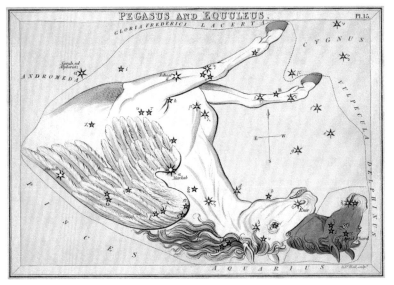

* "Spit on the Carpet," seminar text
for Columbia University Graduate School
of Architecture, Planning and Preservation,
New York, 2019.

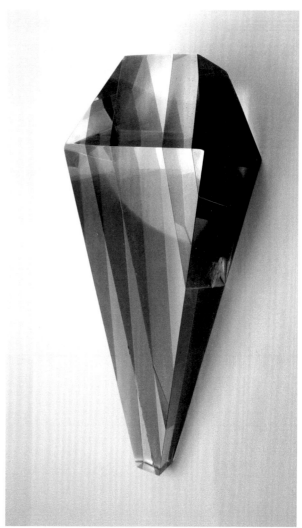

005

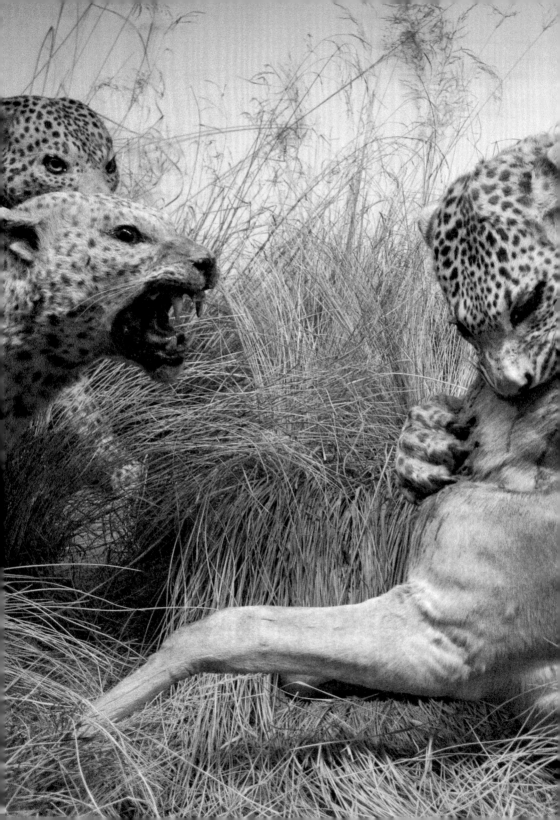

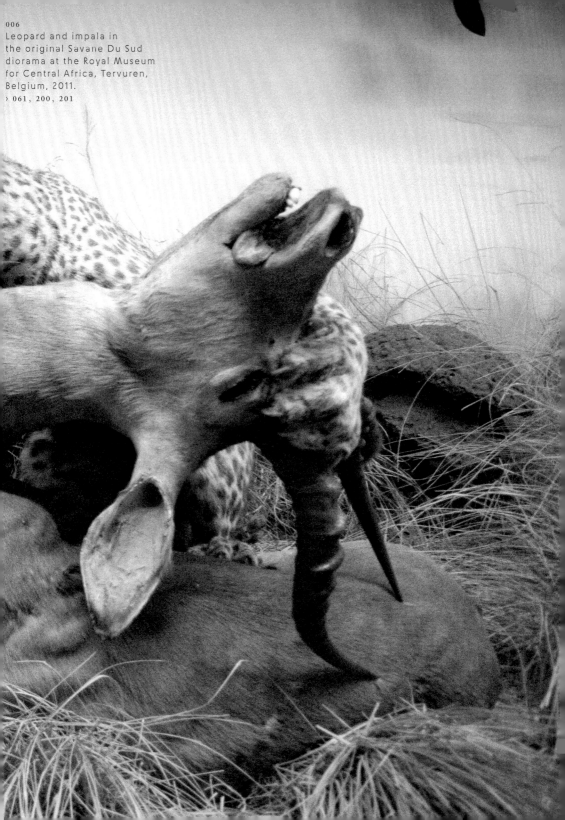

006
Leopard and impala in
the original Savane Du Sud
diorama at the Royal Museum
for Central Africa, Tervuren,
Belgium, 2011.
› 061, 200, 201

We have been working together ever since, but I wouldn't say there
has been a merger. It is really important to us to maintain autonomy
within this collaboration and remain two individual artists that
are making work together. This is why we use our full, individual
names and why our texts are mostly written in the first person—it is
not a collective "I," but fragments that are written by either of
us and later assembled. We also give each other the freedom to talk
about the works in a personal and subjective way, which means
my interpretation will not necessarily be the same as his. In general
I would like to imagine a togetherness of differences, like in a family,
rather than a corporate, unanimous we. *

Conversation with curator Christina Li, in *Palms Palms Palms Palms Sourcebook* (Hasselt: Z33, 2020), published in conjunction with a survey exhibition of the same title at Z33, October 4, 2020–January 3, 2021.

*

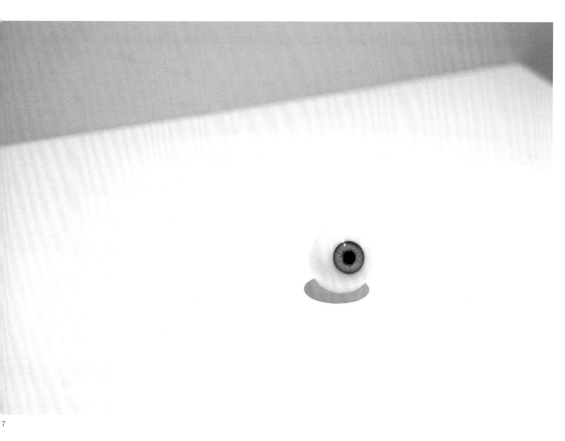

007
The Opening 2019
Hand blown glass
28 × 28 mm

A glass replica of one
of the artists' eyes, hovering
somewhere between
commodity and amulet.

› 012, 023

008

It is harder to imagine the end of capitalism than the beginning of other worlds. Thinking of capitalism as an ecology is a way of thinking it weak, even before a virus wiped more than 500 billion pounds off the stock market in a single day. We cannot meaningfully separate human and non-human systems in the messy global entanglement we live in—maybe we never could. That's not just to say there never was only nature but also that there never was only *human*. This entangled environment—which behaves ecologically—has become so omnipresent that it even ingested its own escape strategy. *

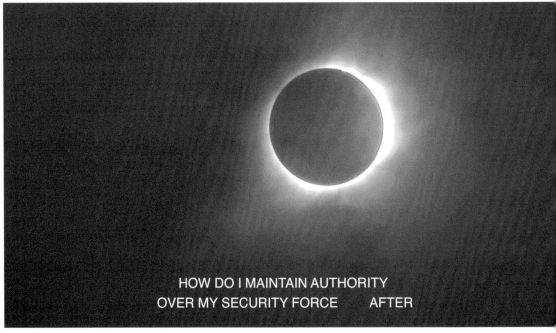

HOW DO I MAINTAIN AUTHORITY
OVER MY SECURITY FORCE AFTER

"Spots, Stars, Tunnel Vision,"
commissioned for *Back to Earth*,
Serpentine Galleries, London, 2020.

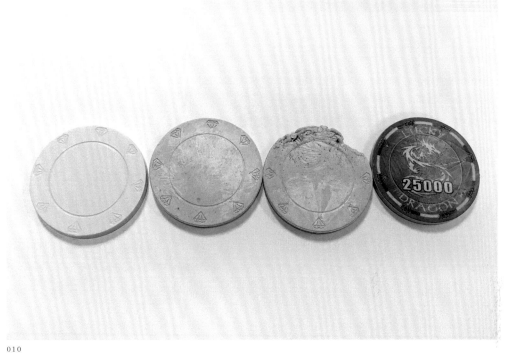

010

Andrés Jaque

At a moment when dreams of human hegemonies are cracking, Revital Cohen and Tuur Van Balen's body of work offers us a way to adjust to the complexities of existence. This book explores how their work unfolds: films, installations, texts, photographs, designs, and research construct a practice that can be seen in its parts and accounted for as a whole—amounting to the material existence of now. This book is neither didactic nor preachy. Rather, it shows us how our eyes and fingers, how institutions, how entire systems (neuronal, ontological, automated) can attune (or rather, re-attune) to the real.

In their 2019 work *The Odds (Part 1)*, a group of six highly-qualified humans help a racehorse fall asleep. The horse has been anesthetized with ketamine and is hanging from a crane in a procedure room with padded walls, where surgery is likely to follow. In this state, the racehorse is both powerful and vulnerable, but definitively not autonomous. Its body is presented here not only as constructed and dependent but also as intrinsically defined by its interconnection with others. In a different scene, glitter-bedecked dancers move their muscles on a stage enclosed by shiny curtains, a ritual repeated in a Macau casino where visitors bet on horse races. Here, gambling is both a mental process and a risky financial transaction. But in being both, it entails much more. Gambling is an entanglement of the fleshy and the technological, of the mental and the physical, of the personal and the collective. It exceeds the discretion of the individual body and denies the possibility for zipped-up self-containment, for both subjects and objects. This work shows that the distinction between subjects and objects no longer makes sense—but neither does the exceptionality of humans. Racehorses, dancers, glitter, padded rooms, bets, and doctors operate symmetrically, both shaping and shaped by the realities they construct together. Gambling is a form of heterogenous togetherness that dilutes human centrality, that redefines humans as entities who hybridize in/as many others, and whose ontologies and power structures coexist, collaborate, confuse, meld, and dispute with many others.

Presenting gambling as a product of procedures, training, matter, and conformation does not mean that the result of gambling is determined by them. This is not a machine-like system. The accuracy and the expertise mobilized in these processes does not eliminate uncertainty. Inquiring, enacting, and conjuring are inextricable here. Procedures, training, matter, and form create neither predictability nor probability. Instead, they operate as mythological presences that, acknowledging the rule of

uncertainty, contribute to the collective convening (and making) of propitiousness.

The Odds (Part 1) is not a film but an installation. In it, the changing light projected by an HD LED screen reflects on the metalized surfaces that cover the room. The carefully sequenced projection expands through these surfaces, as does the sound from the speakers. This rhythmic *pace-making* of the room excites the sight and hearing of those watching. Their retinas and the thin skin of their eardrums physically resonate, becoming components of an installation that not only reenacts but also resituates gambling. There is no *outside* to this work, no safe place from which humans can witness it without being affected by it. In this reen-actment, the myths on which gambling is founded are complicated by both the presence of new audiences (additional living tissues excited by lights and sounds, sensing their already existing participation in gam-bling) and the usually invisible parts of their construction (mostly the clinical existence of racehorses and of those who care for and treat them, as well as the repetitive nature of entertainment-making).

Cohen and Van Balen gained international visibility around 2010, when the exquisite images of their works *Life Support* (2008) and *Pigeon D'Or* (2010) were widely circulated in exhibitions and publications. The careful production of these images, the delicate design of the props shown, the hegemonic nowness of the models playing parts in them, and the simultaneously sharp and soft photographic language— all successfully infiltrated the institutions and networks that decide collective sensitivity. These works immediately affected discussions on the political nature of associability across species: in them, there are no moral shortcuts, there is no room for self-indulgence. Instead of redeeming humans for the violence they inflict on non-humans, these works formalize the impossibility of reducing morals to a binary, insisting instead on the uncanniness and tension embedded in human and nonhuman interdependency. In subsequent works, like *The Immortal* (2012), *75 Watt* (2013), and *Sterile* (2014), the avoidance of a dialectical approach to morality is taken further. Cohen and Van Balen reflect on how "life" can be approached as an inquiry about "production"—and then they carefully redefine what "production" can even mean.

75 Watt depicts the production of forty objects on an assembly line at the labor-intensive White Horse Electric Factory in Zhongshan, China. It is unclear what these forty assembled objects are, and their elaborated

aesthetics seem to be somehow lost in time. The functionality of these objects is defined not by their use but rather by their capacity to generate a choreography of production that de-optimizes the process of their fabrication and challenges the scientific management of work in the assembly line where they are produced. The politics of production unfold here as an opportunity to redefine the traditions of labor politics. In such a work, production is characterized through a very different economy: its capacity to introduce difference in the making of life, both fleshy and automated. *75 Watt* shows how Cohen and Van Balen engage in production biopolitically. This biopolitical approach to production—biopolitical in the Foucauldian sense—exceeds the dialectical division between form and performance, between the living and the life-less, by presenting the production of the life of bodies as a compositional practice entangled with the production of commodities.

It is the composition of the fleshy, the mineral, the genetic that becomes the site for biopolitical action, as can be seen in other works, like *Sterile*, *H/Alcutaau* (2014), *B/Ndaltaau* (2015), *Retour* (2015), and *Trapped in the Dream of the Other* (2017). Production in these develops as a *transscalar* and *transterritorial* practice, where entities are neither fixed nor given, but rather emerge in their transition through different forms of life, territorialities, and geopolitical engagements. The process of transitioning becomes a form of existence in itself. And it is understood, through these works, as complicated and critically challenging. These notions of a transitional existence deny the neoliberal ease of free trade and free circulation of matters, revealing the failure of colonial, Cartesian, and human-centered ontologies. These works call for alternative and non-resolutive ontologies. Cohen and Van Balen provide an ontological threshold where the scientific and the mythological, the technological and the spiritual, the material and the intangible are reassembled as mutually interdependent; where humans are dispossessed of a privileged space from which reality can be seen from above, from outside.

Trapped in the Dream of the Other climaxed in a performance from 2016, in which bespoke fireworks imported from Liuyang (Hunan Province, People's Republic of China) were set off in an open-air mine near Numbi (Democratic Republic of Congo) via a remote control in London (United Kingdom). The artist asks: "Where exactly, though, is the scene, and where is the set?" In the formulation of this question, terms like "People's Republic," "Democratic," and "United" resound as incapable of making sense of the

conflicted entanglements the work mobilizes and is part of. The complex geographies, bureaucracies, and displacements implicated are registered through digital technology fueled by the minerals extracted by adults and children working in inhumane conditions created by advanced capitalism's reliance on exploitation. In the *after-aftermaths* of a modern colonial culture built on the beliefs of "exactness" and Cartesian control of space, the impossibility of providing an "exact" answer to a fundamental question like "Where?" is how the momentousness of and need for Cohen and Van Balen's politics-within-transitioning-materialities are revealed. Rather than *announcing*, this impressive body of work *makes vivid*, in/through those intervened by it—the neuronal and physical modes of life that emerge in/from the cracks of a colonial, technocratic, and exploitative world in a state of collapse.

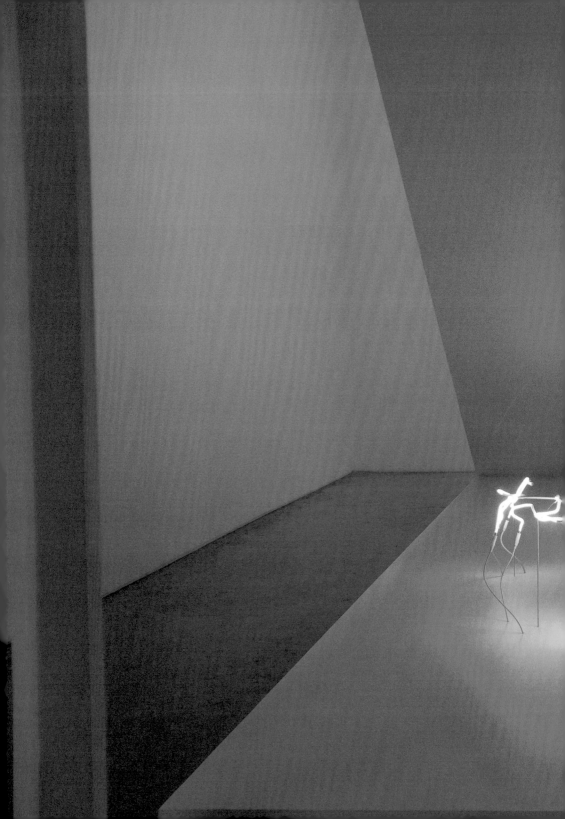

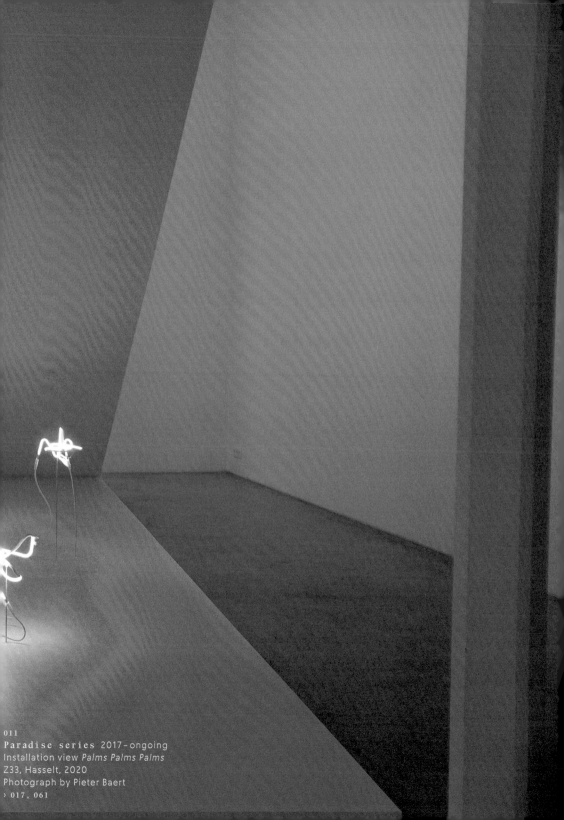

011
Paradise series 2017-ongoing
Installation view *Palms Palms Palms*
Z33, Hasselt, 2020
Photograph by Pieter Baert
› 017, 061

Revital Cohen and Tuur Van Balen

You find yourself faced with the invisible. A vast white surface like Mallarmé's
blank page. A beach in a blinding sun. All is white. No trace of anything.
It's an odd feeling, like finding a gap in your memory. There you are in the
very furthermost corner of your memory. You have a writer's job to do.
You could write: "I go to bed early." Or like Rimbaud: "A black. E white.
I red." Or: "Love and kisses from Marseilles." Or: "I Love you. I love you."
Or: "Where's my ten francs?" But no. You want to see. You want to re-cei-ve.[1]

*

If we consider the work to be a process of becoming as much as an
exhibitable outcome, perhaps this process can be found *here*.

This book attempts to capture an amorphic and expanded flow of
thoughts, actions, and encounters, where boundaries are continuously
dissolving—boundaries between process and outcome, between dream
and reality, between work and life, between matter and spirit.

The book may give a glimpse into the backstory, side story,
another story. It acts as a cross section through our practice and its
entanglements (personal, ethical, practical, political). Perhaps it's
more like a series of core samples, holding up hidden narratives for
analysis or (mis)interpretation. Within it are multiple views of our
work and working, reminiscent of constellations of stars where each
pattern or cluster is subjective and abstract.

*

She was the mother of Chimaera who breathed raging fire, a creature fearful,
great, swift-footed and strong, who had three heads, one of a grim-eyed lion;
in her hinderpart, a dragon; and in her middle, a goat, breathing forth a
fearful blast of blazing fire. [2]

*

A batch of albino goldfish were engineered to hatch without reproduc-
tive organs. Following a long conversation in writing and in person,
Professor Etsuro Yamaha produced an edition of 45 goldfish for us in his
laboratory in Hokkaido, Japan. The fish were not conceived as animals
but made as objects, unable to partake in the biological cycle.

Next to them stands a machine that is capable of producing
sterile goldfish in an automated reenactment of Professor Yamaha's
movements and actions. Physically articulating the process of fabri-
cation, its mechanization allows for the standardization of both
sequence and animal. A contraption with its own (dormant) choreography,
the machine is an assembly line, a reproductive organ, a potential.

*

~~The cake is a lie.~~

1 Jean Luc-Godard, Scénario du film "Passion" (Geneva: Télévision Suisse Romande, 1982), film, 54 minutes, English translation by Tom Milne.
2 Hesiod, *Theogony*, trans. Hugh G. Evelyn-White (Ola Press, 2015), 319–324.

writing between the lines

or maybe something about backstage / when the making-of eclipses the

too-meta-to-matter

in an everlasting Droste effect

*

Forty kilograms of destroyed hard drives were sourced from a data destruction service, a mountain of shiny deformed bricks scrapped out of the guts of computers. Mined out of soil, designed in the United States, made in China, destroyed in England. Labor starts in reverse, dissolving the virtual into the fake from the other end of a consumption chain. Metals and rare earth minerals are mined from the pile of hard drives and reconfigured back into mineral form.

Neodymium (Nd) magnets are shredded with a water jet, tantalum (Ta) is filed out of capacitors, and gold (Au) recovered with acids. The aluminum (Al) platters—still holding their ones and zeros—are melted and recast in a sand mold. An artificial ore emerges from the earth, unexpectedly black.

*

The work became harder to contain when we wanted its making to appropriate, partake in, or slightly interrupt complex existing systems. The rush of reality was too good, too strong; fiction or speculation would not do anymore. But this ambition to make work within hermetic realities also slowed down the process, as this "situated" method of working demands research, relationships, logistics, weather, peace treaties, border control, and a lot of hustle. All these became part of the work—in many ways it is the work—but we leave it out of the gallery.

Possibly not articulated in the best way just yet, I think the work needs to be somehow uninterrupted, or clear when it is encountered in an exhibition.[3] Ideally it would allow for multiple readings, for personal and potentially more visceral or emotional experiences. Opening up the guts of the beast has its own magic, but that should happen on another layer or at another time or through other means—a guided tour, a lecture, a subtitle track, this book.

Many of these moments, encounters, mistakes, relationships, bureaucratic documents could themselves be moments of reflection and interpretation, not so much a chronological story of the work being made but a way of thinking of the world: through animal import laws, a receipt for a fine that was actually a bribe, or a note from a marketing agent describing how an art gallery feels.

*

A spiritual experience vs. an intellectual one?

A common experience vs. an intimate one?

*

Five life-support machines, connected to each other, circulate liquid and air in an attempt to mimic a biological structure. Working without a body requires a definition of this creature as its own species, liberated from function but forever charged with its resonance. The Cell Salvage machine has been born out of Jehovah's Witnesses' refusal to accept blood transfusions. The Infant Incubator, pulled out of a skip in the auctioneer's parking lot in Wiltshire, was a rare find, as its siblings embarked on their migration trail to the Global South, where sustaining new bodies is a priority.

*

There's a François Lyotard quote I sometimes use in lectures about our work, from his book *Que Peindre*:

> Figure and ground trade places. The figure is always determined, and the
> ground is anything at all, but also that without which determination would
> not take place, and upon which the figure is determined. That this figure
> is determined rather than another: such is the event, the contingency.
> What is necessary is that its determination leaves behind a ground. "Leaves
> behind a ground": the figure is wrapped in something unfocused, and it
> is not determined; if it is, it is no longer the ground left-behind. As if
> the eye and thought or language could determine this only by leaving
> around it that which the eye, thought, or language does not see,
> conceive, or articulate.[4]

I sometimes show this quote on top of an image I took while spending a few weeks on a container ship that sailed from China to Nigeria. I could see and touch the containers but couldn't know what was inside

3 "Clear" as in water.
4 Jean-François Lyotard, Que Peindre?, Que Peindre?/What to Paint?: Adami, Arakawa, Buren, trans. Vlad Ionescu, ed. Herman Parret (Leuven: Leuven University Press, 2012), 281.

them: the ground left behind.

In her solo performance *If You Couldn't See Me* (1994), the choreographer Trisha Brown dances for about ten minutes with her back to the audience, a constraint proposed to her by her artistic collaborator Robert Rauschenberg.

Brown says the following about it:

> I understood what my back meant to an audience because of how it functions when I am facing the audience. My back is the body's backstage. Backstage is where you hide all the equipment that makes all the beautiful things happen out on stage. So my back is a metaphor, for my back functions that way for my front. Even though I don't approve of launching movements from the back; I think that movement should emanate from precisely the joint where the tendons are wrapped and the muscles extend to the next joint. I didn't want to admit that I do what I do; I mean, I know that when I want to make a beautiful form in the body and I'm rotated to the left, my right arm looks absolutely beautiful. But what do you do with the left arm? I put it behind me. It's the way I get rid of it. It goes backstage.[5]

Ground–backstage–back–container: it seems we are drawn to that which cannot be determined or articulated but without which the figure cannot be formed, or without which the system cannot operate.[6]

*

> Far from drifting at random, human and animal studies have found foetal origin cells in the mother's bloodstream, skin, and all major organs, even showing up as part of the beating heart. This passage means that women carry at least three unique cell populations in their bodies—their own, their mother's, and their child's.[7]

*

It starts with a hoover, a kettle, a hairdryer, and a radio: we buy small Made-in-China electronic products, take them apart and put them back together, over and over again. Alex comes to the studio and takes them apart on camera. We study his movements, our movements, the movements of the laborers Tuur filmed in Shenzhen assembling tripods, joysticks, LED screens. We select the hinge testing sequence, the measurement sequence, the wire looming/weaving sequence, the subtle bolting finger movements. Some materials and movements are tested in a dance studio at the Royal Opera House with four dancers, a desk, and a ballet barre. The final object will have a two-part resin case holding

5 Trisha Brown, interview by Emmanuelle Huynh, in *Histoire(s) et Lectures: Trisha Brown/Emmanuelle Huynh*, eds. Emmanuelle Huynh, Denise Luccioni and Julie Perrin (les presses du réel, 2012), 35.

6 Thank you Jeroen Peeters, for conversations and writings, especially *Through the Back: Situating Vision Between Moving Bodies* (Helsinki: Theatre Academy

cut aluminum parts, a loomed electroluminescent wire, six small fans, forty-one hexagon nuts, eighteen rivets.

This product is designed to be made in China. Its only function is to choreograph a dance performed by the laborers manufacturing it. The assembly/dance takes place at the White Horse Electric Factory in Zhongshan, China between March 10–19, 2013 and results in forty objects and a film documenting the choreography of their assembly.

*

The industrial is abstract. A global fragmentation of production processes—driven by ideologies of engineering and standardization—is assembling an ecosystem of magical objects, disconnection, and denial.

Residues of anatomies, cultures, geologies, and centuries build under my fingernails. The body of a Japanese goldfish, removed from the animal kingdom. The tusks of mammoths, hunted in the frozen Siberian mud to bring good luck in China. Ores and minerals that brought an economist-proven curse upon their land are soon to be cast onto the moon. Sands, cells, ashes of civilization.

In a supersized casino, day and night do not exist. The clay chips circulate over felt surfaces and under carpeted halls. Miners dig for the earth of immateriality, laborers perform their perpetual dance, frozen fish glide on top of the ocean in steel containers.

*

The process itself becomes as much of a force as my intentions; maybe realities can be slightly bent but never broken, maybe those that can be broken or those that are fully malleable just aren't interesting enough, maybe I need to hit the wall first in order to feel that something meaningful has happened. The work never ends up exactly as intended, the image in my mind never materializes—like holding a paintbrush on the back of a bull, a rougher, dirtier, thing emerges. Alive with flaws and some unruly energy. It is not what I meant.

I mourn the death of that beautiful image, but the nature of this goes beyond beautiful. It is unexpected, energized, injured by the vulnerabilities of ecology, money, physics, love, gut, time, and chance. The beautiful image stands pale in comparison, perhaps lacking this zealous energy, perhaps limited by the boundaries or boundarylessness of imagination.

The problem is that I feel most alive on the side of a mountain in Hunan surrounded by heaps of gunpowder stars, inside the fridge at

of the Arts, 2014), which pointed me toward Lyotard and this quote of Trisha Brown. Katherine Rowland, "We Are Multitudes," Psyche, January 11, 2018, https://aeon.co/essays/microchimerism-how-pregnancy-changes-the-mothers-very-dna.

a horse morgue, in the engine room of a bingo hall, in a fish lab in the middle of nowhere. In those moments when the places I found in my head become real and open, a door unlocked in some global subconscious, a holy place became so because I decided it was.

*

> The camera moves through an active mine near Numbi whose workers, on that particular day, are extracting either coltan or cassiterite (the minerals can't be distinguished in the mine itself). On other days, they will work in other mines—their daily labor and the material that they dig for is determined by the fluctuating prices of minerals and metals on the global market. The camera's movements are clearly those of a human operator, walking, trudging and climbing, turning, searching for the pyrotechnics, trying to anticipate the Sega controller's commands. In the moments when the camera catches a nearby detonation, it is enveloped in white, green, or pink smoke that creeps through and lingers in the trenches, ethereal yet gravity-bound and strangely soulful. The metallic airbursts sizzle after detonation, the shimmering gold dust disseminating back into the soil that it came from (much like in the earlier photographic work Retour). To make them fly in the right direction (up), nearly all fireworks contain a small amount of soil taken from the local area of manufacture. Trapped in the sparklers and released via remote control, tiny quantities of Chinese earth are thus disseminated in the Congolese mine, blending for a moment with the other ultimately China-bound minerals.[8]

*

The assemblage /

multiplicity or dissolution of the self

have I been watered down by us

have I sacrificed my sparkle to become a double-headed calf.

*

> Secondly, the Sirens in Homer aren't sexy. e.g. we learn nothing even about their hair—in contrast to other divine temptresses. The seduction they offer is cognitive: they claim to know everything about the war in Troy, and everything on earth. They tell the names of pain... The modern visual iconography of Sirens is very different from the ancient. Ancient depictions (vases, mosaics etc.) make them bird-women-poets; they often have musical instruments, the lyre and/or the aulos (double pipe). They offer a poetic/aesthetic/epistemic temptation.[9]

*

8 Eva Wilson, "Trapped in the Dream of the Other," in *The Work of Wind: Land,* ed. Christine Shaw and Etienne Turpin (Berlin: K. Verlag, 2018), 115–137.

I'm in Amsterdam in a complimentary designer hotel room. There's only one room in the hotel. We were invited to do research for a new commission: something about labor. We've got initial directions and intuitions and they're not even that misaligned, but still we argue.

Even when labor is immaterial, when we consider things "virtual," those things often still rely on a very material reality; something is dug out of the ground somewhere. One of these things is tantalum, dug up as coltan, in which case that somewhere is in Congo. Congo Free State, Belgian Congo, Zaire, Democratic Republic of Congo: under various denominations throughout history the country has provided the materials needed to feed the world's industrial fantasies. Ivory, rubber, copper, uranium, gold, tantalum. This list had been in my head for a while, and it somehow seemed to fit the new work. Something with rewinding supply chains by mining these materials from finished products. But surely making a fake mineral would be too obvious, and that's worth an argument.

*

A gorilla, half a lion, and a leopard killing an impala were taken from the archive of the Royal Museum for Central Africa in Tervuren, Belgium, and X-rayed in a local hospital, exposing the sculptural structures within. The radiography waves reveal natural history as a cultural practice, a colonial interpretation of nature and wildness. The X-ray machine performs the excavation of subconscious form: a taxidermist imagined the movement and posture of two animals they had never seen, based on hunters' stories and empty furs.

*

laborer boy and boxes boy

in screws in boxes in screws with

fingers dancing with screws

making moves and screws

against plastic through screws shape dance

and move more move more move more

plastic windmills on boxes and balconies

Emily Wilson (@EmilyRCWilson), "Secondly, the Sirens in Homer aren't sexy," Twitter, March 4, 2018, 3:12 p.m., https://twitter.com/EmilyRCWilson/status/970406696836304897, and Wilson, "The modern visual iconography of Sirens is very different from the ancient," Twitter, March 5, 2018, 7:10 a.m., https://twitter.com/EmilyRCWilson/status/970647640328278017.

conveyor bringing back and

stack pull slide release

push check clean push check push check

cardboard circuit board usb connection

test pick plug test hold test

game move up down arrow

release superpower

push move up down thrill feel

square cross circle push

blink L blink E blink D

check stick throw

return

game move up down arrow

test pick plug test hold test

blink L blink E blink D

young hands long hair

can't care

smoke test outside

*

A theater's infrastructure was used to rehearse forms of exhibition in which research, process, and outcome cannot be meaningfully distinguished. We move our entire physical storage and digital archive to the theater space and unpack the work into a series of repetitions in collaboration with two curators, a fellow artist, and a theater director. The theater's technicians, who routinely build and unbuild productions every night, reinstall the exhibition every ten days,

activating and deactivating different parts. A writer-in-residence captures each iteration with a text that is hung on the wall, her writing remains and accumulates as the exhibition transforms. By rehearsing the exhibition, the conditions of producing the artwork and of its presentation are exposed and put into question.

Not What I Meant But Anyway, a playscript composed of text generated from our couples therapy sessions, is rehearsed throughout the exhibition. A few days a week, two actors and a director rehearse the script in several of the exhibition spaces. In their absence, the annotated scripts remain in the central space.

*

Atlantic, Pacific, and Indian oceans in temperate to tropical waters, mostly below 200 m. Short and rounded snout. First dorsal fin erectile, with a strong spine; second dorsal fin long and low. Diphycercal tail, i.e. vertebral column runs straight to the tip, dividing the caudal fin symmetrically. Anal fin confluent with caudal fin in Hydrolagus; separate in Chimaera. Feed on small fishes and bottom invertebrates. Males with head clasper. Oviparous; large tadpole-shaped egg capsules are deposited on substrate. Dorsal spine with associated poison gland, the venom of which hurts humans.[10]

*

The work is the working is the product is the knot of processes and situations that are all production. Seeing / writing / following / dancing that knot can reveal individual strands but not what emerges in their entangling. To quote Manuel DeLanda: "Concrete wholes that are irreducible and decomposable… must accommodate… both synthesis and analysis."[11]

*

The exhausted body of a thoroughbred horse, soil upturned through geopolitical ritual, blinking lights conjuring irrational thinking, the song of sirens, the demise of a linear future. A trance-like soundscape hangs in the air, oxygen levels rise as the lights occasionally break into blinking patterns echoing the "siren song" of a slot machine display. A scent commissioned by a marketing company overlays musk with synthetic molecules that mimic human pheromones and the stress-like smell of the Dead Horse Arum Lily. Elsewhere is a constellation of objects: a sculpture made from scans of the collapsed bodies of thoroughbred racehorses, casino chips made in China from clay dug in Jerusalem, a subtitle track projected on the wall, and a glass replica of one of the artists' eyes.

10 "3 Families of Chimaeras," Fish Identification: Find Family, FishBase, last modified June 29, 2012, https://www.fishbase.se/identification/familieslist php?ordrnum=3&areacode=&classnum=3&c_code=.

11 Manual DeLanda, Philosophy and Simulation (London: Continuum, 2011), 188.

Recent archeological research shows that some of the world's oldest cave paintings aren't simply depictions of animals, as was previously thought. Instead, the animals symbolize star constellations, used to represent dates and mark events such as comets passing. The world's oldest sculpture, the Lion-Man of Hohlenstein-Stadel Cave from 38,000 BCE, also conforms to this ancient time-keeping system.[12]

Trapped in the Dream of the Other was never a work about Congo but a work produced by the relations between Congo and China, between the current Congo and the one my father grew up in, between the coltan when it plays a role in the violence there and that same coltan when it ends up in my laptop so I can type t h e s e w o r d s. The work is never about simple locations, situations, representations. I'm interested in the processes, connections, and relations between them, in drawing animals in the stars.

Sometimes clear and sometimes faint, this book draws constellations of works. Through that, it also reveals some of the cracks opened up by the working—markings from the time we live in, like a prehistoric sculpture of a lion-headed figurine.

*

Apophenia (/ˌæpoʊfiːniː/) is the tendency to mistakenly perceive connections and meaning between unrelated things. The term (German: Apophänie) was coined by psychiatrist Klaus Conrad in his 1958 publication on the beginning stages of schizophrenia. He defined it as "unmotivated seeing of connections [accompanied by] a specific feeling of abnormal meaningfulness." He described the early stages of delusional thought as self-referential, over-interpretations of actual sensory perceptions, as opposed to hallucinations.[13]

*

I Love you. I love you.

12 See Martin B. Sweatman and Alistair Coombs, "Decoding European Palaeolithic Art: Extremely Ancient Knowledge of Precession of the Equinoxes," *Athens Journal of History* 5, no. 1 (2019): 1–30.

13 "Apophenia," Wikipedia, https://en.wikipedia.org/wiki/Apophenia. See Klaus Conrad, *Die beginnende Schizophrenie. Versuch einer Gestaltanalyse des Wahns* (Stuttgart: Thieme, 1958).

double membrane

colour more blue than grey

Ring around the iris

012

Instructions for a
glass eye manufacturer
for The Opening (2019).
› 007

013

Date: April 1, 2014
Subject: moonbounce
From: JVM

Finally, finally!!!
We bounced the hare yesterday :)
See and hear attachment.

We will have a big reopening ceremony on Saturday April 5.
And we will do all kinds of moonbounce activities.
To test and to rehearse we operated the big dish yesterday.
And the first thing we bounced was your hare

FYI, it was sent to the moon from Italy by Nando Pellegrini
(I1NDP is his radio designation)
Nando uses a 10 m dish which he completely built himself....

And the bounced radio signals were received by us in Dwingeloo
using our 25 m dish.
This was the first animal sound ever to be bounced off the moon

Enjoy!
All the best!
Jan

013
Others 2012
Sound
01:14 minute loop

Moonbouncing (or Earth-Moon-Earth
communication) allows Earth-based
radio stations to communicate by
reflecting radio waves off the surface
of the moon. Using radio telescope
antennas, a hare's mating call was sent
to the moon on March 30, 2014, from
Italy by the I1NDP station and received
by the team at the PI9CAM radio-
telescope in the Netherlands. It was
the first animal sound ever bounced
off the moon's surface.

› 145, 259

016
Avant Tout , Discipline 2017
Printed voiles
500 × 300 cm
> 107 , 136 , 205

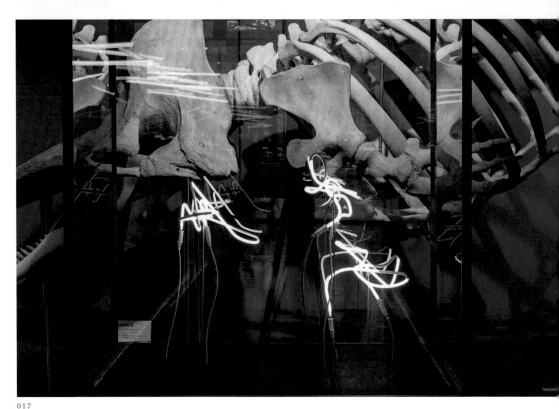

017

017
Paradise 2018
Rare earth neon, mammoth ivory,
copper, paint
Dimensions variable
Installation view
The Center for Natural History, Hamburg
Photograph by Michael Pfisterer

The steel structures within taxidermy
birds-of-paradise, collected by naturalist
Alfred Russel Wallace while developing
his theory of natural selection, were
revealed by a horse veterinarian through
an X-ray machine. They were then
reconstructed from the radiographic
images in rare earth neon and
mammoth ivory.

› 011, 061, 261, 262

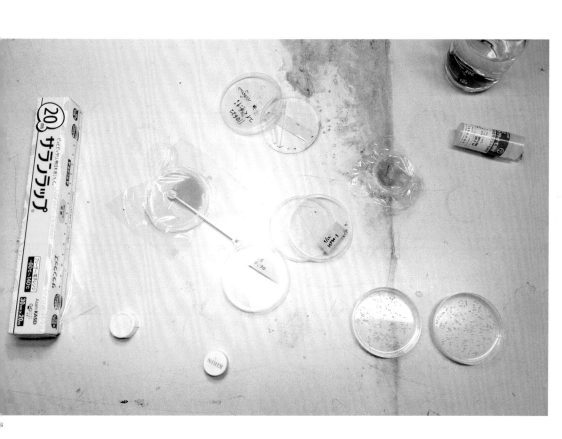

018
Sterile 2014
Production documentation
Yamaha Lab, Nanae Freshwater
Station, Hokkaido University, 2013

(Goldfish IVF)

› 051, 236–239

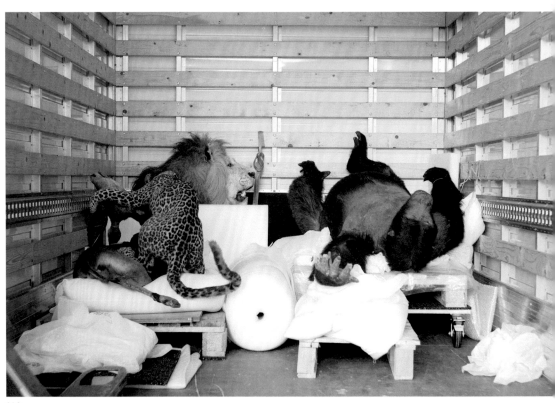

019

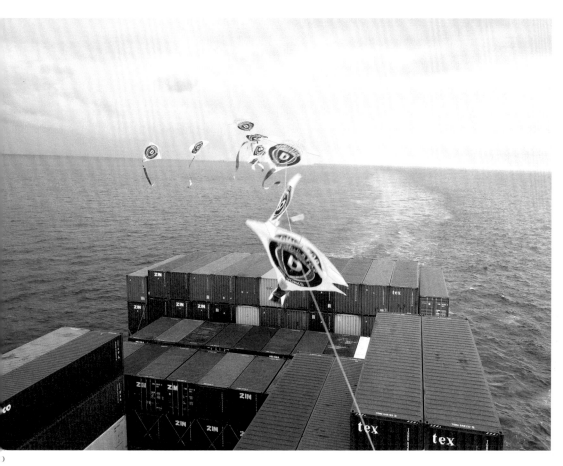

)

019
Heart Lines 2016
Production documentation

(*Six men lift a gorilla*
that died in the 1900s)

› 060-065, 200

020
Dominator Fireworks kite
flown on board the Dignity,
a container ship sailing
through the Indian Ocean.
› 127, 133, 137

75 Watt 2013
Production documentation

*(Regardless of those little
moments of true connection
and sincerity)*

› 162, 170

If you could only know my feelings

So, to recap, we fight mostly about work.

Okay. You don't have to recap, just repeat the last question. Which fight is reoccurring?

I think which fight is not so important, although it always seems to be about the work and whether it's form versus context? And maybe the kind of references, and maybe we want the works to be different. Maybe we like different works, maybe we want to achieve different things, I don't really know.

What do you mean by "kind of references"?

That we would fight because we were trying to work something out, and you would often make me feel like I was going in a very formal and shallow direction, while I would feel like you're taking things into a too abstract, sometimes pretentious one… It's actually our decade-old argument, but when we were students, we could do what we wanted because we didn't work together, and now we do.

Why do you think it's pretentious?

Because sometimes it's trying really hard not to communicate. It's like you're scared of communicating, you're scared of being seen as simple, or maybe you see me as simple.

Maybe I am simple.

That's not a very confident thing to say. You're

not simple.

I'm just keeping all options open. [Laughs.]

You're not simple, and you know you're not

simple.

I don't know anymore.

You don't actually think you're simple. Really?

Since you started reading all this theory

that I can barely—

[Driver starts playing music. Both laugh.]

that I can barely read through a sentence of.

I feel kind of simple, yes. I don't have the

patience. [Laughs.] I don't have the patience,

maybe I don't see the relevance or maybe I don't

really want to get into all this theory because

everyone is doing it and I don't want my work

to be like everyone's… but maybe it is anyway.

["If you could only know my feelings, you would know how much I…" plays from the

song "If You Were Here Tonight" by Matt Goss.]

We're pulling in these two directions and we

feel like shit in the end.

That I don't agree with, because I do fee

like in the end… [Changes tone to draw atten-

tion to the use of a deeply hated catchphrase.

After the work, at the end of the day, when it gets dark… [Back to serious tone.] I feel like the work contains these multiple layers that can also accommodate this tension. And I think this is a struggle that I would also have on my own, between these shapes or multiple layers of references.

It's not just that. It's more like fast ideas, things that you sometimes… react to me like you feel are gimmicks.

Yes, but same, I'm also for fast ideas, I'm not the one pleading for every work to take five years. But I do feel like my fast ideas are blamed as silly jokes.

That's true. They are.

And I feel like there needs to be room for that. For me, it's making the kind of work where I don't really know why, that I also cannot explain. And I'm against things that are simple to explain, not because I mind them but because why would you make them into a thing or a film? If it's just a thing you can explain very simply, why wouldn't you just explain it very simply?

don't know, the bottom line is it works. Look at the minerals: we could explain them very simply, but they still work as a thing, they needed to be.

Yes, but I like those too. And it's true that in the beginning I was…

I really had to fight for them so hard.

Yeah, but also I think they do something that we cannot 100 percent explain yet. And they've evolved—the Croydon one is doing something different from the original ones. The context in which the original one was shown made it into something slightly different from what it was when it was shown outside of this context, right? It's not that much around labor anymore in some way, but maybe it still is. And we didn't know this would happen beforehand. So, I feel like they're kind of simple gestures to make, but they're still quite complex in what they can do, no?

Yeah, I guess. I don't really want to talk about the works again because every thought that became the work was probably a result of agreement. I'm trying to think about the process and why is it so hurtful?

But I think it's good to make it concrete.

Yeah, yeah.

[There's nobody there, no one cares for me / Oh what's the sense of trying hard to find your dream / Without someone to share it with / Tell me what does it mean? / I wanna run to you, I wanna run to you plays from the song "Run to You" by Whitney Houston.]

Is this Celine Dion?
I would put my money on Whitney. But yeah,

she's made it impossible for me to think.

Like all gamblers, they took the credit for their
wins but not the responsibility for their losses
(it was the jockey, the weather, the stupid bloody
horse). Seeing the same men—almost all of them
were men—come back time and again, the winners and
the losers, interchangeable and predictable, was
cumulatively dispiriting: the timeless dance of
the self-deceived…

Very few gamblers have any illusions about what
will happen in the long run: they know they
will lose. No one believes bookies make money by
accident. The self-deception going on here is both
complex and routine: it is a part of the cocktail
of cognitive biases we all share, which makes human
beings liable to misapprehend the relationship
between short-term outcomes and long-term
consequences. Everyday gamblers accept that
they can't really win, yet fervently believe their
next bet will be a winning one.*

David Runciman, "A Pound Here, a Pound There"

David Runciman, "A Pound Here, a Pound There."

023

The Odds (Part 1) brings together racehorses anaesthetized and collapsed on ketamine in a "knockdown box," showgirls from a Macau casino belonging to the world's biggest political donor, and Steve Ignorant from anarcho-punk band Crass, performing in a bingo hall originally built as a cinema designed to look like a church. Produced specifically for a large LED screen, the footage is overlaid with pulsating light formations inspired by Las Vegas techniques of visual seduction. The interconnections evoked draw logic from apophenia —a psychiatric term describing the tendency to perceive meaningful connections between unrelated things or to recognize patterns in random information.

Enter a spinner, allotter, a cutter.

Yasmin: Now stop your ship and listen to our voices.

Naomi: All those who pass this way hear honeyed song / poured
from our mouths.

Georgina: And we know whatever happens anywhere on earth.

All: Bound yourself to the mast, bung your ears with wax.
No one holds clear of entering our green mirror.

 [The sound instructs the soul, they
 tell the names of pain. Bird
 creatures of the underworld bridging
 the human world and what lies beyond.]

Come in and out, if that works with not being slapped in the face with her feathers.
No more sailing,
So long sailing,
Bye bye sailing.*

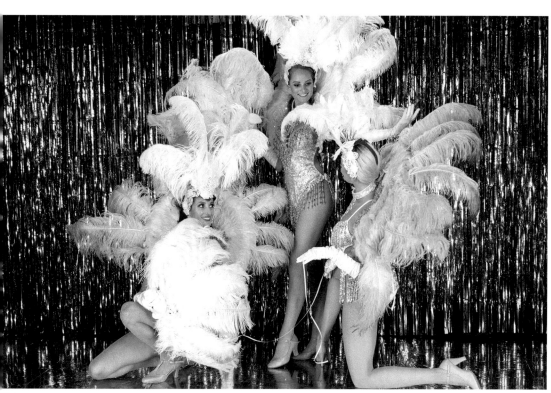

The Odds (Part 1) 2019
Film still

*(Sands Sirens Naomi,
Yasmin, and Georgina)*

022–023, 025, 084

025

horse02-medium.stl ^ horse01-test2.stl ^ horse03.stl ^

026

025
The Odds (Part 1) 2019
Production documentation

*(I literally never remember
my dreams)*

› 023

026
Screen shot from morgue scan.
› 023, 248, 257

September 29, 2018

Dear Lucas, Isabelle, Clara and Chris,

We look forward to seeing you later!

In case we don't manage to talk before the event begins, here is
a short briefing on how things will run tonight.

You are each assigned a number and allocated a space in the room.
The order of appearance will be determined by the throw of a dice,
so until you are called to perform please join the audience as a
spectator. When you hear your number being called please go to your
position, we will join you with a light and the audience will follow.

The numbers and positions are:

1 - Lucas (the economist) - high stool
2 - Clara (the gambler) - left side of card table
3 - Chris (the dancer) - right side of card table
4 - Isabelle (the vet) - pommel horse
5 - Tuur & Revital (the artists) - tbc
6 - video (the oracle) - screen

To let us know your presentation is finished and we should throw
the dice again please end it with the words *Thank You*.

The audience will have a betting form, please try not to look at
it before the event so it doesn't influence your actions, we don't
want to rig the game :)

There is some time at the beginning of the event for the
audience to place their bets, so I'm sure we can talk and also
answer any questions then.

Thanks so much and see you all shortly,

027
Betting sheet for an event
in Paris, featuring economist
Lucas Chancel from the World
Inequality Lab, a horse vet,
a gambler, a dancer, and
an octopus.
› 023, 030

KEEP THIS COPY

REHEARSE
ANTICIPATE
GAMBLE

ODDS ARE DISPLAYED
AS FRACTIONS E.G.

€1 STAKE
ON 4-1 ODDS
RETURNS €5
(€4 WINNINGS + €1 STAKE)

€1 / BET

WHY DO WE SUBMIT OURSELVES TO SYSTEMS WE CAN ONLY LOSE FROM IN THE LONG RUN?

Calling to mind a Deleuzian conception of affect as dynamic states of sensing, energy, and attention outside of conscious awareness yet critical to action, atmospherics are understood to be most effective when they operate at a level that is not consciously detectible. [1]

NOTE TOTAL STAKED

[1] Schüll, Natasha D. *Addiction by design : machine gambling in Las Vegas.* Princeton, NJ: Princeton University Press, 2012. p.46.

TO BE CALLED	1ST	2ND	3RD	4TH	5TH	6TH
☐ the economist	4-1	4-1	4-1	4-1	4-1	4-1
☐ the gambler	4-1	4-1	4-1	4-1	4-1	4-1
☐ the dancer	4-1	4-1	4-1	4-1	4-1	4-1
☐ the racehorse expert	4-1	4-1	4-1	4-1	4-1	4-1
☒ the artists	4-1	4-1	4-1	4-1	4-1	4-1
☐ the oracle	4-1	4-1	4-1	4-1	4-1	4-1

ANTICIPATIONS	ODDS
The introduction to the event to come last	4-1
The economist to roll up his sleeves	4-1
The dancer to be blindfolded	5-1
The house lights to go down	3-1
Calling the economist to take more than two re-throws of the dice	5-1
The gambler to start dancing	4-1
The vet to mount the pommel horse	4-1
The dancer to knock on the table	3-1
The evening to be interrupted by a natural disaster	20-1
The economist to talk about religion	7-1
The gambler to accuse the artists of cultural appropriation	5-1
The oracle's impressenation to be interrupted by a poem	3-1
The dice to roll off the table	3-1
The oracle to smell of coconut	4-1
The artists to mention a casino	2-1
One of the artists to cry	7-1
The vet to talk about breeding	3-1
The free booze to be finished by 19:30	3-1
A white cat to enter the room	4-1
A showgirl to shed a feather	5-1
The gambler to speak someone else's words	4-1
One of the performers to lay on the floor	2-1
One of the performers to film the others	2-1
One of the performers to touch the face of an audience member	2-1
A technical failure to embarrass everyone	5-1
A throw of the dice to abolish chance	20-1
Sirens to announce an ending	2-1

NUMBER	0	1-2	3	4	5-6	6+
of times the economist to say the word 'inequality'	9-1	7-1	4-1	4-1	2-1	2-1
of rehearsals the dancer to perform	9-1	3-1	2-1	2-1	5-1	9-1
of diagrams the gambler to draw	3-1	2-1	2-1	3-1	5-1	9-1
of audience members to leave before 20:30	3-1	2-1	2-1	3-1	5-1	9-1

A THROW OF THE DICE WILL CALL THE PERFORMERS. IF A PERFORMER HAS ALREADY BEEN CALLED, THE DICE WILL BE RE-THROWN UNTIL A NEW PERFORMER IS CALLED.

ENTRIES MUST REACH THE BOOKMAKER BEFORE THE FIRST ROLL OF THE DICE

BEADED CURTAINS
BROKEN HOOVES
BINGO HALLS
BLINKING LIGHTS
BONELESS DOG FUR

Paddypower's odds on the UK to apply to rejoin the EU by 2027 are 5-6

Octopuses have three hearts, blue blood and can change the colour and texture of their skin. The length of the aquarium should be around four times the arm span of the animal, efficient biological filtration is essential and the media should be replaced frequently. Replicating a heterogeneous rocky habitat is essential if the animal is to display well. Keep the lighting low. Provide entertainment and mental stimulation. Do not keep more than one in a tank due to cannibalistic tendencies. A tight-fitting lid is an absolute must.

F A T E
F A T E
F A T E

[2] Margaret Atwood, *Siren Song* Selected Poems, 1965-1975

OFFICE SPACE

COLLECTOR CLIENTS MUST PAY

The Economist Lucas Chancel is codirector of the World Inequality Lab and of the World Inequality Database (WID.world) at the Paris School of Economics. Could well be up to the task in hand.

The Gambler is both no-one and everyone. Doesn't seem to have these matters. Therein lies his chance.

Théoricien-artiste Chris Cyrille tonight performs the role of the The Dancer. Clear run would be most welcome.

Veterinary physician Isabelle Vilarem is an expert in racehorses. She teaches hippology and zootechny in an agroalimentary university. Look to avoid trouble early on to feature.

The Artists are trying to keep this together. Yet to win after seventeen attempts so couldn't be overly confident.

The Oracle has been forbidden from making an appearance. A hint of a 60-year old ancestor will echo its presence. Clear run needed.

CLAIMS can be made at the bookmaker's desk after the SIXTH PERFORMER thanked the audience. All CLAIMS must be made on the NIGHT of the event.

REVITAL COHEN & TUUR VAN BALEN

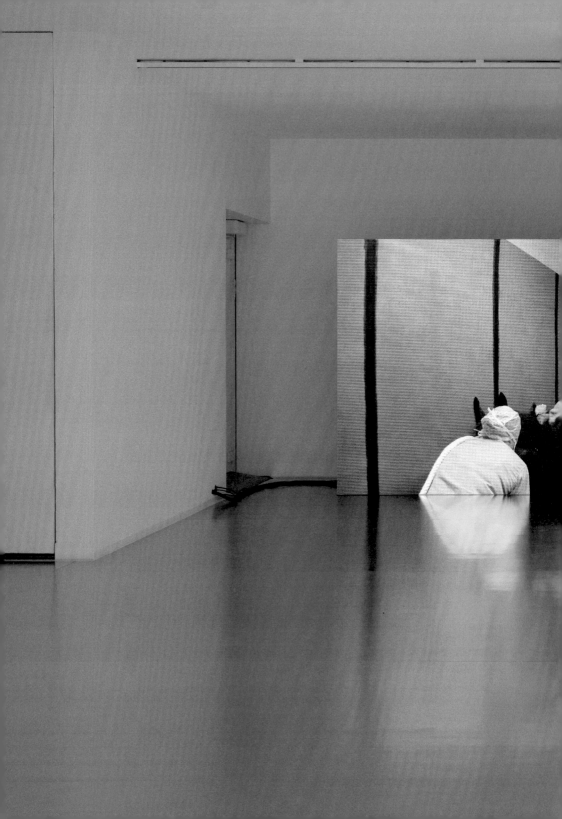

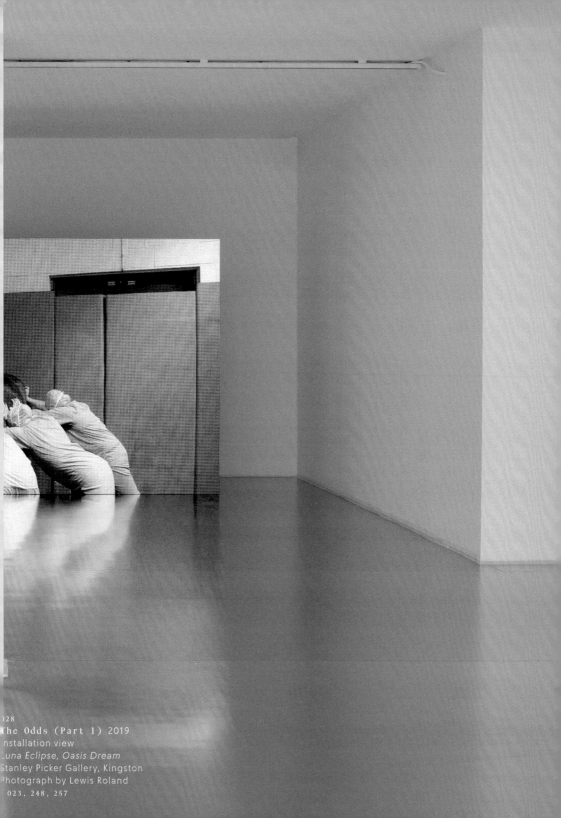

028
The Odds (Part 1) 2019
Installation view
Luna Eclipse, Oasis Dream
Stanley Picker Gallery, Kingston
Photograph by Lewis Roland
023, 248, 257

The trick to multiline slots is this: while
mechanical slots either pay *nothing* on the
given spin or significantly *more* than the amount
of the initial bet, multiliners pay *something*
frequently—but *usually for less than the
amount of the initial bet*. "By creating wins
where players receive less than their wager,"
writes a game designer and consultant, "we give
them a sense of winning but also continue to
accrue their credits." This "sense of winning"
is communicated by presenting gamblers with the
same audiovisual feedback—colorful blinking
lines, sound, the musical score—that occurs
during actual winning.*

Natasha Dow Schüll, *Addiction by Design:
Machine Gambling in Las Vegas*

Natasha Dow Schüll, *Addiction by Design:
Machine Gambling in Las Vegas* (Princeton:
Princeton University Press 2012) 131

*

29
The Odds (Part 1) 2019
Film still

*This specific feeling of
abnormal meaningfulness)*

023, 031–034, 252

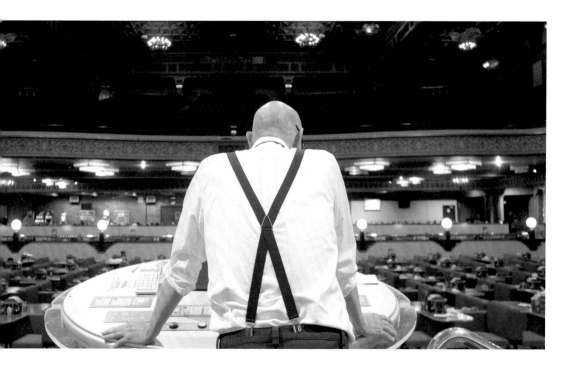

30
atent drawings for slot machine
atterns. Philip C. Crouch,
Multi-line gaming machine,
JS Patent 5,580,053, filed
December 21, 1994, and issued
December 3, 1996.
023

31
he Odds (Part 1) 2019
ilm still

*Steve Ignorant as the
ingo caller)*

023, 249–251

* Jonathan Parke and Mark D. Griffiths, "Gambling Addiction and the Evolution of the 'Near Miss,'" Addiction

The player is not constantly losing
but constantly nearly winning. *

Jonathan Park and Mark D. Griffiths,
"Gambling Addiction and the Evolution of the 'Near Miss'"

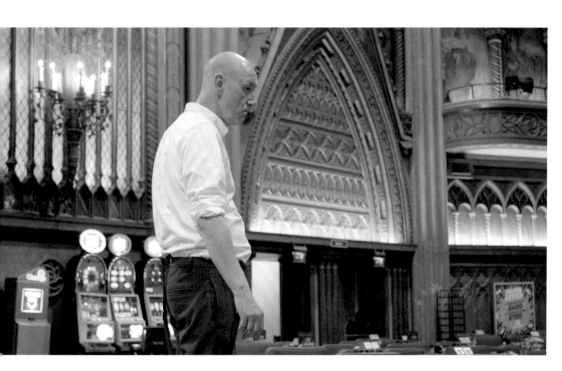

The Odds (Part 1) 2019
Film still

(We all suffer from dreams)

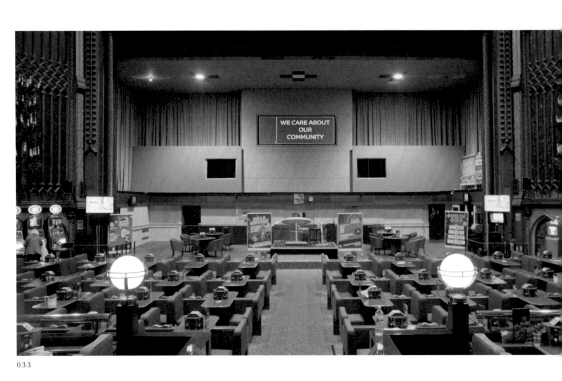

The Granada Cinema in London
was designed in the 1930s
by Russian stage-set designer
Theodore Komisarjevsky, to
the specifications of the owne
who wanted cinema-goers to
consider Granada a "religious
experience." Reproducing
the style and ambiance of a
cathedral, the building has
grand marble staircases,
gothic windows, chandeliers,
and a hall of full-length
mirrors reflecting the foyer
columns to create an illusion
of endless space.

Steve:

Going out there… on that little boat… surrounded by, you know,
as high as that, um, balcony, by green water… The first time
I went out there it was to pull three people out of the sea, they
got caught in a riptide and couldn't get back in, they were on
the point of hypothermia and about to go under.
And we got there and pulled them in.

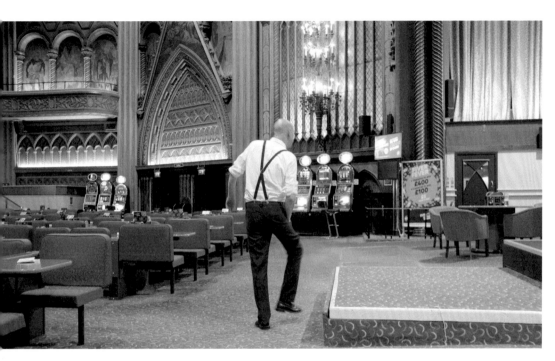

033–034
The Odds (Part 1) 2019
Film still

(Get in line)

› 023, 249-251

Heart-on-sleeve type of horse
(Notes from a meeting with a professional gambler)

/ your joy is predicted at your neighbour's misery
/ extreme empathy-off
/ emotional hormonal situation

Betting big creates *vivid memories*

a gambler looks for:
- a horse in its 2nd or 3rd run of the season
- behaviour: alert or asleep
- two years old (don't want them sweating)
- cold blood

bloodstock agent – an office to take a good look
at the horses' physique

Galileo, the modern day sire, has a calm temperament
(getting a trip from a race)—he had that magic dust
that gives a great mind to his foals.

Cue card – "heart-on-sleeve type of horse"
"he is in love with the game"
"I'd follow him off a cliff, I love his attitude"

035

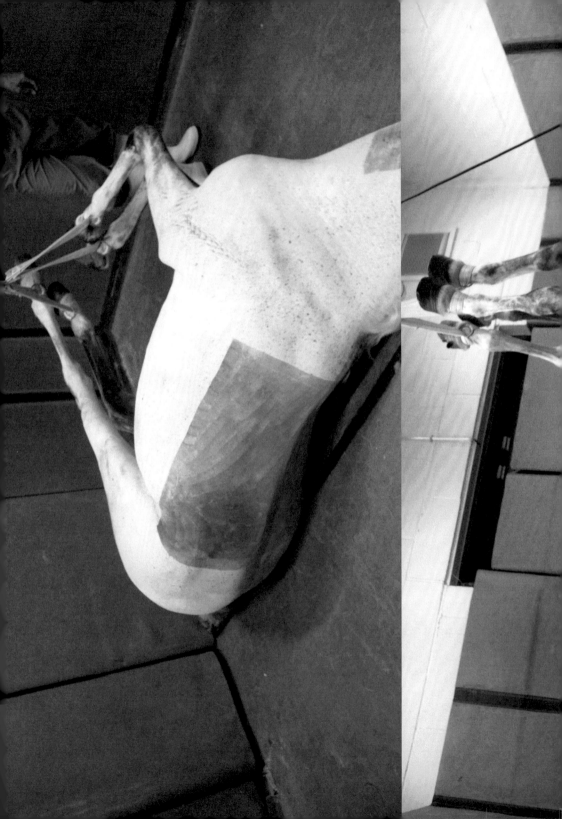

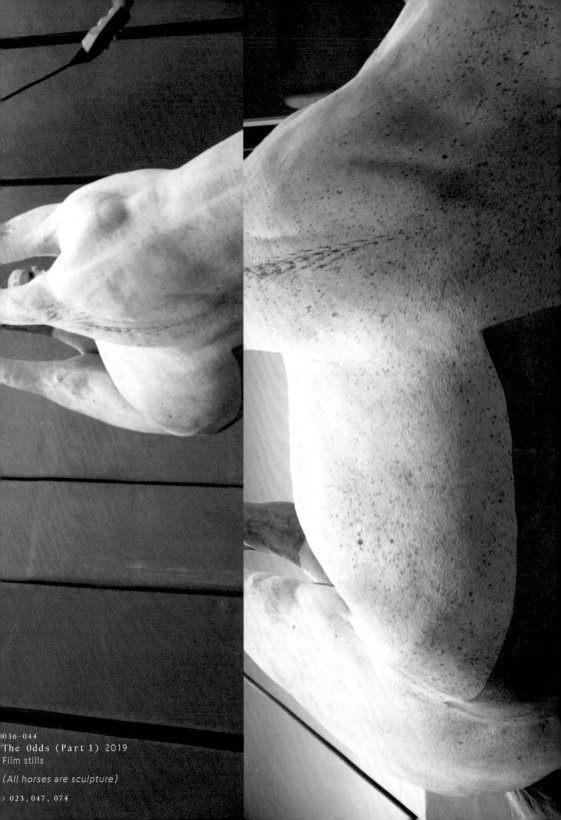

036–044
The Odds (Part 1) 2019
Film stills

(All horses are sculpture)

> 023, 047, 074

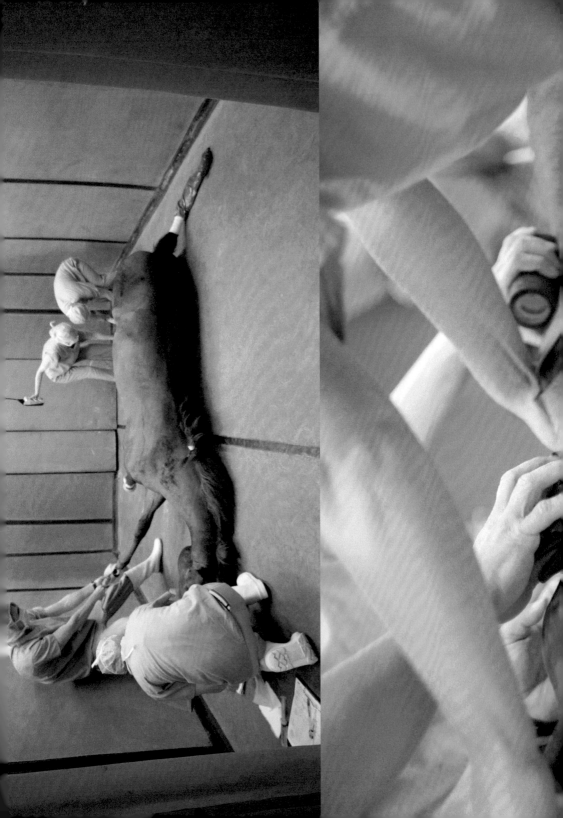

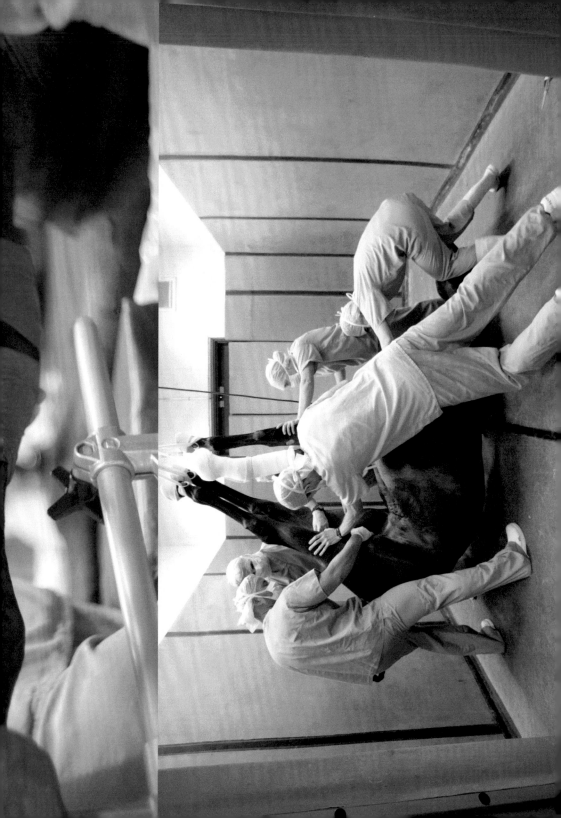

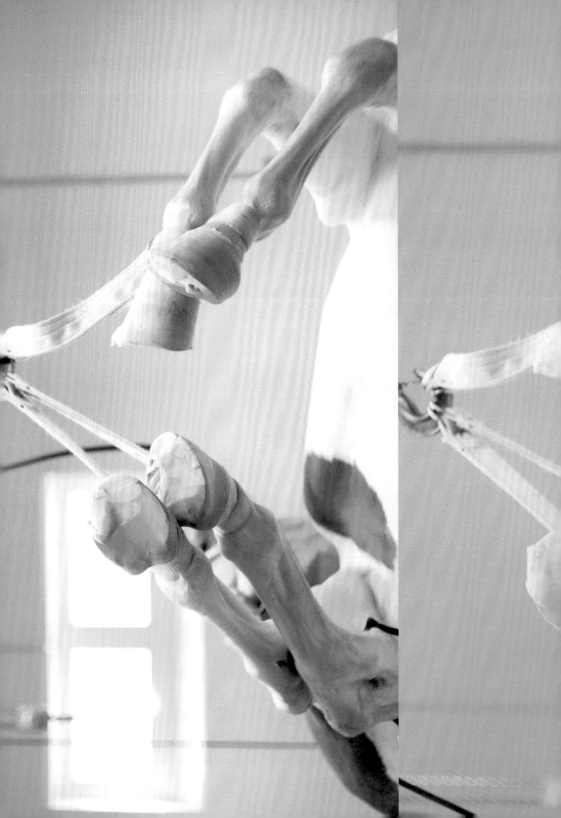

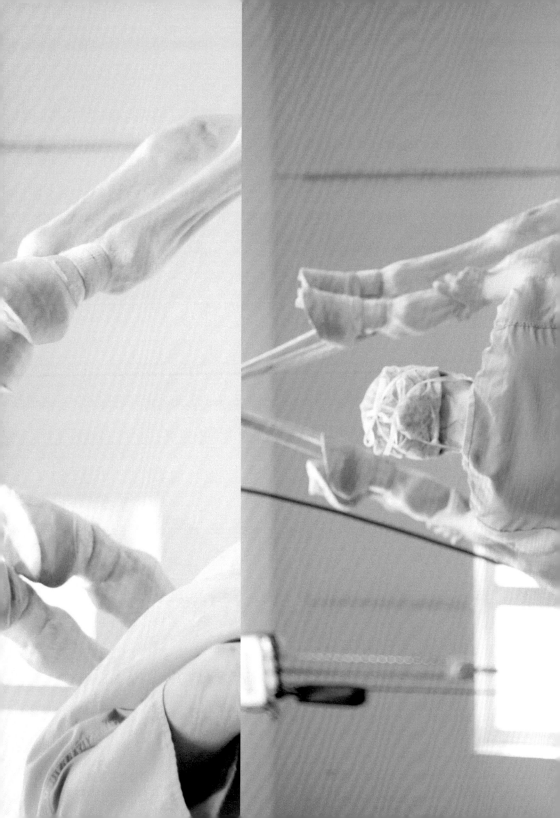

045

We start at sea.

A casino is constructed on reclaimed land. Drawing from Freud's iceberg analogy in which the unconscious mind is the primary source of human behavior, we can think of this building as being built on water.

An ecology of matter designed to appeal to and activate primal urges. The Sirens, adorned in feathers as mythical bird women, lure the sailors that come in through the marble corridors. We are on land but still floating.

As co-founder and lead singer of 1970s punk band Crass, Steve Ignorant was at the forefront of the anarchist movement. He later moved to the seaside and became a volunteer on the coast independent lifeboat. This boat used to be pulled in and out of the ocean by horses.

We look at the stars.

A star constellation is a known expression of apophenia. Look up to see Pegasus and Equuleus, a horse and foal loosely drawn between a sea of dots. I draw dots on the body of the dead horse in the fridge, to 3D scan it with my phone.

Sea The Stars (foaled April 6, 2006; 2021 stallion fee: €150,000; size: 16.2 hh / 68 cm) is a champion Irish Thoroughbred racehorse. Regarded by many as one of the greatest racehorses of all time, he is best known for winning the 2000 Guineas, the Derby, the Eclipse Stakes, and more.

Openness to experiences

hoist > prep > machines

what appears to be a mythical beast,

reproducing asexually

(I'm Thinking About Us)

an embodiment of empire

(Love You Hearts)

in a womb-like padded k-hole

(Magical You)

there is no shared air

but flashes that originate in the spine.

Heads in buckets

205 times more luminous than the sun

Oceans rise, empire falls

that can only be seen when

some men bewitch a horse with a stare.*

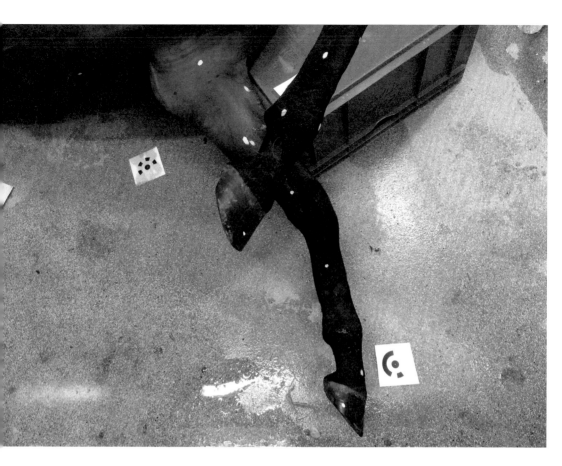

ipp-Ex correction fluid bought in
roadside shop is dotted on the
ody of a thoroughbred racehorse
facilitate photogrammetry.
004, 023, 259

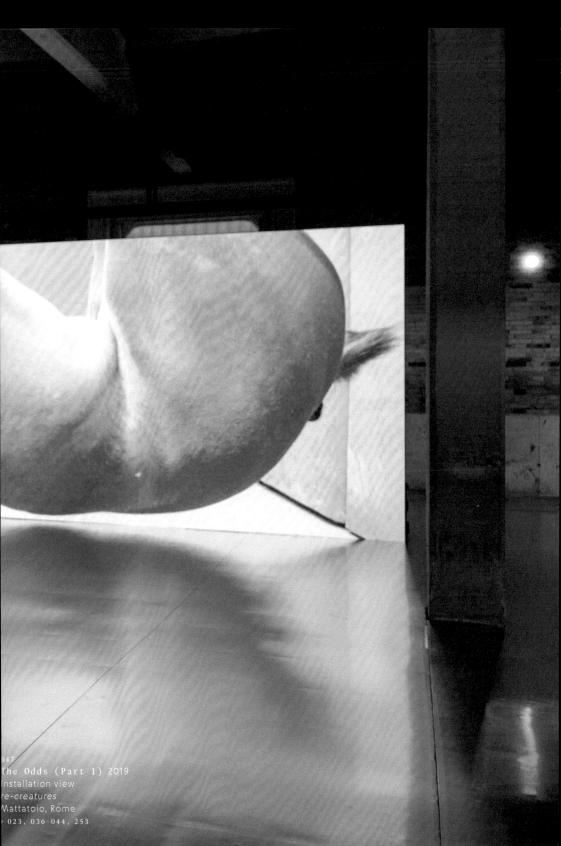

The Odds (Part 1) 2019
Installation view
re-creatures
Mattatoio, Rome
023, 036–044, 253

Ranchu breeder Ito walks us through his domestic farm,
a suburban building designed and built for goldfish breeding.
After retiring from running a construction company, he built
this unassuming house on a quiet Yokohama street, engineered
to hold thousands of liters of water. The roof and terraces
are constructed to hold multiple fish-breeding pools and are
covered in anti-bird nets.

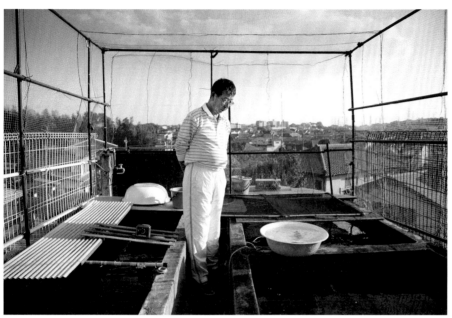

048

048
Kingyo Kingdom 2013
Film still

(Mr. Ito on the roof of his house)

› 051, 054, 117-123

00:03:55
最初から鉄骨で、上に10トン以上の水を載せるのと、
I use more than 10 tons of water on top of this
reinforced concrete house.

00:04:03
水道がすごくかかるから、最初から井戸を掘る、60mぐら
い掘っているんですよ、
I use so much water for the fish, that I had to
dig deep foundations.

00:04:08
水質は飲めるようにして、さらにxxxまでくみ上げて、家を
建てたんて、
When I built this house, we made sure the
local water was drinkable and put in a system
to pump it up to the roof.

00:04:19
家自体が本当に、皆さん蘭鋳御殿なんて、蘭鋳のために家が
あるなんて、皆に言われますね。
So the house is—like everyone says—a Ranchu
Castle, the house is there for Ranchu.

From Kingyo Kingdom film transcript

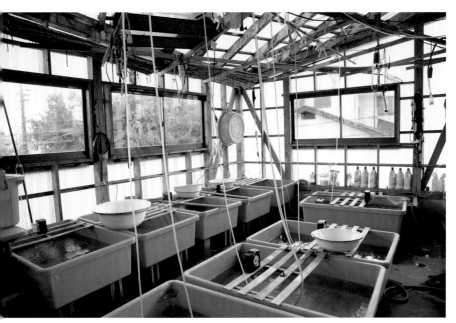

049

049
Kingyo Kingdom 2013
Film still

《Ranchu Castle》

051, 117-124, 233

Date: November 15, 2012
Subject: Re: Sterile Carassius auratus
From: 山羽 悦郎

... The most important thing, I did not mention
about it to you, is rearing condition in your country.
In case I induce your ideal fish, you must to rear
those fish so as not to die. You have better to look
for the good baby-sitter (or goldfish-sitter?),
or practice to take care of goldfish, as soon as
possible. If possible, you had better to have several
separated aquariums and goldfish-sitters in your
country or exhibition points, for risk diversification.

Anyway, I will inform you when I get the parent fish,
and get the offsprings.

Best regards,
Etsuro Yamaha

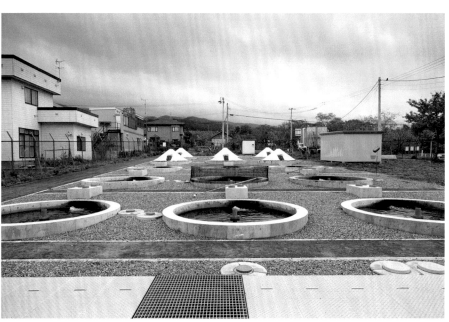

050

050
Yamaha lab, Nanae Freshwater
Station, Hokkaido University, 2013.
› 051, 117–125

Sterile 2014
Goldfish
Dimensions variable

An edition of goldfish engineered to
hatch without reproductive organs.
The fish were produced for the artists by
Professor Etsuru Yamaha from Hokkaido
University in Japan, in a single edition of
45. The fish went on to live in the artists'
studio and their bodies were eventually
preserved as a memorial.

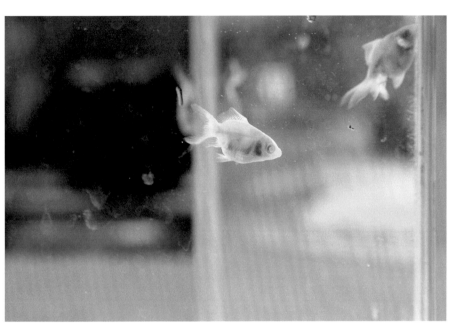

051

051
Sterile goldfish at Yamaha lab,
Nanae Freshwater Station,
Hokkaido University, 2013.
› 003, 018, 066–073, 239

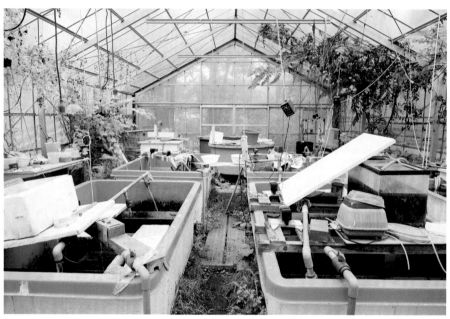

052

)52-053
Yamaha lab, Nanae Freshwater
Station, Hokkaido, 2013.
050, 051, 233

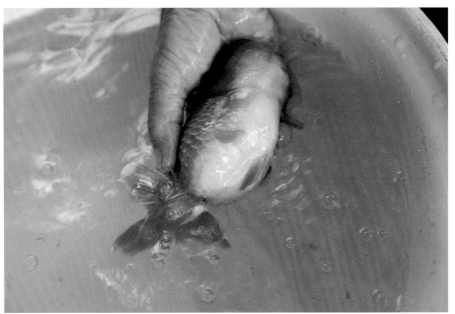

054

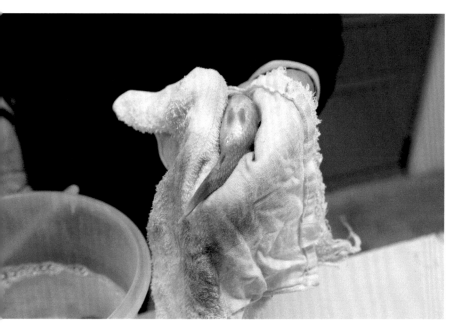

54
Kingyo Kingdom 2013
Production documentation

(Mr. Ito sexing a Ranchu goldfish)

117

55
Sterile 2014

The first visit to Professor
Yamaha's laboratory in Nanae,
Hokkaido in 2013. He is about
to extract sperm from a goldfish
for in vitro fertilization.

035,051

AATTGTGAGCGGATAACAATTGACATTGTGAGCGGATAACAAGATACTGAGCACATACTAGAGAAAGAG
GAGAAATACTAGATGCAAATGACGGAAGCTACCTGTTGACGCTGCTGTAAAACCGGAGCAAAGGGGAT
TGTATTTGCCGGTTCTGGGAACGGGTCTTTATCTGATGCAGCCGACGGGAAATGGTGTCGTCACCACCAAGACTAT
AAAAGGCGTTACAGTGGTGCGCTCTACCCGCACGGGAAATGGTGTCGTCACCACCAAGACTAT
GCGGAAAGGACTTGCTGGCATCGAACTCTTAAACCCCAAAAGCACGGATGTTGCTGATCGTTGC
TCTTACCAAAACAAATGATCCTCAAAAATCCAAGCTTATTTCAATGAGTATTGAAGAAAAGAAGGCGA
ATAAGCCTTCTTTTTTTTGGCTTTTTAGGACCAATAATGACCCTCTGAATCTTAAAATTTCTTTAAAAATA
AGCCAAAATTACCCTTTACTTAATTAATTTGGTAACGTAATATAATTGGAGAATTTGTTACAAAAAAAGG
AGGATATTATGAAATTTGTAAAAAAGAAGGATCATTGCACTTGTAACAATTTGATGCTGTCTGTTACATC
GCTGTTTGCGTTGCAGCCGTCAGCAAAAGCCGTGAACACAATCCAGTCGTTATGGTTCACGGTATTG
GAGGGGCATCATTCAATTTGCGGGAATTAAGAGCTATCTCGTATCTCAGGGCTGGTCGCGGGACAAG
CTGTATGCAGTTGATTTTTGGGACAAGACAGGCACAAATTATAAACAATGGACCGGTATTATCACGATTTG
TGCAAAAGGTTTTAGATGAAACGGGTGCGAAAAAAATCTGGACGGGCGGAAATAAAGTTGCAAACGTCGTTGGCGG
AACACACTTTACTACATAAAAAAATCTGGACGACAGGCAAGGCGCTTCCGGGAACAGATCCAAATCAAAAGATTTTATACACAT
CGCGAACCGTTTGACGACAGGCAGGCGCCTTCGATGAATTAGTGTCATGAATTACTTATCAAGATTAGATGGTGCTAGAAACGTTCA
CCATTTACAGCAGTGCCGATATGATTGTCATGAATTACTTCTGTACAGCCAAGTCAACAGCCTGATTAAAGAAGGGC
AATCCATGGCGTTGGACACATCGCGCCTTCTGTACAGCCAAGTCAACAGCCTGATTAAAGAAGGGC
TGAACGGCGGGGGCCAGAATACGAATTAATGAAAAACAAAACCTTGAAGAATGCTATTCTTCAAGGTTA
TTCTGCTTTCAGCACACAATGGTTTTCGCAGCCATATCATGAACGGTTGTTTTTCTTCGTAAATGCGGC
AGTCAAATAGATCAGGCGGGAGAAACACATGCACCCACGCTATCAGGTAACGGACCAATGGCTTGCGGGA
AGGATATTTTTTATATGTTTCGTCCCTCACGATTTGCAGCCCGATGCTTTTTTGCCCAGTGTGCCCTT
CCAATTGTCAGCGGCATCAGCAAAAATACCGGCTGCGCCAAAATCACTGCTGCGCAATGATTACATCAAGTTAATAA
GGACCCATCGCCCAAACGTAAATCCGGCTGCGCCAAAATCACTGCTGCGAAAGACTGGGCCTTTCGTTTATCTGTTG
TACTAGAGCCAGGCATCAAATAAAACGAAAGGCTCAGTCGAAAGACTGGGCCTTTCGTTTATCTGTTG
TTTGTCGGGTGAACGCTCTCTACTAGAGTCACACTGGCTGCCACCTTCGGGTGGGCCTTTCTGCGTTTATA

057

057
Pigeon d'Or 2010
Production documentation

Working with biochemists and pigeon
fanciers, techniques from synthetic
biology were used in an attempt to
make a pigeon defecate soap. In order
to do so, the DNA of bacteria was
modified so it could metabolise soap
inside the pigeon's gut.

› 023, 051, 117, 125

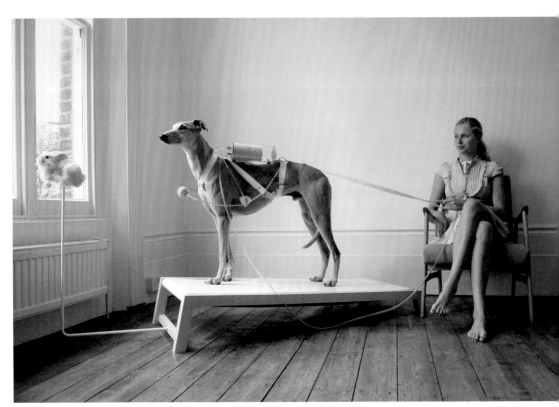

058

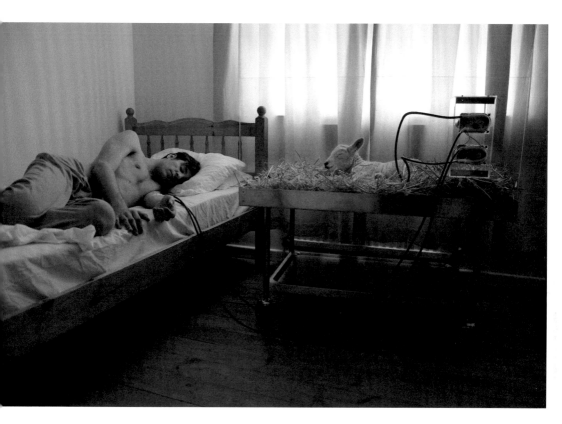

The Life Support series
proposes the use of animals bred
commercially (for consumption
or entertainment) as companions
and providers of external organs.
The use of transgenic farm animals
or retired working dogs as life
support "devices" for renal and
respiratory patients suggests
an alternative to machine-driven
medical therapies.

Lucia Pietroiusti

"The sky is always perfect blue when painted on the ceiling."[1]

Collaboration is not a shape. It is an infinite number of subtle re-adjustments; an occasionally stable object in perpetual internal motion; a seemingly tangible thing, made of millions of tiny, quantum catastrophes every fraction of a second. Just like everything else, it barely holds together. The way gravity holds us just so, neither crushed by the pull beneath nor flung into outer space by the force of the spin.

Then there's the parallax: Revital Cohen and Tuur Van Balen, a man of rehearsal and a woman of faith, we once joked. A collaborative—but by no means homogenized—practice. Four eyes on the same objects make different relationships, see different distances—complex and overlapping ones. There are ecosystems stacked on top of one another—webs of ecological disaster and capital flow; the international movement of materials; political projects of dispossession; interspecies encounters with the more-than-human in which the latter always, one way or another, ends up as just another cog in the production line, another link in the supply chain. Products producing products, being produced by the invisible lines that hold it all together, all the horror and the innocence.

And there is no such thing as innocence, the woman of faith says, not with her words but with *their* work, as she draws it into that other gravitational pull, the one they call the death drive, or what they mean when they say that vertigo is really just your desire to jump. That thing inside you that knows that the merciless is all around even if you don't see it, not because it's not there, but because it's just easier that way.

You look away.

You look away from *Sterile* (2014), with its a genetically modified albino goldfish bred to grow without reproductive organs: "goldfish, dimensions variable, edition of 45." An animal that becomes an object of production in its deprivation of any system for reproduction, and the artwork that, in the shape of *forty-five actual fish*, shines a light back onto the butchery inherent in the notion of art-as-commodity. You look away, because you are not outside of this. Do you remember the goldfish you took home in a plastic bag from the fun fair? I do, two

of them. I called them Paddy and Alex after a couple of inseparable friends of mine. I don't know what I did wrong, but they agonized for two or three days, so bloated that they'd float up to the surface whenever they stopped their frantic swim back down. When they gave up, they died.

Sterile, a school of forty-five, cared for by the artists and their families as if they were children. Some survived for seven years and, having lived as artworks, they were then buried as artworks (having been cared for as children, they were mourned as children), encased in a transparent, resin cube, held in place between sand and heavens, staring back from the end of their own production line.

Carefully documented by the artists, the process from concept to goldfish is cloaked in the cold, clean language of "science," "design," and "engineering," and is surprisingly tactile, matter-of-fact, corporeal. We watch as Dr. Yamaha, in Hokkaido University's Department of Marine Life Science, reaches into a featureless plastic bucket on a white, metal table, rusting from time and use. He wraps a fish in an old, ripped towel, squeezes a greenish goo of eggs from one "parent" and pricks the other with a cannula that sucks out the sperm. It is noisy in the lab, not like labs in the movies or those high-security facilities that store deadly viruses in locked-off vials and vaults. It's messy and fleshy, like a kitchen or a market. We watch through a microscope as fertilized eggs are injected, one by one, with morpholinos, a molecule that modifies gene expression and renders the embryos sterile.

E-mail from Revital Cohen to Dr. Yamaha, December 12, 2011: "By doing so I hope to explore the meaning of infertility, the classification and perception of an organism which is not a link in a chain but a being which encapsulates both the beginning and the end of its existence."

E-mail from Dr. Yamaha to Revital Cohen, January 25, 2012: "In many cases, they allow the modification in plants, but refuse that in animals… But, I also feel that it is very difficult to analyse the deep psyche of mankind, including our students. We cannot remove vague anxiety of uncertain issues, such as uncertainty about the future."

This doesn't really have a beginning. I was underwater and you fished me out. It was like a part of me had been cut off and I had bled out. It was like I was hollow. The belly was there, but flaccid and weak, empty, exhausted. I didn't even ask where the baby was.

Sterile is a work that brings up a vague, metallic aftertaste, just on the sides of your tongue, at the back. The aftertaste of iron-rich water you're told to drink when anemic and pregnant (which is also the aftertaste of blood, you think, as you drink, before pushing the thought away). It asks questions of extinction, of inextricable anthropogenic "trouble," of both the animal-industrial complex and the complex industriousness with which all of it is hidden from view. And it injects the fish, not only with morpholinos, but with the existential fiction of the "art object," another gene-modifier, through which the fish is rerouted away from its designer-pet destiny and into another, quite adjacent, fate.

[13:30, 19/02/2021] Lucia Pietroiusti: Fact check—how long did your fish live for?
 (the longest one)
[13:31, 19/02/2021] Revital Cohen: 7 years I think
[13:31, 19/02/2021] Lucia Pietroiusti: wow
[13:31, 19/02/2021] Lucia Pietroiusti: my goldfish Paddy and Alex lasted
 about 3 days in my care
[13:41, 19/02/2021] Revital Cohen: Haha
[13:42, 19/02/2021] Revital Cohen: Well these were artworks,
 they got the best care ever.

As I scroll through the materials that document the making of *Sterile*, I encounter a picture of the only novel I ever threw in the trash.

Notes from meeting Jan at the Newmarket Horse Hospital

breeding

Embryo transfer / IVF is banned, no vet will agree to do it
all mating is natural in racing
Every horse has its birthday on the 1st of January
National stud breed horses (wtf was that place)
horses retire by the age of 4, and rehabilitated for hunting, dressage or riding

You look away from *The Odds (Part 1)* (2019) and the constellation of works that surrounds it, a body of objects, research, and situations that revolve around the subject of gambling. Gambling, not as an addiction, but as a chronic condition that—in this gamified present—haunts us all and shapes our choices. In these gambling works, the produced animal finds form in the body and lineage of the thoroughbred

racehorse—the design of animals within chains of desire and pro-
duction, their anthropogenic existence, is a recurrent trope in
Cohen and Van Balen's work. All thoroughbreds can be traced back
to three stallions imported into England between the late seven-
teenth and early eighteenth centuries. Their care, reproductive
and sterilisation regimes, the course of their life, their finan-
cial value, and the causes of their death are all human designs.
Nothing about thoroughbred racehorses is exempt from humans'
interference; almost everything about their demise is kept from
view.

Notes from phone call with Dene Stansall

As soon as a horse begins to show signs of collapse security put up a green
screen around an injured horse, within minutes the horse is surrounded by
green screens and its end (death or destruction) is hidden. Horse deaths are
kept secret private as they fear it will turn public opinion against racing.
Look at the historical races: http://www.horsedeathwatch.com/ all deaths of
exhaustion are listed.

Originally titled *Nearly Winning* (the gambler never loses, they
are always nearly winning), *The Odds (Part 1)*, like Cohen and Van
Balen's other gambling works, traces lines across money and blood.
Lines traced from a casino in Macau to its owner, one of the
world's biggest conservative political donors.[2] Lines that follow
settler-colonial projects unspool through a London cinema
designed to look like a Gothic church, now repurposed as a bingo
hall; through poker chips cast in Jerusalem clay (*The Circuit*,
2019). Lines that converge into the artist's eye, reproduced in glass
and resting, *as though innocently*, in the middle of all of this,
not looking away (*The Opening*, 2019).

You need a kind of paranoia to follow these lines; a habit of mind
through which the structure of the real reveals itself as a dense,
complex tangle. Cohen and Van Balen's practice often experiments
with the exhibition as a medium in and of itself, and in the gam-
bling works that paranoia is mapped onto their articulation in a
gallery space, such as at the Stanley Picker Gallery in Kingston,
where I experienced this mapping one sunny afternoon in 2019. So
much of the exhibition is intentional, from the near-reflective
surface of the floor—"dead light," I remember thinking—to the

smell of the place. Pixel-sized glitches, coded into the media player, are overlaid onto the film *The Odds (Part 1)*, playing on a large LED screen, so that everything shimmers slightly. Track lighting dims up and down, but only when you're told do you realize, uneasily, that you've seen it happen.

In a casino, a mall, or a theme park, "atmospherics" (light, music, smell) are designed to dull the senses and distort time. Atmospherics perform best when they rest just below the threshold of perception. But when these markers configure themselves in a gallery, that threshold is ever-so-softly transgressed. You become a visitor in a place that was not intended for you. That physical pre-perception of something pre-encoded becomes a discomfort, as if someone had just disappeared around the corner.

As weird atmospherics leave clues behind, this slight unease becomes a defamiliarized "not-quite-there"-ness. And there you start to feel— maybe not yet see, but feel—those lines across blood and money, those sense-dulling infrastructures that hold everything together (art, ecology, economy, geopolitics) while hiding themselves from view. These are ecosystems—the man of rehearsal articulates them just so— and if you recognize them as ecosystems, do they then become fragile enough to upset, or break, like ecosystems do? Slowed down to just over fifty minutes, Abba's "The Winner Takes It All" stretches itself under and around the exhibition, carrying chord structures that you nearly recognize. Even at a glacial pace, the song retains the bombastic arrangement of the original, so that the pop drama in one threatens catastrophe in the other. And never is this tension more acutely felt as when, on the screen, an entertainer from the Macau casino filmed upside down—a "Sands Siren"—crashes upwards in slow motion onto the shiny floor: feathers, tassels, and all, gravity reversed but no less unavoidable. Sedated horses hang from their legs on a hoist in a room that threatens slaughter but instead dispenses care. You will not see disaster; you'll just stand there on its doorstep, and you'll look away, because everything is upside down, and disaster fugues upwards, a mushroom cloud of glitter, blood, and money.

You came out of me defiled, bloody, tumescent, victorious.

There were pools of blood on the floor.

The placenta looks like every organ that it replaces. It makes him breathe, it looks like lungs. It makes his blood flow, it looks like a heart. It cleans, it looks like kidneys, livers. Sweetmeats, and a butcher's block and puddles of blood. The midwives with their orthopaedic shoes leave bloody footprints on the floor. I am underwater and I think about mopping.

In a performative iteration of the gambling research in Paris in 2018, the artists brought together some of the ghostly figures that haunt the works—an economist, a racehorse trainer, a dancer, a croupier— in a kaleidoscopic set of conversations and appearances in which the audience was able to place bets on the events of the evening, including the odds of the event being "interrupted by a natural disaster" (20-1 odds), or "a white cat entering the room" (4-1), or something pushing "one of the artists to cry" (7-1). An octopus, physically absent but evoked, figured as the Oracle. A red tinsel curtain, stretched behind the stage, set the scene (the same tinsel curtain found in the background of the Sands' Sirens in *The Odds (Part 1)*).

Amidst the research materials, I find a photograph—dozens of octopi, half covered in snow and ice, tied alongside what is perhaps the railing of a ship, pinkish tentacles hanging perfectly down all in a row, tinsel-like. Below them, a paragraph:

The vapors that drove the oracle into a state of ecstasy were believed to be produced by the eternal decomposing of the flesh of Python. The first oracles were shepherds that lived in the area and inhaled the vapors and entered ecstatic states only to die afterwards.

An octopus mother will protect her eggs against predators, dying of violence and starvation in the process. Once the eggs have hatched, she will die. Apophenia abounds: you will always, in these works, see what you want to see.

You look away from *Heavens* (2021), an immersive installation conceived for planetary-style projection methods, inspired by Walter Benjamin's mournful comment in his essay "One-Way Street" that the development of astronomical technology brought about the death of the cosmic experience of antiquity: the more we see, the less we sense; the more we know, the less we conceive.[3]

Heavens itself is dedicated to that cosmic trance, and to the peculiar

3 Walter Benjamin, "One-Way Street," in One-Way Street and Other Writings, trans. Edmund Jephcott and Kingsley Shorter (London: NLB, 1979), 103–104.

4 Edward J. Steele et al., "Cause of Cambrian Explosion—Terrestrial or Cosmic?," Progress in Biophysics and Molecular Biology 136 (August 2018): 3–23.

and otherworldly behavior and biology of the octopus, that age-old Oracle, a being perhaps too alien to be alien. And yet it might just be so, as a scientific paper from 2018, "Cause of Cambrian Explosion—Terrestrial or Cosmic?" suggests, positing that the mass increase in biodiversity that occurred on Earth some 500 million years ago may have been due to extraterrestrial DNA.[4] Given a potential cosmic origin to the octopus's secret history, the artists proceed as detectives, working their way back from the animal's odd properties to a vast, cosmic state, utterly ungraspable in all but the briefest of moments.

They tell me it's been three hours, that I need to feed him.

Panic rises from a rumbling to a scream.

Daddy, I can go in, but I can't come out. I don't know how to say. I can't hold onto the real. Daddy am I having a psychotic breakdown? You're not. How do you know? I know.

I wonder sometimes about these collaborators. Dr. Yamaha contemplating our fear of the unknown; the Sirens with their perfect, steadfast smiles; the horses, unconscious in their hoists; the fish, in their suspended resting place; and the octopus-Oracle, with its three hearts, nine brains, and desperate mother instincts.

I wonder how they all fit into this tangle, whose lines run through infinite places and pass through the man of rehearsal and woman of faith standing side by side, making fish and children, whose lines come to meet here, on this cold mid-afternoon as I finish writing. I wonder about them in the way you look up as an airplane flies overhead, and for just one moment you think there's someone up there looking down—and right there, your eyes and maybe your souls must be—they must be—meeting, or exchanging something, otherwise you wouldn't be there, in that very place, so willing to look up.

R

060
Heart Lines 2016
Production documentation
(Original plates: steel wire, plaster,
glass, hay, and skin)

A gorilla, half a lion, and a leopard killing
an impala were taken from the archive
of the Royal Museum for Central Africa
in Tervuren, Belgium and X-rayed in a
local hospital, exposing the sculptural
structures within.

The radiography waves reveal
natural history as a cultural practice,
a colonial interpretation of nature and
wildness. The X-ray machine performs
the excavation of subconscious form:
a taxidermist imagined movement
and posture between two animals
they had never seen, based only
on hunters' stories and empty furs.*

12:24:07
12/03/2016
12:38:44
12/03/2016

› 006, 019, 061–065, 200

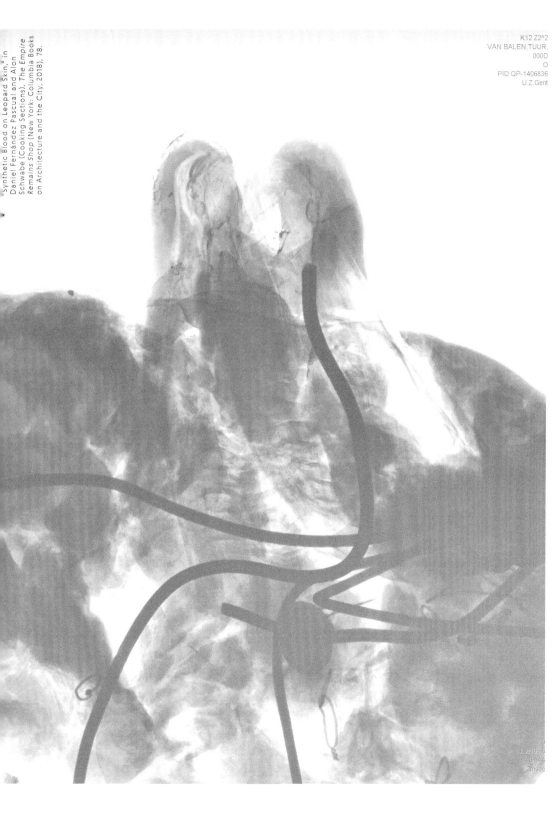

"Synthetic Blood on Leopard Skin," in Daniel Fernández Pascual and Alon Schwabe (Cooking Sections), *The Empire Remains Shop* (New York: Columbia Books on Architecture and the City, 2018), 78.

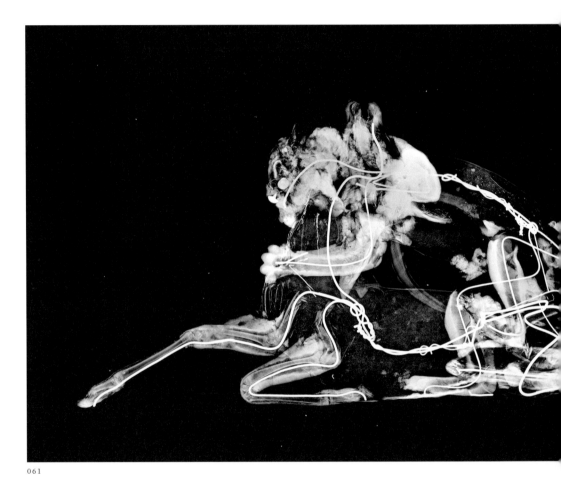

061

061
Savane Du Sud 2016
C-type print
197 × 105 cm

An X-ray of a taxidermy scene of a
leopard killing an impala. The title of
the series (Heart Lines) is borrowed
from a tradition of Siberian rock drawings,
which were based on a shamanistic belief
that animals could be brought back to life
from the portrayal of one line running
from the mouth to the vital organs.

› 006, 060

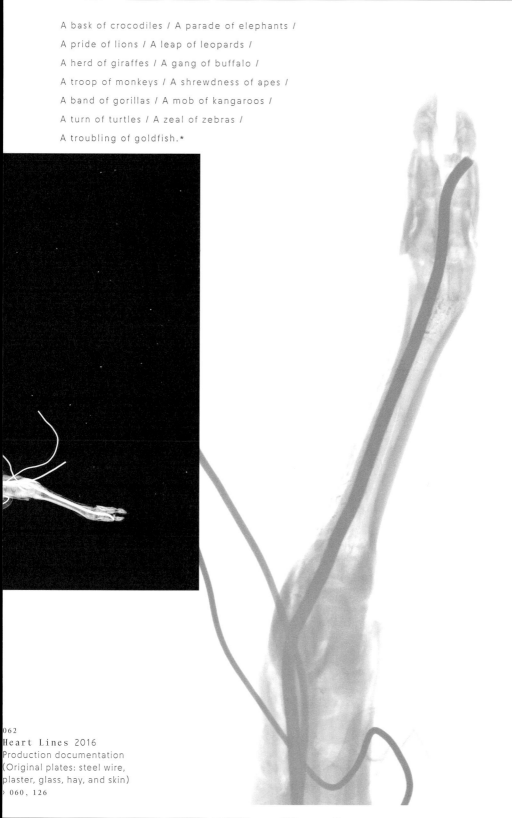

A bask of crocodiles / A parade of elephants /
A pride of lions / A leap of leopards /
A herd of giraffes / A gang of buffalo /
A troop of monkeys / A shrewdness of apes /
A band of gorillas / A mob of kangaroos /
A turn of turtles / A zeal of zebras /
A troubling of goldfish.*

062
Heart Lines 2016
Production documentation
(Original plates: steel wire,
plaster, glass, hay, and skin)
) 060, 126

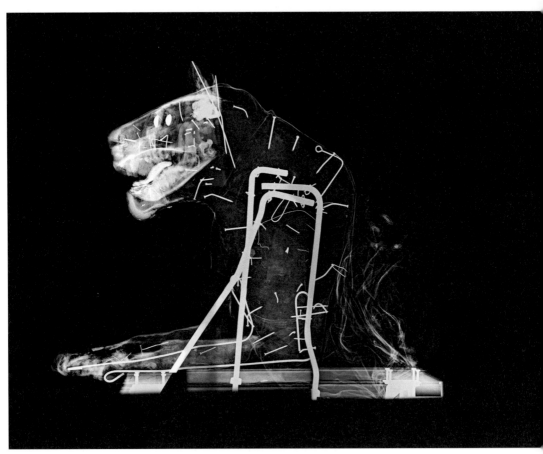

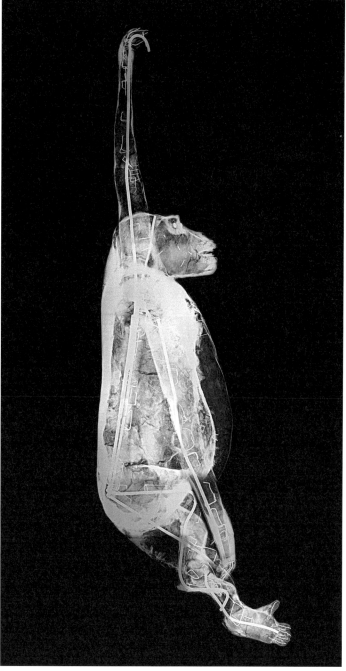

064

In 1898 King Leopold II of Belgium opened the Museum of Congo to showcase the civilizing mission and economic opportunities in his Congo Free State amid accounts of murder, mutilation, and enslavement. Since renamed The Royal Museum for Central Africa, the institution still shapes how many Belgians imagine both Congo and the whole African continent. Until its recent closure for a major renovation, the museum presented a Western view of Africa that has hardly changed since 1960, when Congo achieved independence. Tropical taxidermy are still roaming fantasy landscapes in elaborate dioramas next to statues of naked African children.*

In one of the meetings with Garin Cael, the Biological Collection manager in Tervuren—who seems to know everything about specimen preservation—we ask about preserving fish. He advises that freeze-drying is the only way to avoid future rot from within. We try to figure out how to do that without the resources of a national zoological collection. First we consider buying a machine, then we call up factories that freeze-dry berries or mushrooms, but none agree to contaminate their food-grade facility with my "pet goldfish." In the end a pharmaceutical biotech lab agrees to help. I arrive there one morning after a long train journey with a big styrofoam box in which the fish are packed within piles of dry ice. The company director happens to open the front door. "Hello, I'm here for the goldfish," I say. He looks baffled but lets me in with a smile. "Something tells me that the less I know about this, the better." Somehow, a scientific goldfish drying protocol is named after me.

065

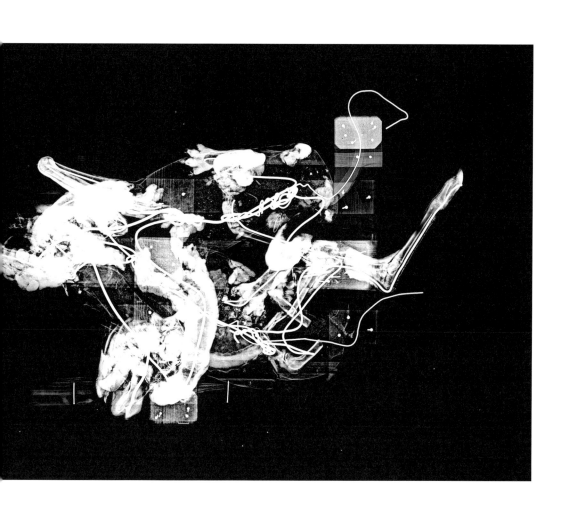

65
Savane Du Sud Dessus 2016
C-type print
97 × 122 cm
060, 149

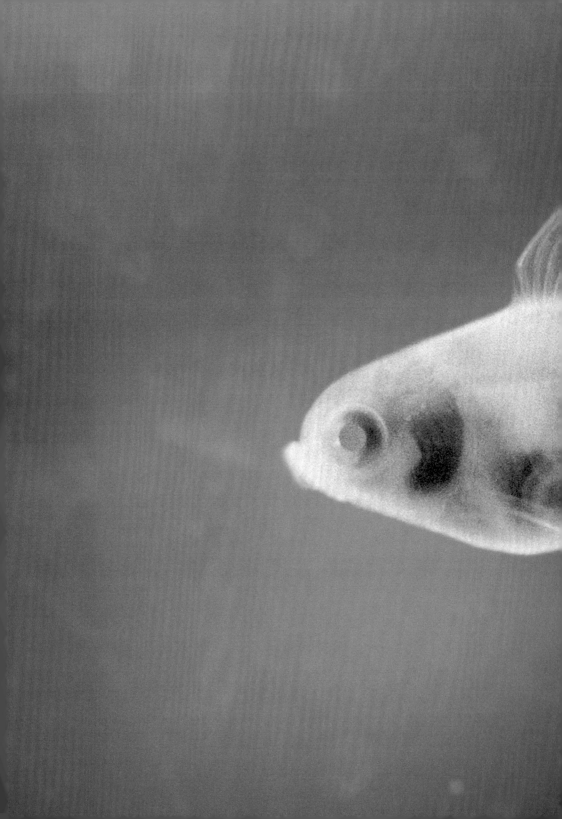

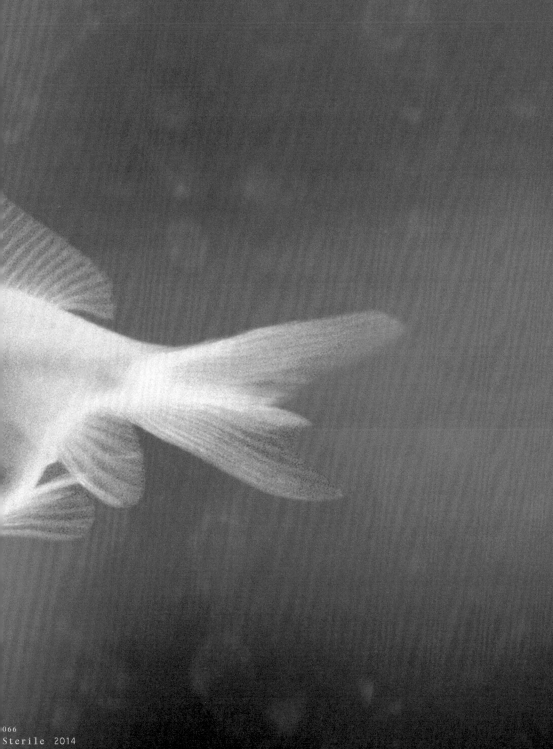

066
Sterile 2014
Goldfish
Dimensions variable
051, 232, 239

After a long drive, we arrive at the Koi farm. The breeder (fish-sitter?) takes us to see our fish, who have been staying in this luxury facility for a few months. He still can't comprehend why we wanted such expensive care for these small, "simple" goldfish (no fancy tails, no exotic colors, not a rare breed) but is entertained by the whole thing and happy to teach us how to care for the fish. In his farm the pools are deep and dark, and the water circulates vigorously. How do we simulate a piece of river in a glass box on the second floor of an old factory building? Who ever thought that made sense.

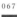
067

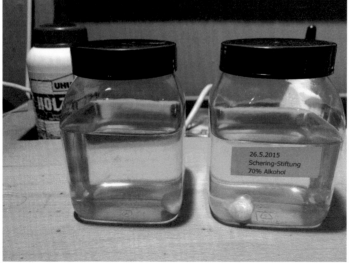

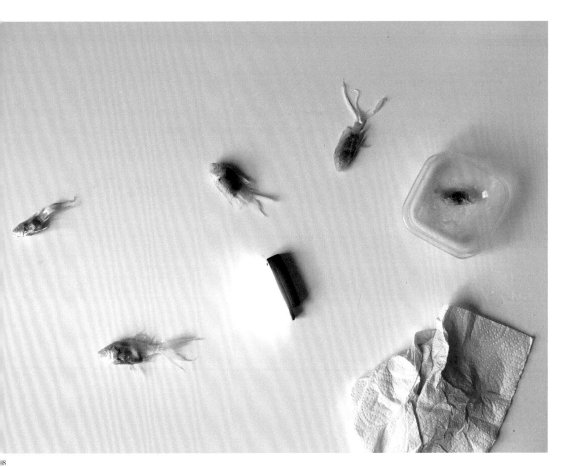

067
The first two fish to die,
preserved in alcohol. Later lost
in transit on their way back from
an exhibition.
◦ 051, 232

068
Bodies of the last
S t e r i l e goldfish from the
studio: out of the freezer,
being prepared for freeze-drying.
◦ 046, 051

Date: September 26, 2016
Subject: RE: Goldfish
From: Magdalena

Hi Revital,

It was nice to meet you too. It was very
interesting meeting.
Your fish is still in the freeze-dryer and
it will still be for a few more days.
I will keep you up to date.
Have a nice day.
Kind regards
Magdalena
Research Scientist and Quality Coordinator

Date: September 29, 2016

Hope you are well.
Your fish is still in one piece :)
(see photo attached). I'm afraid the cycle
will be longer than we thought, and we will probably
leave fish over the weekend in
the freeze-dryer. Hope this is not a problem
for you.
Kind regards
Magdalena

Date: October 10, 2016

Hi Revital
Hope you are well.
The cycle has finished. Fish lost it weight :) It looks
and feels dry. I put the fish into the glass container
– see photos attached. I put molecular sieve in and
blow some nitrogen gas in. It is ready for collection.
Kind regards
Magdalena

069

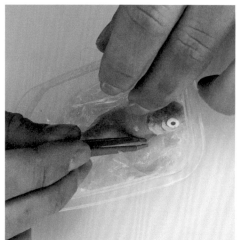

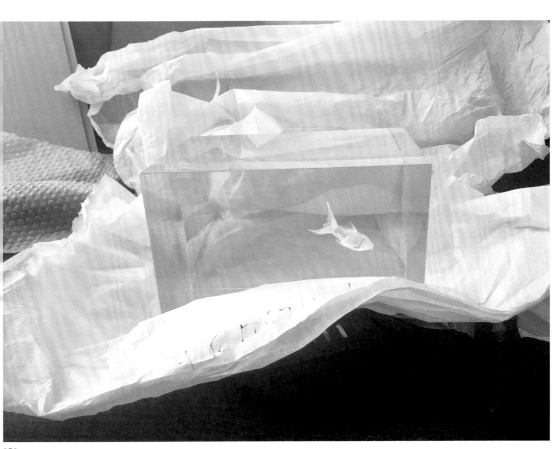

070

069
Dead, sterile goldfish propped
up in Tupperware for freezing.
› 051, 055, 238

070
Freeze-dried goldfish cast in resin.
› 051, 232

Jan found his body while we were on a
container ship somewhere in the Indian Ocean.
Akira was light orange (or light gold), small and
bulb-shaped with a triangular tail. I loved him
the most because from the moment he arrived
in our studio and floated out of the plastic
bag into the tank, he would swim upside down.
I could not stop seeing this abnormality—
caused by a problem with his swim bladder
(a common ailment with goldfish)—as an
expression of an endearing and charismatic
disobedient personality.

The worst moments were having to admit
to each other that something was going wrong.
Once it was acknowledged, it was real. When
a fish started to behave unwell—"resting" on
the bottom, floating on its side—I held on to
self-delusion for as long as I could—they were
only sleeping, trying some things out. But the
moment I'd catch you looking, or when one
of us finally said out loud that something was
wrong, death became a reality. We'd enter
the studio each morning racked with anxiety
until a floating body was found and mourning
could begin. Change the water, quarantine
tank, biological enhancer, water conditioner,
new gravel, call Ken, ask the shopkeeper.
Some things worked but then they didn't.

The ones who died in the studio we took home
and placed in the freezer between frozen peas
and ice trays. It felt obsessive and pointless
but disposing of their bodies seemed worse.

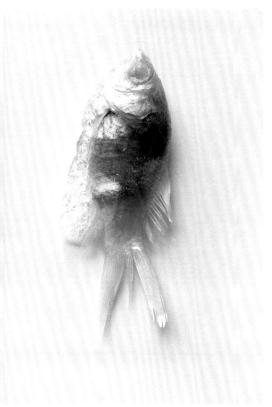 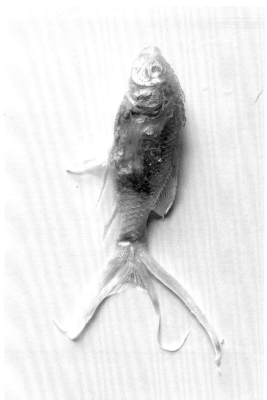

071

072

071–072
Frozen sterile goldfish.
› 020, 051

Date: December 20, 2017
Subject: Names of fish
From: Tyler Coburn

What were some of the names you gave to the
fish? X

From: Revital Cohen

ugh I really repressed that. painful memories.
my all-time favourite and first to die was Akira,
who swam upside down. Then there were also
Shiro, Pinku, and Great White.
It's crazy but I can't remember anyone else's
name... if any more come up will text you :(
Xx

From: Tyler Coburn

Oh, sorry to bring it up. Three names is enough.
No more bad memories please! X

From: Revital Cohen

no no, I so enjoy your questions, please don't
hold back. bad memories are part of the game :)
x

From correspondance with Tyler Coburn in preparation
for the exhibition **White Horse / Twin Horse**

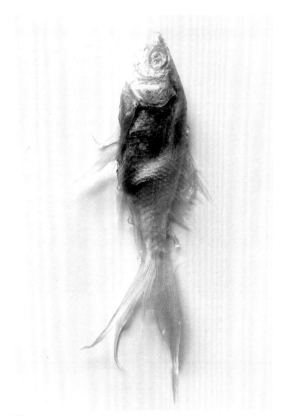

073

073
The frozen body of a sterile
goldfish, before being packed
in dry ice to be taken for
freeze-drying.
051, 152

Thoroughbred history concentrates on three
stallions imported during the late 17th and
early 18th centuries to whom all modern
Thoroughbreds in the world can trace their
ancestry through the male line. The effect of the
focus on the three stallions is to produce an
idea of the Thoroughbred as a mythical beast,
reproducing asexually and thereby preserving
male attributes directly without the dilution
or perhaps pollution introduced by a female
mate…

The Thoroughbred is essentially an expression
of empire. The hybrid names of the three
progenitors, fusing eastern origin with
English owner, express this point emphatically.
The portraits of thoroughbreds by George Stubbs
(1724-1806) and John Wootton (c.1682-1764)
are early examples of brand management.*

Rebecca Cassidy, *Horse People: Thoroughbred Culture
in Lexington and Newmarket*

Rebecca Cassidy, *Horse People: Thoroughbred
Culture in Lexington and Newmarket*
(Baltimore: Johns Hopkins University Press,
2007) 7-8

*

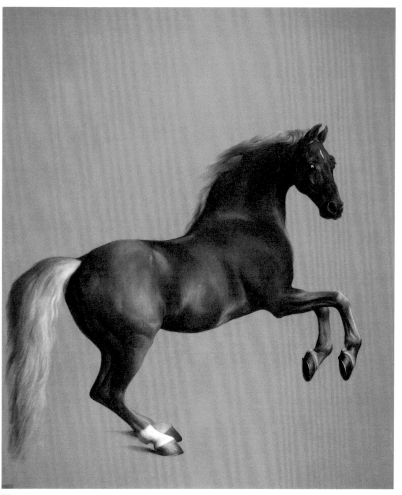

074

074
George Stubbs, *Whistlejacket*, 1762,
oil on canvas, 296.1 × 248 cm.
Courtesy of the National
Gallery, London.
036–044, 075, 079,

Blue Roan series 2020

Ashes of a thoroughbred racehorse
were used to make a bespoke powder
coat formula. The powder particles are
specified to be the thickness of horse-
hair and the color is mixed to match
a blue roan—a rare color pattern for
horse coats. The powder is then applied
unevenly by hand to aluminum and
steel sheets in a powder coating factory,
suggesting a breed of horse painting
that is material rather than figurative.

75
Blue Roan 2020
Production documentation

(Powder coating factory)

002, 079, 267

We received the new Bone Ash this morning
thank you.
Before we get into formulation details etc,
are you able to supply TDS & SDS
(technical & safety data sheets) for this latest
sample? It does have an extremely unpleasant
smell and I need to ensure that there won't
be any issues during processing.

Kind Regards,
Paramount Powders

076

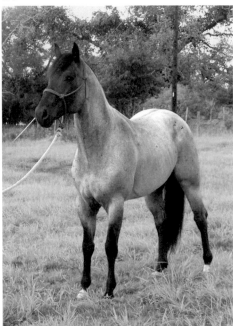

76
ound image included in
he color reference document
ent to the powder factory.
012, 075, 144, 187

77
lue Roan (Occipital) 2020
Horse ash powder coat on
teel panel
25 × 180 cm
002, 075

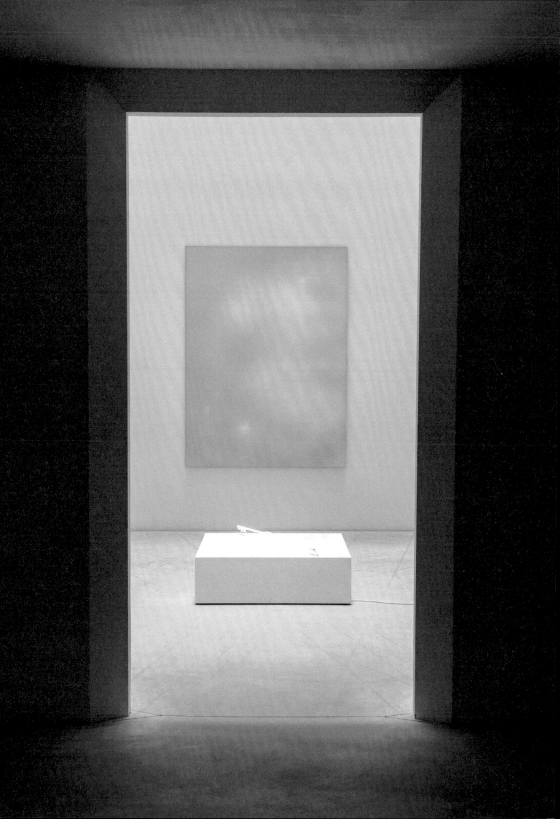

Wolf Park, Indiana, at an educational facility
that strangely feels like a zoo. The wolf jumps
to the trainer's cues and is awarded a
watermelon full of leftover carbs (?). I think
of the words of Aaron Payment, "what happens
to the wolf, eventually happens to us." *
I buy a vial of grey wolf hair in the gift shop
for my homeopath friend in Berlin.

* Aaron Payment is the chairperson of the Sault Tribe of Chippewa Indians. Rick Pluta, "Tribes Get Behind Effort to Repeal Wolf Law." Interlochen Public Radio, January 23, 2013.

080

Nowhere A Shadow 2013
Six-channel infrared video
07:00 minutes

By likening the nature reserve to a stage
set where fauna and flora act out a
meticulously observed routine, the film
positions conservation as a form of
entertainment. "The wilderness" is
perceived as a place from which humans
have been removed, allowing other
species to act autonomously. However,
all acts of preservation—from research
biospheres to conservation projects and
recreation parks—are still human-centric;
maintaining other species for the benefit
of humans. Perhaps performance is
therefore a survival strategy for an
endangered species, sustained by its
audience.

The invisibility of the exchange between
the plants and the wolf is reflected in the
undetectable display, unseen by the wolf
and aimed only at the distant spectator.
By using infrared lights, the wilderness
as a spectacle is revealed only to the
audience at a physical remove, fusing
nature documentary, surveillance
technology, and theme park aesthetics.

› 036–044, 125

Date: February 14, 2014
Subject: Mr T. Van Balen Addressable LED Strips for Art Sculpture
From: CiCi

My suggestion is WS2811 is so suitable.
60leds per meter, it is so brightness.
Hope you and your family are happy, your business
is booming in the new year of horse.

Cici

Date: July 11, 2014
Subject: July led lights promotion / ALLED Shanghai / 2014.7.11
From: Frank

Dear friend,
Thanks for your attention my friend.
Enjoy the holiday coming.
It's Frank from Shanghai China, see you again,
the led lights are as hot as the July weather:
Please find the attached price lists for
this July promotion season,
LED COB down light new series
LED Philips flood light
Philips module LED tunnel light
LED street light Philips and Meanwell driver
Hopefully they can be workable and useful
for your future business.

Keep in touch.
Best Regards

We Have To Work Hard And Work With Our Heart 2014
Installation view
Palms Palms Palms
Z33, Hasselt
Photograph by Pieter Baert
> 088, 093

Part of the series Giving More to Gain More, this aluminum structure is set with programmable LED strips displaying fragments of text from conversations with LED manufacturers. Made legible by animated illumination, the language that emerges is a by-product of global mass-manufacturing processes: a production-centered pidgin prose, where Alibaba.com becomes a source of both material and content.

We can see and feel the waste of material things. Awkward, inefficient, or ill-directed movements of men, however, leave nothing visible or tangible behind them. Their appreciation calls for an act of memory, an effort of the imagination. And for this reason, even though our daily loss from this source is greater than from our waste of material things, the one has stirred us deeply, while the other has moved us but little. *

Frederick Winslow Taylor, *The Principles of Scientific Management*

083

Frederick Winslow Taylor, *The Principles of Scientific Management* (New York: Harper & Brothers, 1915), 5.

*

0

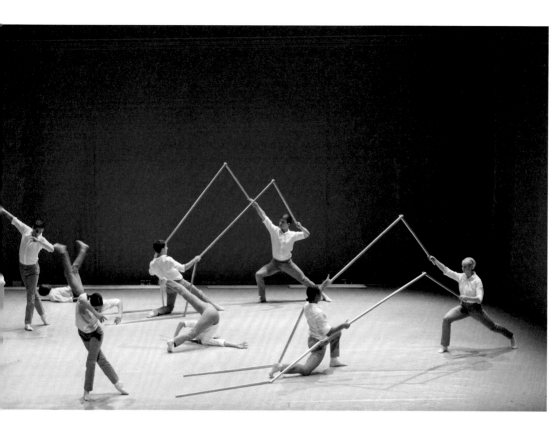

086
Frames 2015
Performance
40:00 minutes

A collaboration with Alexander Whitley
for Rambert Dance Company. Score by
Daníel Bjarnason.

Frames presents Rambert's dancers
at work. Confronted with a mass of
material stripped away from the
conventional mechanisms of the theater,
they come together, organize one
another, and are put to task at
their own production site. Objects of
numerous forms emerge between the
dancers' actions and a system of metal
structures, growing and morphing
in and out of life as they surpass the
sum of their parts.

The dancers construct and reconstruct
familiar elements of a dance production,
the material and immaterial, the visible
and what is seen. What does dance
itself produce if no visible artifact is left
over from the dancers' efforts?

85
rames 2015

echnical drawing
or aluminum parts.

086, 160

› 083–085, 087, 162

Instructions from Alex—guidelines for set/movement apparatus based on
choreographic principles:

Let the problem be the subject. Exhaust the possibilities of an
idea. How much can you make from one thing? Explore the idea
in 3D: Alter the plane / Change the orientation / Change the scale
/ Reverse it / Invert it. All the time attempting to stay as close
to the original thing. Keep the logic – change the conditions.
Explore different forms of linearity. Straight or curved / One
line or many / Direct or indirect pathways / A coordinated or
conflicting directionality.

Instructions for Alex—movement guidelines based on *Principles of Scientific Management*
by Frederick Winslow Taylor and Frank and Lillian Gilbreth's time and motion studies:

Eliminate all false movements, slow movements, and useless
movements / Introduce a lot of tiresome and time-consuming
motions / Even if motions cannot be planned to be similar
for each hand and performed simultaneously, the plane in which
the work is to be done should be carefully located. The direction
of a motion that is most economical is the one that utilises
gravitation the most / The best "direction of motion" is not only
important in itself for increase of output; it must also be kept
constantly in mind in standardising the placing of both
materials and men.*

Including quotes from Taylor, *Principles of
Scientific Management*, 117; and Frank
Gilbreth, *Motion Study: A Method for
Increasing the Efficiency of the Workman*
(New York: D. Van Nostrand, 1921), 68, 74,

*

Frames 2015
Rehearsal documentation
001, 086, 146

The entity called compromise

One of the first things I wrote for myself a really long time ago, when I was first thinking about our collaboration, was the sentence "not to be watered down by us." It was not something that I felt was happening but something that I wanted to warn myself against.

Hmmm…

I guess that's something that occupies me a lot: How do you not dissolve into each other? How do you keep some form of boundary, where you are still a full human being? Not everything has to be divided and reconstructed, like a cell that has to split. I wonder how you can have a vision between two people. And how can you be an artist without a vision.

It sort of reminds me, on an abstract level, how I was so obsessed with Deleuze's idea of the assemblage, of when you put things together and something emerges between the individual things. Which is also the cliché marketing slogan of "more than the sum of its parts," "one and one equals three."

[Baby roars.]

Speaking of the sum of its parts. [Laughs.]

The sum of its parts is also pitching into this conversation. [Laughs.] But the question of value coming from the things within, while

not being not-valid, also comes at the ex-
pense of the things themselves. So we create
these—these assemblages, let's say—but that's
at the cost of having an individual self.

Initially I wasn't even interested in assem-
blages in relation to collaboration. I became
interested in assemblages when we were mak-
ing *75 Watt* because I felt they could brea
engineering logic.

But doesn't it somehow—I don't know, in try-
ing to find the sum of its parts you have to
delete a lot of very individual things because
they don't belong, or maybe because they
reached their place and then lost—

Why though? That kind of assumes you have
to find common ground.

No, I don't know how to explain it. I just won-
der if you can remain a person. Are there still
things I like? Are there still things I love? Is
it always things we love? Do I have my own?
Can my work ever reflect me? No, because
it's not me, it's this third… It's this third being
which is the artist.

The entity called compromise.

[Baby roars again.]

Fuck it. I don't agree with it, and also, I find we're falling into a pattern in which I'm having to argue pro collaboration. If you don't want to collaborate, feel free to quit. Let this be made clear.

I'm not saying I want to quit, although maybe one day I will, and maybe one day you will too. I just want to really critically examine what it means to collaborate, because I am just not a person who is very good at "we."

I agree with not having to say "we."

Personally, I feel like a person whose life got rolled off its trajectory. I feel like I got completely derailed by you—in a positive way, because I never imagined being so much in love, and I never imagined having a kid. And it's amazing how lucky I got, but I don't really recognize the person I was, within this.

It's two different things, no? Recognizing the person you were or recognizing the person you are. As long as it's equal… ish. I also have the same concerns.

feel like I had a very deep knowledge of myself before. I was a lot unhappier in every possible way, so it's not like I'm saying things got worse, they only got better, but I miss this conviction and the confidence of knowing

what I'm doing and this feeling: "This is the

thing, and if people don't like it, whatever,

I don't care, this is how I do things." And I feel

like I don't know this anymore, I've become

too fragile.

Don't you think the ultimate confidence is ex-

actly not knowing what you're doing?

Can I actually suggest something? I think that

maybe a lot of my self-doubts about work,

since working with you, come from the fact

that a lot of the things you bring into the

work, I don't understand or I don't feel confi-

dent enough to repeat to other people. I like

them, but I'm embarrassed that I would say

them wrong. Someone once put me on the

spot when I was quoting you and I couldn't

really defend it, while you would have been

able to just shut him up.

But isn't that the beauty of this? You don't

have to represent it. You don't owe anyone

anything.

But I used to… I used to have the whole story,

because I was the whole story and now—

Pfff…

Don't breathe like that…

What?

Don't breathe when I tell you things! [Laughs.]

I recognize the things you're saying. I was also never planning on becoming an artist but it happened to me, to us. And of course I was super confident when I came straight out of college. But it's not just because it was only about me. For me at least, I'm not going to ascribe all this to the fact that we now col-laborate—a lot of other things have changed since that you also have to take into account.

From a research trip to Shenzhen
in 2011 during which I visited
(and gate-crashed) electronics
factories manufacturing joysticks,
tripods, screens, and electric
toys, observing and documenting
the laborers' movements—solder-
ng, assembling, wire looming—
as well as a range of product
testing rituals.

020, 162, 264

090

091

We bought a selection of made-in-China electronic products
and filmed Alex and ourselves disassembling and assembling them.
The next stage included testing material manipulations with Alex
and a group of dancers in the studios of the Royal Opera House
and slowly narrowing a list of components and a sequence of
movements.

090-091
Tests and rehearsals with
Alexander Whitley at the Royal
Opera House dance studios
in London, sometime in 2012.
› 087,162

092
Wire looming in the factory of
Century Man Communication
Equipment Co., Shenzhen, 2011.
› 162, 195

All the parts and components for the final object were manufactured in the Pearl River Delta, as we wanted to use the existing mass manufacturing infrastructure. As ever and everywhere in production, many things turned out wrong. However, nowhere are these mistakes rectified as quickly as in Southeast China—parts were remade overnight to arrive the next morning through an extensive logistical network of trucks, cars, and scooters carrying raw materials or (half-)finished goods. The effects of this rapid ecology are visible all over the objects: in tiny blemishes, misalignments, and greasy fingerprints. We also set up an impromptu workshop in our shabby hotel room, and every night after filming sat around making small repairs with Alex, who had to learn how to solder.

093

75 Watt 2013
Production documentation

*(Being friends is one thing,
renting a factory is one thing)*

› 096, 162

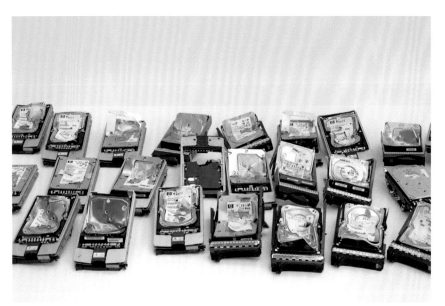

095

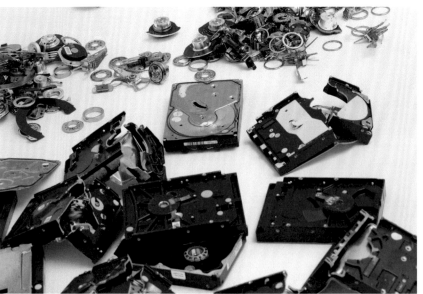

096

"Mine," in *Rare Earth*, ed. Boris Ondreička and Nadim Samman (Berlin: Sternberg, 2015), 57, published in conjunction with an exhibition of the same title at Thyssen-Bornemisza Art Contemporary, Vienna, February 19– May 31, 2015.

*

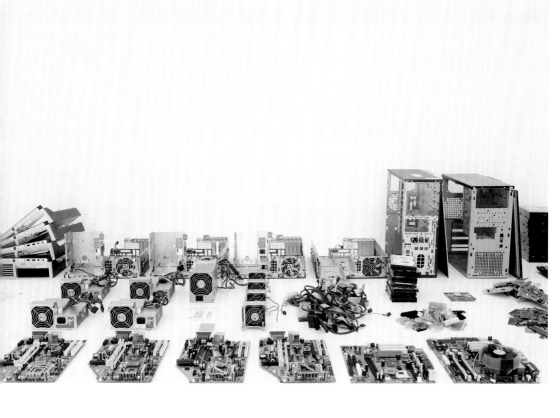

Dismembering a computer, my pliers
remove a flat square plate. It is branded
Foxconn. This aluminium rectangle
contains an enormous and expanding
anti-suicide net, surrounding the factory
where earth is standardised and turned
into magick. The name spells the dance
of Chinese fingers assembling tiny
synthetic insects in endless repetition.
I cannot melt this plate. I put it on the
floor near the debris of circuits, like
a rare collected stamp from a far
away place. *

B / NdAlTaAu 2015
Detail
Neodymium, aluminum,
gold, tantalum
14 × 9 × 7 cm
Photograph by Jens Ziehe

40 Kilograms of destroyed hard drives
were sourced from a data destruction
service, a mountain of shiny deformed
bricks that were scrapped out of the
guts of computers. Mined out of soil,
designed in the United States, made in
China, destroyed in England. Labour
starts in reverse, dissolving the virtual
into the fake from the other end of the
consumption chain. Metals and rare
earth minerals are mined from the pile of
hard drives and reconfigured back into
mineral form. Neodymium (Nd) magnets
are shredded with a water jet, tantalum
(Ta) is filed out of capacitors and the
gold (Au) recovered with acids. The
aluminium (Al) platters—still holding
their ones and zeros—are melted and
recast in a sand mould. An artificial ore
emerges from the earth, unexpectedly
black. *

› 097, 162

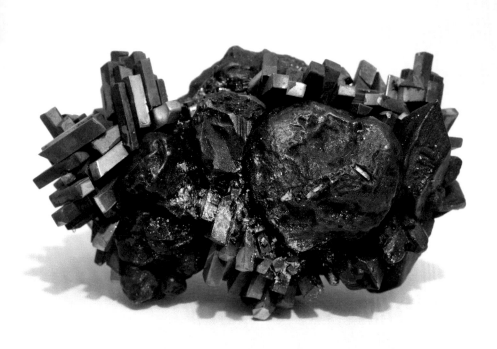

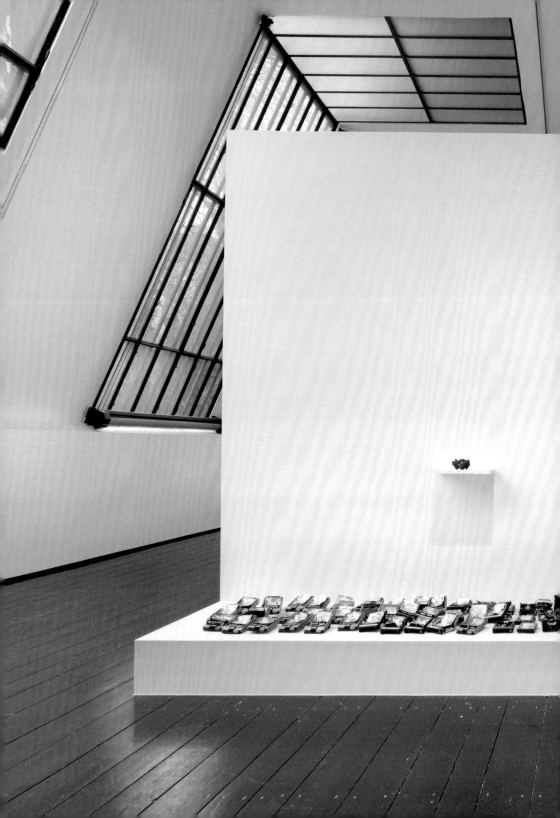

3/NdAlTaAu 2015
Installation view
Rare Earth
TBA21-Augarten, Vienna
Photograph by Jens Ziehe
098, 135, 136

A Dutch furniture manufacturer goes bankrupt; the contents of their
warehouse, showroom, offices, and factory are auctioned online. We
buy everything electronic. Most of the stuff is made in China: comput-
ers, smartphones, hand tools, monitors, keyboards, hard drives... and
from the other side of the supply chain, we start mining. Every object
is unscrewed, unglued, separated into parts. Using hydrochloric acid
(34 percent, activated with hydrogen peroxide), gold is recovered
from plated connections. A phone still has a note taped to it with the
company's internal numbers. Danny is on line 8. Whetstone is ham-
mered into pieces and tantalum capacitors are filed out of their
plastic shells. Copper and aluminium are melted down and poured
in between. A new mineral emerges from the burnt casting sand,
the first stone to emerge as we dig ourselves to Congo.*

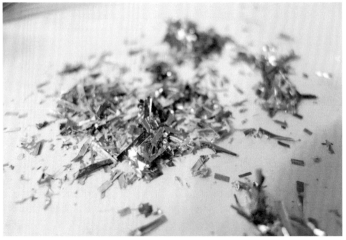

100

100-102
H/AlCuTaAu 2014
Production documentation

DIY gold mining of a computer
motherboard, heatsink melting.

› 097, 141

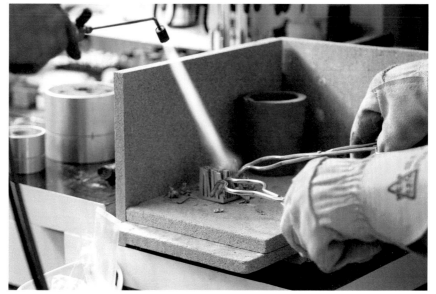

101

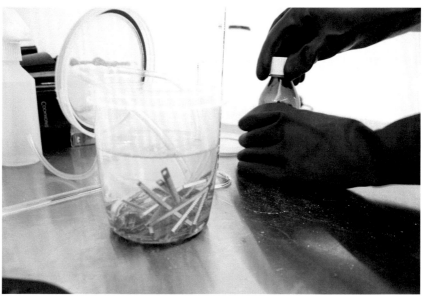

102

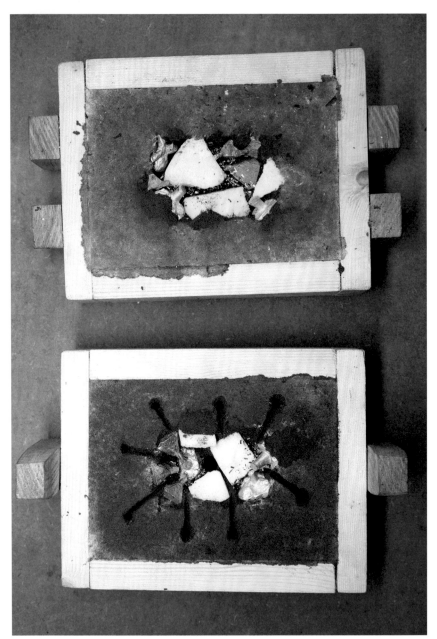

103–105
H/AlCuTaAu 2014
Production documentation

(*Reincarnation by sand and fruit*)

› 097, 214

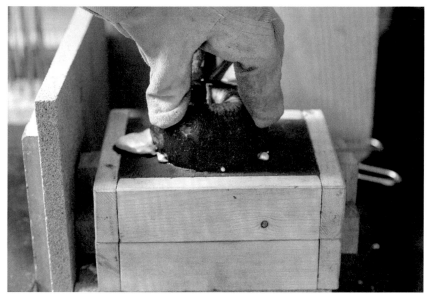

104

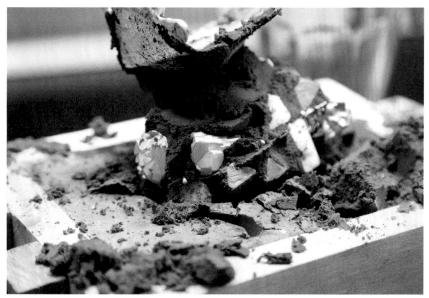

105

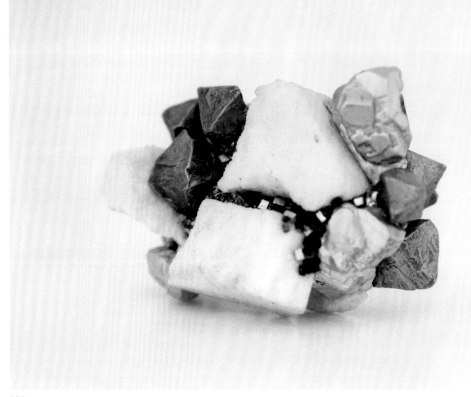

106

106
H/AlCuTaAu 2014
Aluminum, copper, gold,
tantalum, whetstone
12 × 7 × 6 cm
› 097, 133

107
Avant Tout, Discipline 2017
Printed voiles
500 × 300 cm

Coltan, a mineral used in most electronic
products, such as laptops, smartphones,
and game consoles, could be considered
the material of virtuality. A coltan mine
in Numbi (South Kivu, Democratic
Republic of Congo) is rendered using
a program for making computer games.
The images are printed on theater
backdrops.

› 016, 135

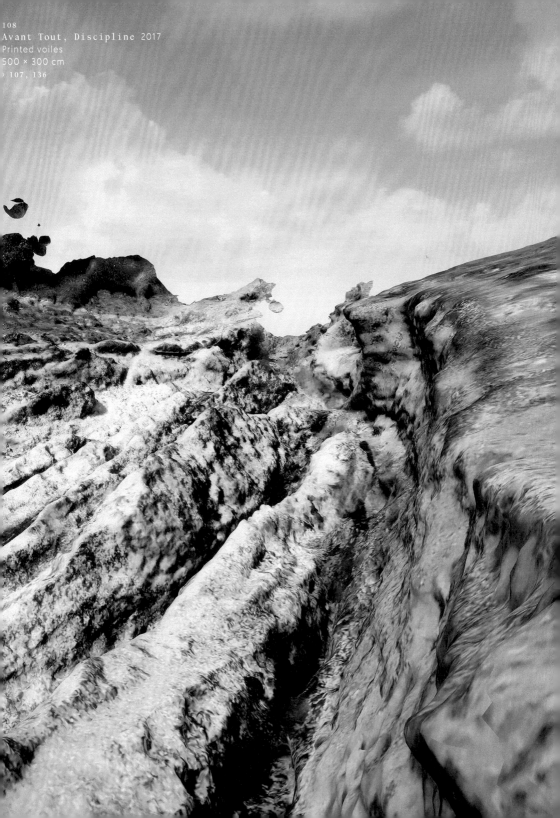

109

Every Increased
Possession Loads Us
with New Weariness
2017
Production documentation

(Window panes cut, laminated,
and polished)

› 005, 110

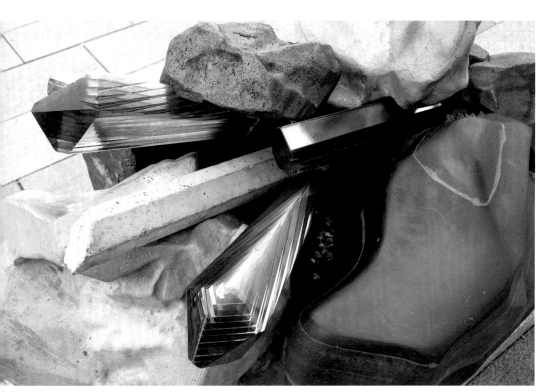

110

110
Every Increased Possession
Loads Us with New Weariness 2017
Steel, concrete, glass, aluminum,
copper, cast iron, Caithness stone
184 × 135 × 87 cm

A public sculpture for Ruskin Square—
a large-scale development in Croydon—that
reverses the supply chains of the complex,
unmaking the building and remaking it into
an artificial mineral of steel, concrete, glass,
aluminum, copper, cast iron, and Caithness
stone.

A steel girder was taken from the building
and sent back to the factory (Hare in Bury,
near Manchester) where workers were asked
to unmake the product they normally make.
This process was repeated with the aluminum
window frames, copper pipes, cast iron drain
pipes, concrete tiles, glass window panels,
and Caithness stone. Within the existing
supply chains of the building, these materials
were transformed (cast/shaped/laminated…)
into rock or crystal shapes to return to the
square as an "artificial mineral."

› 005, 097

Date: May 13, 2016
Subject: TVITEC Ruskin Sculpture send samples to UK
From: TVITEC.COM
To: DAVID

Thanks a lot David & Carlos.
I think that our cooperation is a good idea. Some day
we could to say: "Tvitec Glass is Art" JJJ
As David says, inform us about the project in the future.
We keep in touch.

Date: April 13, 2016
Subject: RE: RUSKIN SQUARE SCULPTURE COMMISSION
From: GARY
To: ALEXANDER

The majority of the steel elements on the Ruskin project
were sourced from Tata rolling mills in the UK (a touch
ironic given the recent Tata announcement to sell off its
UK steel making plants).

We can supply any number of off-cuts that are similarly
sourced, and can fabricate these into whatever shape or
sculpture you decide upon. Alternatively we can supply
a quantity of off-cuts for you to send to an independent
foundry, or lastly we can put you in touch with the Tata
mills to source new materials ... please let me know
which you prefer.

In relation to the support framing, it's your call. You can
continue with your current supply chain (props maker)
or we can supply.

11

112

11–112
very Increased Possession
oads Us with New Weariness
017
roduction documentation

Aluminum from window frames
s molten and re-cast in the shape
f an oversized mineral)

101, 110

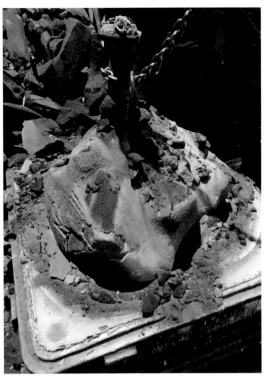

113

114

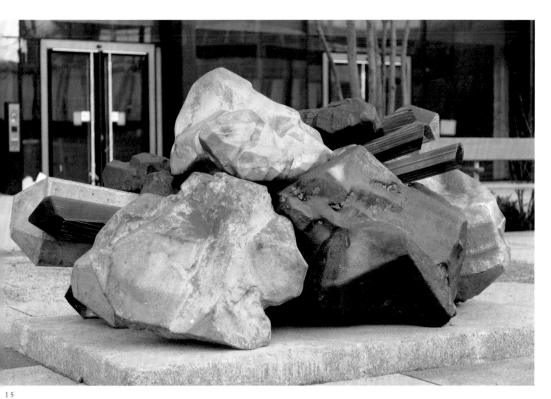

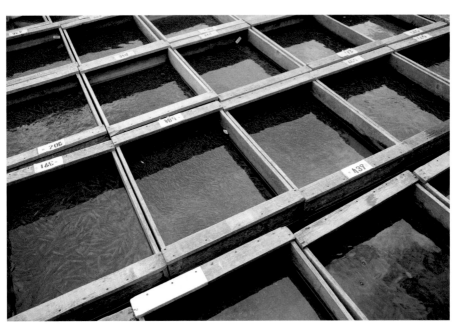

117

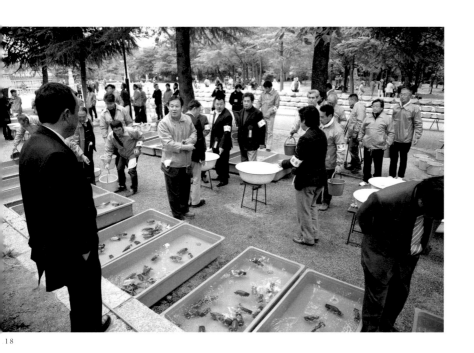

Kingyo Kingdom 2013
HD video with sound
20:00 minutes

A film following the stages through
which goldfish become objects: a house
built by a breeder, a national competi-
tion, a wholesale market preparing
boxes of goldfish for airfreight.

00:09:32
あの蘭鋳っていうのはですね、やはり背びれを無くした魚ですから、
あの、なるべく背びれ感を見せないように、
Well, Ranchu were created to have no dorsal fin,
so the posterior contour should be curved,

00:09:40
あの、背がとんがっていない、その部分がやはりポイントになって、
which is an important point when judging.

00:09:45
あと筒のところは、フナみたく三角になってないで、筒が丸くなっている。
The waist shouldn't be triangular like carp's, but
should be round.

00:09:50
あと、頭がしっかり、土台がしっかりしているというところを見ますね。
あと泳ぎですね。
We also check whether the foundation of the head
is sturdy enough, as well as whether it swims well.

00:10:17
あ、色についてはですね、元々蘭鋳はですね、発祥時点のところで無地金
魚と言われたんですけども、
Originally Ranchu were called "no color goldfish,"

00:10:24
まあそれは素赤って意味なんですよね、
全体が赤で尾の先がちょっと白く抜ける、それで無地金魚。
which means they have red scales covering their
entire body, leaving a white line on the edge of
the tail.

00:10:30
それで、形がですね、なるべくフナから、背びれがあったものから、
その形がわかりやすいような、無地の金魚で赤がきれいな赤、そういった
ものが求められてましたね。
The form of the fish has to be as far as possible
from the carp, with a standard, beautiful red. That's
what people desire.

00:10:45
赤はなるべく鮮やかな色のほうが、
見栄えがいいというか、健康的でいいというところはありますね。
The red should be as vivid as possible, the fish
should look nice and healthy.

The following excerpts are from Kingyo Kingdom film transcript

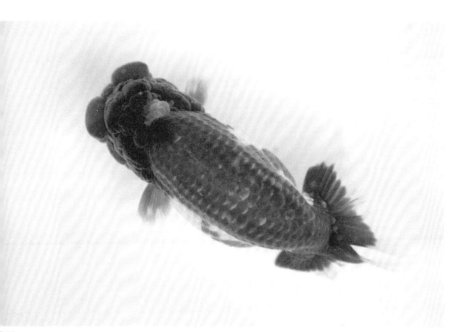

19
Kingyo Kingdom 2013
Film still

(Top view, 2D fish)

00:01:40
元々蘭鋳っていうのは、フナなんですね。
Ranchu originates from carp.

00:01:42
先祖返りして背びれが出たりとか、フナになったりする魚は排除して捨てていっちゃうんですね。
But Ranchu don't have three point tails or a back fin. They often revert to their ancestors being born with a dorsal fin; we just abandon those with carp features.

00:01:50
それで、残った形に背中がいいとか腰がいいとか、尾形が切れるとか、そういうのを残して、あとはみんな捨てちゃいますね。
We judge whether the fish has a nice back and waist and a well-balanced tail shape, and we keep those and discard all the rest.

00:01:59
だいたい、5000匹返っても4500～4600は捨てちゃいます。
More or less, even if 5,000 fish hatch, we discard 4,500 to 4,600.

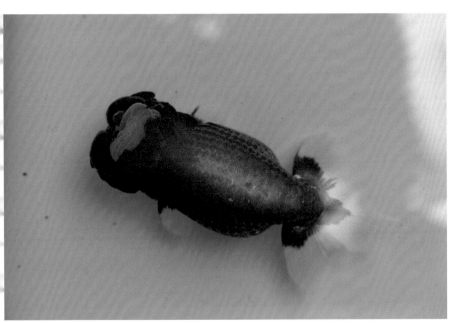

120

Kingyo Kingdom 2013
Film still

*("When the red is strong, the
fish tends to look a bit tighter
and more stiff")*

› 072, 117

00:13:07
えーと、蘭鋳っていうのは大きく分けると、頭のタイプで分けるとですね、
Ranchu can be divided into types according to the
shape of its head.

00:13:09
龍頭、それはドラゴンのような竜ですね、竜ような龍頭、あとは獅子頭、大
きくはその二つて、
The main types are Tatsu-gashira, which is like a
dragon, and Shishi-gashira, a mythical lion.

00:13:17
後はおかめって言って、えらのところにも肉が載っちゃうような形がありま
すけども、
Then there's Okame, which has lumps even on the gills.

00:13:24
求めてるのは、獅子頭、頭のてっぺんが四角で、トキンの部分が四角に上がる、で、
I try to breed the Shishi-gashira type, whose head is
rectangular with a deep skull.

00:13:34
側って言う下の方につくフレームがあるわけですけども、それとがはっきり
別れたような頭の形、それがまあ求める姿ですね。
Ideally, the fish has a well-defined frame where
the head is clearly separated.

00:14:02
獅子って言うのは真四角にスクエアにぐっと上がってますから、その分太い
わけですよ。
Shishi-gashira head is square with a deep skull,
that is why it's sturdy.

00:14:09
それで龍頭って長四角になりますから、こっから出るわけですから、辺が短
くなるわけですよね。その分細いっていうことですよね。
Tatsu-gashira head is rectangular, the head is narrow,
which makes the body thinner.

00:14:20
あと、胴のタイプで言うと、茄子胴っていってこういう風ななすのね格好し
たようなやつ、それはちょっとフナに戻ってるような形です。
In terms of the body, there is the aubergine type
with a shape that is going back to the carp.

00:14:33
後は丸胴っていうやつですね、これは背びれ感が見えないんですけれども、
若干細い。
The rounded type with the dorsal contour is curvy,
but tends to be a bit thin.

00:14:38
それで一番太いのが角胴っていって、背中がある程度フラットで、それで太
みもあると。
Then there's the square body with its fairly flat dorsal
and its sturdiness.

00:14:45
それで、獅子頭のこの四角の部分からストレートに出る、それが一番太いと、
それで背びれ感もないと、そういうところがやっぱり理想じゃないですかね。
When the shape is straight from the rectangular
Shishi-gashira head to the sturdy body with dorsal
fin-less contour—that would be the ideal.

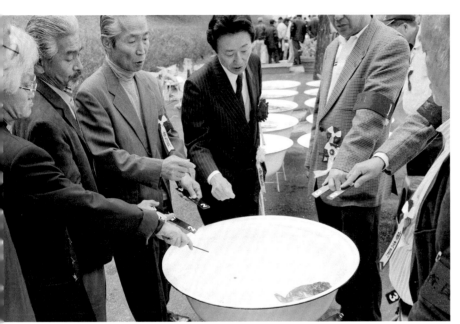

121
Kingyo Kingdom 2013
Film still

*(Scoring, Ranchu breeding
competition, Nagoya)*

> 024, 035, 117

00:09:32
あの蘭鋳っていうのはですね、やはり背びれを無くした魚ですから、
あの、なるべく背びれ感を見せないように、
Well, Ranchu were created to have no dorsal fin,
so the posterior contour should be curved.

00:09:40
あの、背がとんがっていない、その部分がやはりポイントになって、
which is an important point when judging.

123

Date: January 16, 2015
Subject: Heck Cow Skull
From: Derek

Hi Revital – by bizarre coincidence
we have 1 [skull] from a cow that was
shot last year. It has a round hole in its
forehead but the horns are still there
if of any use
BW
Derek

124

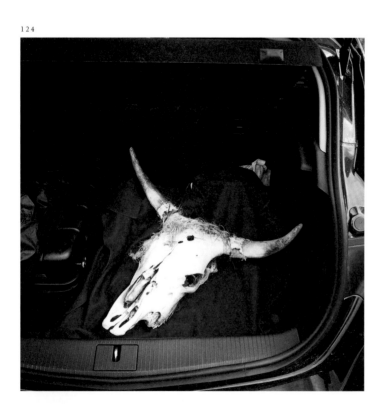

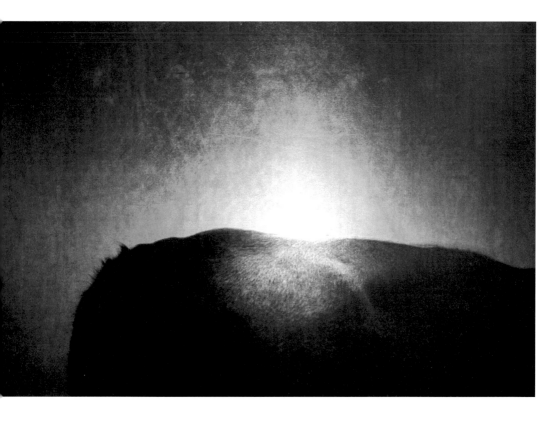

Advances 2015
HD projection on silver screen
10:00 minutes

A herd of Heck cattle moves across
a green screen. The breed was the
result of an attempt to bring extinct
aurochs back to life in 1930s Germany:
a de-domestication project in search
of an animal's "true form." The remaining
cattle are now self-replicating sculptural
objects, inspired by an ideological
dream of nature. In the south of England,
a farmer is rearing Heck to be photo-
graphed, a reflection of a post-Fordist
economy where the image of an animal
is more valuable than its flesh.

Xiaoyu Weng

1 Kathleen Miles, "Ray Kurzweil: In The 2030s, Nanobots In Our Brains Will Make Us 'Godlike,'" HuffPost, October 1, 2015, https://www.huffingtonpost.co.uk/entry/ray-kur zweil-nanobots-brain-godlike_n_56055a0e4b0af3706dbe1e2

In the sound performance work *Others* (2012), the London-based duo Revital Cohen and Tuur Van Balen sent recordings of a hare's mating call from a radio station in Italy to the moon. Bouncing off the moon, the sound was received by another radio station in the Netherlands. According to the artists, this was the first animal sound ever to be reflected off the surface of the moon using radio waves. The call is a romantic gesture; I can't help but think of it as a search for a legendary hare, the sole companion of the moon Goddess Chang'e. In Chinese mythology, Chang'e is the wife of Houyi, a courageous archer who shot down nine of the ten suns, which had risen together to the skies and scorched the Earth, causing hardship for the people. To reward his heroic act, Houyi was given the elixir of immortality. In one version of the legend, Chang'e stole the elixir and drank it out of curiosity and greediness. She became immortal and rose to the moon. But immortality comes at a price. Chang'e resides on the moon, forever alone; never able to return to Earth and reunite with her husband, her only companion is her pet rabbit. To be immortal is to be eternally lonely.

Once a cautionary tale, the desire for immortality now seems much closer to becoming a reality. In fact, according to futurists such as Ray Kurzweil, nanorobotic technology will be capable of making humans immortal by 2045, by entering the human body and repairing any damage, or even by connecting human brains in "the cloud."[1] Kurzweil's absurdly confident assertion represents the quintessential transhumanistic ideology of overcoming death by technological acceleration. Such belief is deeply paradoxical: it longs to save the human while denying humanity. It relies on super artificial or biological intelligence, and in doing so places the "human" in the shadow of the enhanced "super-human."[2] In this view, what has been and is currently "human" reveals itself to be incompetent, ceasing to have a reason for continued existence, thus reducing humanity's future to one possibility and one truth.

Though not always explicit, the idea of immortality—and its relationship with death, time, and memory—constantly looms over much of Cohen and Van Balen's work. One of their most direct commentaries on the body-as-machine and hyper-ability, the installation *The Immortal* (2012) presents a version of the techno-fantasy of mechanical immortality. Connected by webs of tubes and electrical cords, life-support machines such as a Heart-Lung Machine, a Dialysis Machine, an Infant Incubator, a Mechanical Ventilator, and an Intraoperative Cell Salvage Machine create an operating circulatory system. According to the

refers to a hypothetical agent that surpasses humans in overall intelligence or in some particular measure of intelligence.

artists, "the organ replacement machines... [keep] each other alive through circulation of electrical impulses, oxygen, and artificial blood (salted water)."[3] The use of the word "alive" here has interesting connotations. In what sense, to and for whom are these devices alive? Who turns them on and off? Or have they achieved full autonomy so they can serve humans?

Science fiction writer Liu Cixin speculates about a related scenario in his short story "Taking Care of God."[4] In the story, a civilization has lengthened life spans so extremely that people are nearly immortal. Machines are fully automated to take care of individuals and, as a consequence, they have completely forgotten their knowledge of technology and science. In their spaceships, "old components have broken down. Accumulated quantum effects over the eons have led to more and more software errors. The system's self-repair and self-maintenance functions have encountered more and more insurmountable obstacles."[5] But they themselves lack the knowledge to repair these ships that have been operating for tens of millions of years. More tragically, humanity's thoughts have completely ossified—they have lost all their creativity.[6] The immortal civilization is dying. Interpreting Cohen and Van Balen's installation *The Immortal* (2012) against the backdrop of Liu's story, one finds the work's shadow in Liu's dark satire, and the impasse of material immortality becomes evident.

The crux of Liu's story lies in the function and evolution of memory. Humanity's loss of memory is a metaphor for the collective amnesia of history. More importantly, even if the memories themselves are restorable, the ossification of thoughts and loss of creativity negate the possibility of effectively learning from these restored memories. The computational processes of recording and memorization would not help; what is needed is a different kind of remembrance, something close to what Jean-François Lyotard understands as "anamnesis." Lyotard explains that the process of anamnesis is not a search for a narrative with an origin or a beginning; it instead points to a passage, a working through, in which a memory is not forgotten but is also not mechanically inscribed. Synthesizing matter and time in an idiosyncratic way, anamnesis disrupts the chronological notion of time, and points to a sensibility in which things of different origins and times associate freely and reflect a non-phenomenal world.[7] Lyotard attempts to further explore this relationship between a traceable origin and a new metaphysics—one

3 Revital Cohen and Tuur Van Balen, "The Immortal," https://www.cohenvanbalen.com/work/the-immortal. Emphasis added.
4 Liu Cixin, "Taking Care of God," in *Invisible Planets: Contemporary Chinese Science Fiction in Translation*, ed. and trans. Ken Liu (New York: TOR, 2016), 321–358.
6 Liu, "Taking Care of God," 332.
7 Jean-François Lyotard, "After Six Months of Work... (1984)," in *30 Years after Les Immatériaux: Art, Science, and Theory*, ed. Yuk Hui and Andreas Broeckmann (Lüneburg: meson press, 2015), 29–66.

that distances itself from the framework of modernity—by quoting a metaphor from the tradition of Zen Buddhism: if a subject appears in front of a mirror, its image appears; but if "a clear mirror" faces the mirror, then "everything will break into smithereens."[8] Philosopher Yuk Hui argues that Lyotard's "clear mirror" "presents something almost opposite to any conceptualization of substance, since it is mere emptiness… The clear mirror negates the substance or essence… Hence, there hasn't been any event that breaks the mirror and marks the beginning. In front of a clear mirror, there is only constant breaking, which destroys the concept of the self" and cancels representation.[9] Additionally, Lyotard considers the "clear mirror" to be a question of writing, a question of the logos, of how substance also means support. He asks if it is possible to record and represent history without support (consider, for example, computer hardware, which requires software for writing and storing) or, say, by actively breaking, deconstructing, or reinventing that support.[10] Does new technology allow for new modes of anamnesis? How can we think of art practice along these lines?

Lyotard's "breaking" and deconstruction are literally manifest in a series of sculptural objects made by Cohen and Van Balen. For *B/NdAl-TaAu* (2015), the duo sourced and collected 40 kilograms of decommissioned hard drives from a data destruction service and mined precious metals and rare earth minerals—neodymium (Nd), tantalum (Ta) and gold (Au)—from these objects, using techniques such as water jet shredding, filing, and acid recovery. Additionally, aluminum (Al) platters are melted and recast to render the final sculpture into an artificial ore. The title of the work represents this manmade rock by combining the elements' abbreviations from the periodic table. The support of immortalized data is de-created and recreated in a new anamnesis of a technological present, complicating the ways the present might be memorialized and represented in the future. Although the elements are re-configured back into mineral form, the end-object is a manmade hybrid—that is, the origin of this present is deliberately obscured. The zeros and ones are still symbolically held in the now deformed hard drives, but they no longer contain any information. The immaterial is re-materialized.

B/NdAlTaAu is a "fake" ore but it departs from the notion of the copy as an unoriginal. It is an artifact without archaeology, yet through which the life and afterlives of the represented original can emerge in a heterogenous way. Consider philosopher and cultural theorist

8 ... "Anamnesis and Re-Orientation," 189.
9 ... on Time, trans. Geoffrey Bennington and Rachel Bowlby, [in The Inhuman: Reflections] 1991), 55, quoted in Yuk Hui, "Anamnesis and Re-Orientation: A Discourse on Matter and Time" in 30 Years after Les Immatériaux, ed. Yuk Hui and Andreas Broeckmann (Lüneburg: meson press, 2015), 188.
10 Hui, "Anamnesis and Re-Orientation," 189.
11 Byung-Chul Han, Shanzhai: Deconstruction in Chinese, trans. Philippa Hurd (Cambridge: MIT Press, 2017).

Byung-Chul Han's book on *shanzhai*.[11] A Chinese neologism, *shanzhai* means "fake" and originated as a description for knock-off electronic goods. Instead of condemning *shanzhai* as illegal piracy and unethical competition for financial gain, Han traces the thread of a philosophical history of "de-creation" in Chinese thought. De-creation, exemplified by practices such as *xian zhang* (seals of leisure), is a continuous making of the original. In practicing *xian zhang*, a collector's personal seal is stamped and affixed onto an artwork as it circulates from owner to owner, the accumulated marks becoming part of the work's content and composition.[12] In doing so, the original is continuously trans-formed, and a sense of immortality is achieved not by acts of creation or insistence on the purity of the original but by unending process.

A series of small-scale, inconspicuous paintings further complicate the tension between creation and de-creation, support and representa-tion, in Cohen and Van Balen's work. Entitled *Inlands* (2016), these earthy red and brown hued, impressionistic, abstract landscape paint-ings are in fact produced by electroplating gold, copper, tin, and nickel onto bronze sheets. In the artists' own explanation, they are "abstract renditions of open mines in the Democratic Republic of Congo," which "are materialized by the elements excavated from the soil" there.[13] The support (the minerals and metals) becomes its own representation. *Inlands* evokes imagery of deep-time geologic stratification, in tension with the contemporary human stripping that produced the metals, or perhaps a dream of the future landscape where the open mines are scars mourning an exploitative past.

Trapped in the Dream of the Other (2017) is a culmination of these lines of thinking, from time, matter, and space entanglement to the abstractions of global trading systems and colonial violence and the complexity of history writing and representation. In the film, the camera follows through a labyrinth of trenches where fireworks are set off, casting puffs of eerie yet sublime white, pink, green, and purple smoke and sparkles. The uncanny scene does not feel earthly, remind-ing one of the wonderlands of the sixteenth century Chinese novel *Journey to the West* (Xi You Ji) where immortals like the Monkey King would emerge from mystic smoke. Visually rendered in the 1986 Chinese TV-serial adaptation *Journey to the West*, this sequence is so arresting that it is hardwired into the memory of many generations in China. Born from a stone, the Monkey King acquires supernatural powers through Taoist practices and accompanies the monk Tang Sanzang on a

journey to retrieve Buddhist sutras from the West (India) where Buddha and his followers reside. But in *Trapped in the Dream of the Other*, such fantasy is soon interrupted by the workers captured by the camera. Carving at a mountainside in the most inhumane conditions and with brutally basic tools, they collect raw minerals to be sold to nearby refineries, the outputs of which are shipped to China and processed by factories that manufacture most of the world's electronic devices.

The project is staged in the ditches of an open-air mine near Numbi in the Eastern region of the Democratic Republic of the Congo, and the fireworks are specially commissioned by the artists and imported from Liuyang in Hunan Province, a famous site for firework production in China. Once placed on site, these fireworks are set off via a remote control by one of the artists in their studio in East London. To import these custom-built pyrotechnics to Congo required an excessively complicated bureaucratic procedure. The representation of the brutal reality of late capitalism, death, and the contradiction of global trade is absent from the cinematic narrative and imageries but woven together by the laborious process of making this event happen to create a "spacetime-mattering" fabric.[14] The never-ending maze becomes a never-ending nightmare. Every explosion of a firework punctuates a different temporality into this fabric. Multiple heterogeneous iterations—past, present, and future—and heterogeneous spaces—natural land, wonderlands, and sites of capitalist exploitation—unfold not in a linear relation but as threaded through one another in a cyclical enfolding. The colonial past is placed not in a distant spacetime but in a continued living present; it is an undead specter, floating through the seduction of the glimmer and the shine. To experience *Trapped in the Dream of the Other* reminds me of the imaginary journey proposed by feminist theorist Karen Barad in which she invites us to experience the world the way electrons do. The project therefore is a way to think with and through "dis/continuity—a dis/orienting experience of the dis/jointedness of time and space, entanglements of here and there, now and then, that is, a ghostly sense of dis/continuity, a quantum dis/continuity."[15]

In many ways, Cohen and Van Balen's practice has evolved over the years to foreground such sense of dis/continuity. Their earlier romantic gestures and techno-utopia projects are complicated by a continued re-negotiation between history and representation, between breaking and re-creating, between time, space, and matter. Their practice is a durational process of working through, of anamnesis, of becoming a clear mirror.

It rejects the overarching sense of temporality, of continuity, in place. See Karen Barad, "Quantum Entanglements and Hauntological Relations of Inheritance: Dis/continuities, SpaceTime Enfoldings, and Justice-to-Come," *Derrida Today* 3, no. 2 (2010): 240–268.
15 Barad, "Quantum Entanglements and Hauntological Relations of Inheritance," 240.

126

It was almost too good to be true… Whenever
there was an acute demand for a certain material
on the international market—ivory in Victorian
times, rubber after the invention of the infla-
table tire, copper in the full industrial and
military expansion, uranium during the Cold
War, coltan in times of mobile telephony—Congo
turned out to have huge amounts of the desired
stuff. Yet this economic history of improbable
luck is also one of improbable misery.*

David Van Reybrouck, *Congo: The Epic History of a People*

The demand for Congolese minerals and organ-
isms has consistently been a direct result of
industrial developments, making the Congolese
soil the birthplace of objects of desire and
destruction that are actualised in other realities.
The nuclear bombs on Hiroshima and Nagasaki
contained parts of the Congo, just as every
smartphone and laptop does today. These techno-
logical objects exist in all places, while Congo
exists in all these technological objects.
In the dust lies the tension between luck and
misfortune, a blessing which is also a curse,
the moment one's earth turns into another's
fantasy. The place is rendered virtual, its
citizens ghosts.**

126
Numbi, a mining town in South
Kivu, DR Congo where coltan,
gold, and turmaline are mined,
November 2016.
> 106, 133, 214, 241

DIY explosives supply chain

Our fireworks were custom made by Dominator Fireworks in
Liuyang, Hunan Province, China. There is no fireworks importer in
DR Congo or any of its neighbours. In fact, there are hardly any
firework importers on the continent at all, apart from in South
Africa, so a supply chain had to be set up especially. Perhaps it
would have been easier if we were shipping ammunition.

- 100 kg of fireworks and detonators were shipped from China
 in a container ship to Durban.
- In South Africa we had huge help from Bonnie and King at
 Starburst Pyro in Johannesburg.
- From Johannesburg, the fireworks were flown on Ethiopian
 Airlines to Kigali (Rwanda) via Addis Ababa (Ethiopia). It was
 meant to take 1 day but took 10.
- From Kigali, the boxes were driven to the DRC border where
 they were confiscated and our fixer arrested.
- After a polite conversation with customs at the border,
 we got the shipment released and drove it to the mining town
 of Numbi.
- In most of these countries, the appropriate permissions and
 stamps were acquired.
- When talking to authorities, fireworks are best referred to
 as "special effects." *

"Particles (an Epilogue) / Epilogue (a Particle)," in *Unthought Environments*, ed. Karsten Lund (Chicago: Renaissance Society, 2019), 145.

*

127
Fireworks factory, Liuyang, 2016.
133, 208, 212

Just like last year, collecting stamps from different authorities is
the only way to avoid difficulties, both in Bukavu (the province
capital) as well as at our arrival in Numbi. Ministry of Mines,
Chef de Village, Immigration Ministry, Police Commissioner,
Army Commander, Secret Service. East Congo is often portrayed
as a lawless place lacking authority but if anything, there seem
to be too many authorities. Also, why can you collect a stamp
from the Secret Service? There's a small island of French vocab-
ulary, which I know just about enough to explain the work:
supply chain, connection, performance of the soil, China,
fireworks. *

*

128
Trapped in the Dream
of the Other 2017
Production documentation
› 133, 205

128

Vu pour le passage de la
Division prov. de la Communication
et des médias au Sud-Kivu

Le CD DASUABUKO MAKAPA

S FAVORABLE

A.M.

le 04. 08. 2016
ANR/ Sud-Kivu

Vu d'arrivée à
Numbi, 9/8/2016
SEC. Poste d'État

Vu

Bulinda Apollinaire

Ministre de Mine

5/08/2016

Vu pour accord SAESSCAM

SAESSCAM

Vu de passage à
l'Escadron PMH KLIE

HAMISSI NYUKI
NUMBI, le 10/07/2016
Comd ESC PMH KALEHE

VU DIVIMINES
TAMBWE RAMASONGO FRANÇOISE
CDai

CPS/ NUMBI

République Démocratique du Congo
MINISTERE DE LA COMMUNICATION ET MEDIAS

Le Ministre

AUTORISATION COLLECTIVE DE REPORTAGE
N°017/CAB/M-CM/LMO/juillet/2016

Noms et Post-noms :

- Monsieur TUUR VAN BALEN, ▮▮▮▮▮▮▮
- Monsieur MICHIEL VAN BALEN, ▮▮▮▮▮▮▮

Organe : REVITAL & TUUR VAN BALEN

Motif : Réalisation des reportages sur les activités de production artistiques en République Démocratique du Congo.

Lieu : Kinshasa, Nord et Sud-Kivu

Durée : Du 29 juillet au 29 août 2016

REMARQUES

1. Ces reportages doivent être réalisés dans le strict respect de la dignité humaine, des lois et règlements de la République Démocratique du Congo et selon l'esprit de la déontologie de la Presse. Ils devront se conformer aux dispositions de l'article 87 de la loi 024-2002 du 18 novembre 2002 portant Code pénal militaire sur l'outrage à l'armée entendue comme « *toute expression injurieuse dirigée contre les officiers, les sous-officiers et hommes du rang des Forces armées sans indiquer les personnes visées* » et s'abstenir de donner lieu à des incitations de membres des forces armées à commettre des actes contraires au devoir et à la discipline militaire ou à la fourniture de fausses informations et de démobilisation de l'armée.
2. Il est, de ce fait, strictement interdit de réaliser ces reportages dans les lieux stratégiques tels que les Camps militaires, les installations de télécommunications, les Ambassades (sauf autorisation).
3. Les producteurs s'engagent à mettre à la disposition du Ministère de la Communication et Médias, une copie du document réalisé.
4. Les autorités tant civiles que militaires sont priées d'accorder aux bénéficiaires de la présente et à leurs collaborateurs Etrangers et Congolais, toutes les facilités compatibles avec les exigences de l'ordre public et de la sécurité du territoire de la République du Congo.

129

Fait à Kinshasa, le 2 6 JUIL 2016

Lambert MENDE OMALANGA

SOUTH AFRICAN POLICE SERVICE
Tel no (012) 393-2767
Fax no (012) 323-1711
E-mail address: pta-explosives@saps.org.za

SUID AFRIKAANSSE POLISIE DIENS

APPLICATION FOR EXPORT PERMIT

1. Name of applicant .. Starburst Pyrotechnics Fireworks Display CC. **Ref No 28/1/2/1**

2. Address**P O Box 61200, Marshalltown 2107**

3. Supplier of explosives or numbers of magazines Starburst Pyrotechnics. **Magazine number (U3767)**........................
... Ref no 28/1/2/1

4. Exact destination of explosives to be exported ... **Goma (DRC) via Kigali (Rwanda)**

5. Method of transport: **by** ~~road~~ / ~~by rail~~ / **by air** / ~~by boat~~

 [a] Name of shipFirst available Cargo Aircraft.

 [b] Name of airport **OR Tambo International**

 [c] Name of border post/port of exit......Johannesburg...............................

6. UN no's and proper shipping name : **UN0 0336 (1,4g) Fireworks.Display**.

7. Quantities and type of explosives to be exported . **Fireworks 1.4 G total 6 cartons**. See attachment.............

8. Please take notice of Regulation 4.1 - 4.9

Signature of applicant ████████ ... Designation ..**Main Member**........................

Name of Company ***Starburst Pyrotechnics Fireworks Display CC** Date 4th July 2016.

*In the case of registered company, the questionnaire must be submitted under cover of a letter reflecting the name, registered address and names of the directors of the company. The signatory must be either the manager appointed or some other senior official of the company. In the case of a syndicate and a partnership, the full names of all the partners must be given and the name or style of the partnership.
N.B.- Any person who gives false information to an inspector shall, in terms of section 24 of the Explosives Act, 1956, be guilty of an offence and liable on conviction to a fine of one thousand rand or imprisonment

FOR OFFICE USE ONLY

Export permit no issued on expiry date

...

Date
INSPECTOR OF EXPLOSIVES

129-130
Trapped in the Dream
of the Other 2017
Production documentation
> 020, 133, 214

131

Office of the PMH (Police des
Mines et Hydrocarbures), Numbi,
South Kivu, DR Congo.
› 128, 133

132
Take a Good Lamp 2016
Screen recording
03:30 minutes

A coltan mine in Numbi (South Kivu,
DR Congo) is filmed through a distant
video call, capturing a landscape
mined for minerals of virtuality over
an unstable connection.

› 133

A camera navigates through what the artists
themselves have called a performance: in the
summer of 2016, bespoke fireworks were set off
in an open-air coltan mine near Numbi, in the
eastern region of DR Congo. The fireworks had
been imported from Liuyang in Hunan Province,
the epicentre of China's fireworks manufacturing
industry, and set off remotely over an unstable
connection.*

Eva Wilson, "Trapped in the Dream of the Other"

Eva Wilson, "Trapped in the Dream of the
Other," in The Work of Wind: Land,
ed. Christine Shaw and Etienne Turpin (Berlin:

*

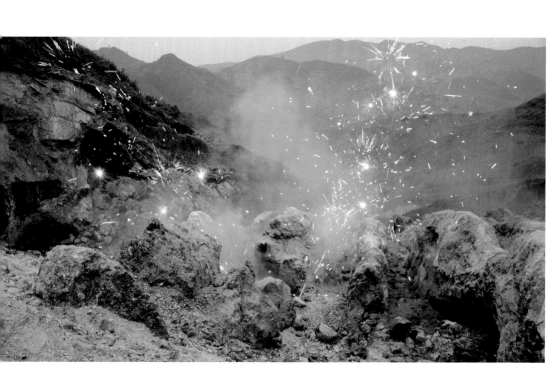

33
rapped in the Dream
f the Other 2017
k video with sound
0:00 minutes
132, 205, 220–230

Enter the ring. A manmade topography of
narrow corridors is etched into the side of a
mountain by shovels and water, resembling
long bony fingers that dissolve into a valley.
Your sharp, jerky motions drag and stretch
the terrain as it reloads. When taking a turn,
the landscape rearranges itself instead of
your body. Climbing out, the mountainsides
abruptly end in pixelated splurts. Over the
edge lies the most spectacular sunset, with
pinks and oranges painted by a machine.*

134
Trapped in the Dream
of the Other 2017
Production documentation
> 133, 214

135
Avant Tout, Discipline
2017
Printed voiles
500 × 300 cm

(Screen grab of the Numbi
Coltan mine processed through
a game engine)

> 107, 133, 136

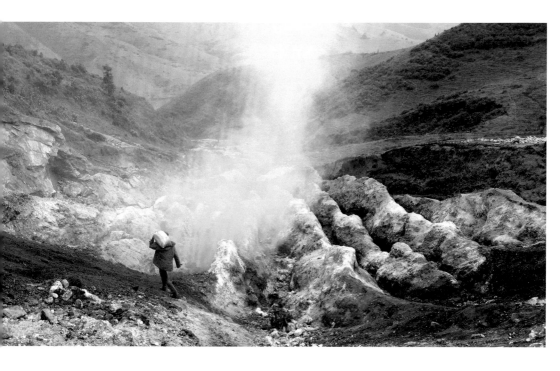

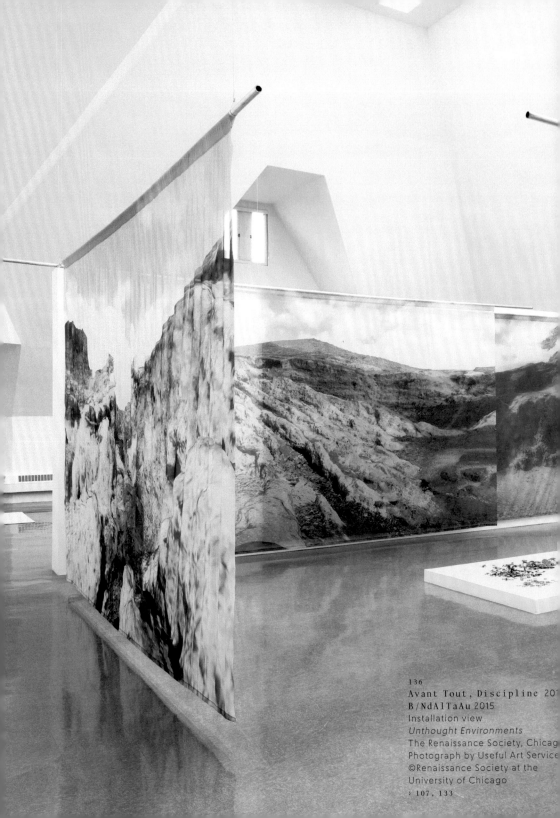

136
Avant Tout, Discipline 201
B/NdAlTaAu 2015
Installation view
Unthought Environments
The Renaissance Society, Chicag
Photograph by Useful Art Service
©Renaissance Society at the
University of Chicago
› 107, 133

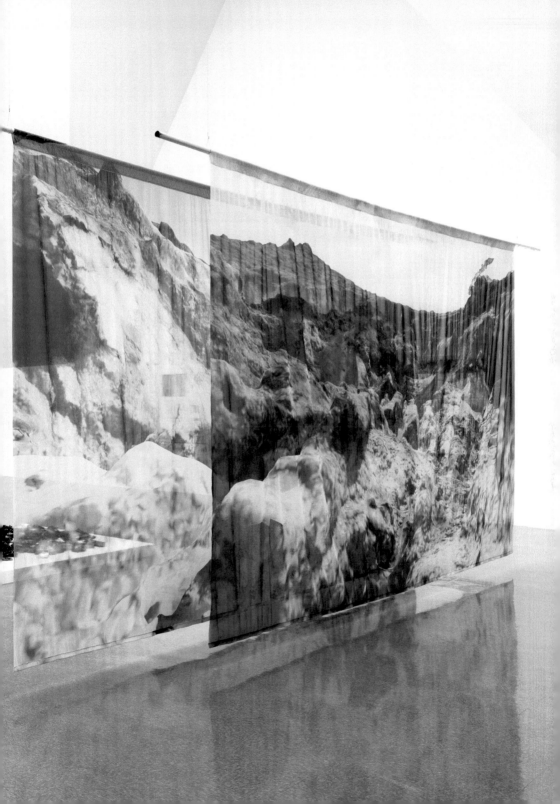

Enter behind the wizard's curtain and we're at sea, alongside
19 men and 4000 containers full of (electronic, car, animal) parts,
heading to Nigeria. One contains frozen tilapia fish now crossing
the sea above the water. We are in a parallel universe,
the backstage of everything, deep in the world's id.

On a ship called Dignity (echo the Glaswegian karaoke anthem)
we live in the electrician's cabin, and are therefore both known
as "electrician" on the bridge. Sometimes we wonder where
the real electrician is.

"We Carefully handle all Services. Whether it is an elephant
or ice cream, We can carry it," reads the copy on the shipping
company's site. I lean over the bridge looking at the containers
and imagine each one of them holds a frozen elephant,
set in a block of strawberry ice cream.

We are not moving things on the water, we are moving their parts,
a galaxy of components. We slide particles on the sea, we are
particles sliding on the sea. Small pools of turquoise and dusty pink
liquids, suspended molecules of remote minerals glide on a sea
of steel. From the acids I collect invisible pieces from the mine,
a geography of systems, desire, magic and destruction. All that
is solid melts into flow.*

Notes taken while on board the containership
Dignity as part of the Container Artists
Residency. Passages later appear in the text
"Karst Notion"

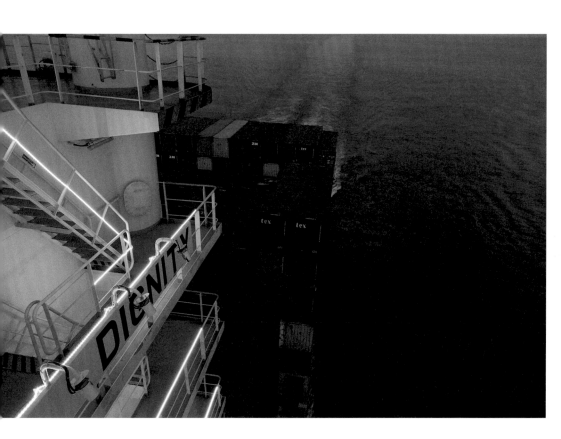

37
Dissolution
(I Know Nothing) 2016
Production documentation

– Electrician
– Yes captain
– Go to bridge. The star Orion
 very beautiful tonight.)

Dissolved tin, nickel, and gold solutions are electroplated onto
stainless steel sheets, echoing seventeenth-century Dutch seascapes
that depicted the early commercialization of the sea. Both material
and process are appropriated from mass manufacturing industries,
bringing together residues of soil and water from the supply chains
through which minerals extracted in Central Africa are transformed
into electronics in China.

138
A Pool of Experience 2016
Nickel, gold, tin, and paint
on stainless steel
300 × 200 cm
Production documentation
Creative Operational Solutions
Para Site, Hong Kong

Containership crew member Elmer
Tagsa disembarked from the vessel
ZIM Rotterdam during a stop in the
Hong Kong port to finish our work
with the ship's deck paint.

› 137, 139, 190

Date: December 5, 2016
Subject: A seaman in Hong Kong tomorrow?
From: Revital

Hi xxxxx,

We're still working on making the deck painting happen for the upcoming exhibition in xxxxxx. However, meanwhile the show in Hong Kong is opening this Friday and we would like to create a prelude:

On Tuesday a ZIM vessel is scheduled to arrive at Hong Kong port. We were hoping to get one seaman (a member of the crew, not an officer) to disembark the vessel and come to the gallery to paint one line on our work. We will obviously pay the seaman for his time and pay for the taxi from and to the port. It will only take 20 minutes in the gallery. Tuur spoke to Jason, ZIM's agent in HK and he can help facilitate it.

He does however need approval from ZIM and for ZIM to contact the master of the vessel to help facilitate this.

Could you help us make this possible?

Many thanks,

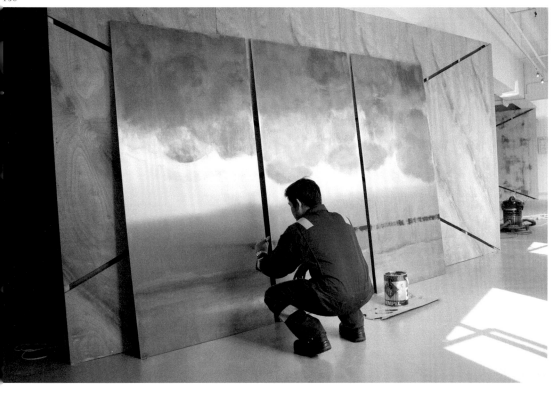

Leave Goma past Kisenyi and take the road to
Ruhengeri. At km 11, Rugerero, centre of Bugoyi,
where one can see 120 "Ntore" dancers. Further,
at km 14 lies the milk farm of Nyundo, and close
by the old imposing catholic mission founded
in 1901 as the base of the first inland diocese
of Rwanda-Urundi. At the sisters of Our Lady
of Africa, one can admire and order beautiful
tapestries, woven by hand from banana fibres
by young inland girls.

Past Nyundo lies the wide Mutura-hill, its
bent roads divided in two. Turn left around km
26, 2km past the stage-hut of Mutura, towards
the Bugoyi region, the richest of Rwanda. Not
an inch of these grounds is neglected, tilled
continuously between harvests. Take a right
at the start of the tour; numerous pyrethrum
plantations. Around km 32, take the small road
left towards the Mutura lava-caves, shelter
of the inlanders during the war of 1914-1918.
Take a good lamp.*

"Service for Information and Public Relations of the
Belgian Congo and Rwanda-Urundi," *Traveller's Guide
to Belgian Congo and Rwanda Urundi*, 3rd ed. (Brussels,
1958), 646. Translation by the author.

*

139

139
Where One Can See
120 Ntore Dancers 2016
Copper, nickel, gold, and tin on bronze
76 × 57 cm

From Inlands, a series of landscapes
produced by electroplating gold,
copper, tin, and nickel onto bronze
sheets. The abstract renditions of open
mines in the Democratic Republic of
Congo are materialized through
elements excavated from the country's
soil. The titles are taken from a travel
guide to Congo and Ruanda-Urundi
from 1958 that belonged to my
grandparents.

› 133, 206

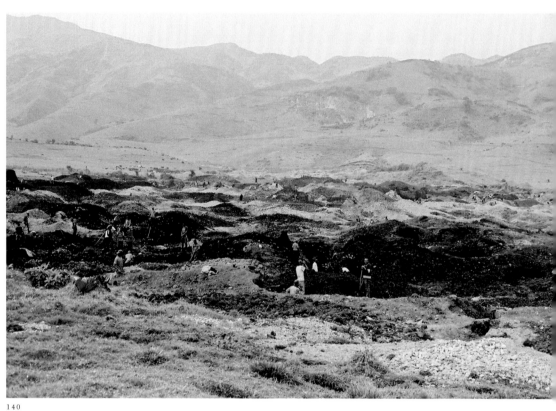

140

Artisanal gold mine near Numbi,
South Kivu, DR Congo, July 2015.

> 141, 214

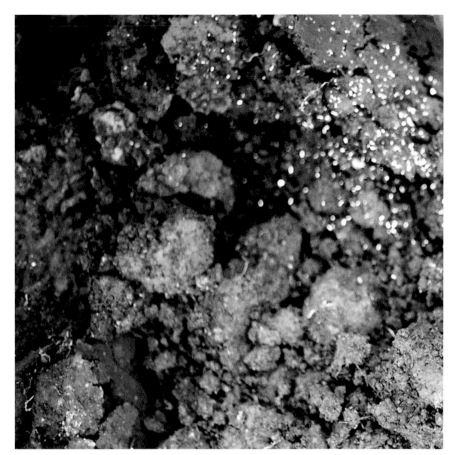

141

141
Retour 2015
C-Type Print
75 × 75 cm

Goldfingers are cut from motherboards
with pruning shears and submerged
in acid overnight. Using a coffee filter,
50 mg of gold flakes are retrieved.
On day 25 in East Kivu, the plastic vial
opens atop an open gold mine, the
particles scattered on the mud. Gold
to gold to dust. *

> 008, 100

In the village of Liuyang in Hunan, dust from the Congolese mine
is packed tightly into the bottom of a cardboard tube. Gunpowder
stars are scattered on top and sealed with a layer of black goo
and a fuse. The cake is wrapped in copper foil, ready to be
shipped for a pyrotechnical spectacle on another continent, where
the particles will fall down from the sky and enter all our pores
and cracks.*

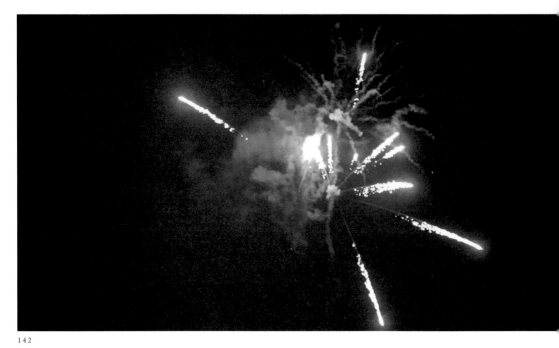

142

142
Grounds 2016
HD video with sound
07:00 minutes

Grounds is composed of footage from
the fireworks testing site in Liuyang in
Hunan Province, China, where most
of the world's fireworks are produced.
A daily "performance" of product
testing unintentionally stages an
industrial spectacle, where mass
quantities of gunpowder mixed with
local soil explode in a battlefield of
colored smoke.

› 133, 212

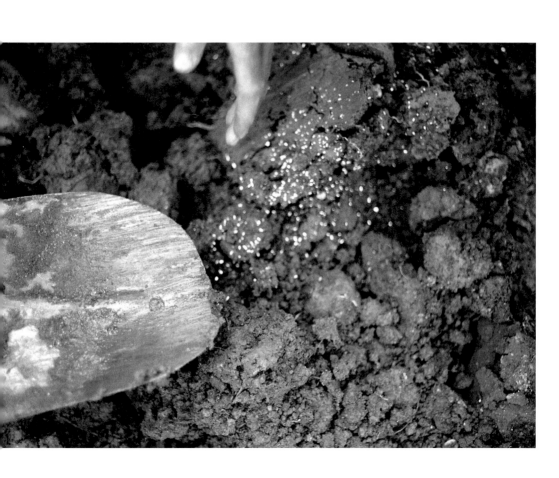

Retour 2016
Production documentation
» 100, 141

144

"Moonbouncing" is a technique deployed by amateur radio
operators to make a connection using the moon as a mirror
for radio waves. The moon is not an ideal mirror: it absorbs
about 93% of the radio message. The 7% of the message that
is bounced back goes in all directions. Of that 7% only a
tiny part reaches earth again.

A subjective take on the gathered oeuvre.
A muted retrospective.
Does this come with sound?
A message filtered by misinterpretation.
A brainstorm gone terribly wrong.
Does this screen fit the work?
Shall we give it a try?
Let's just give it a try.

Excerpt from Samuel Saelemakers' exhibition text

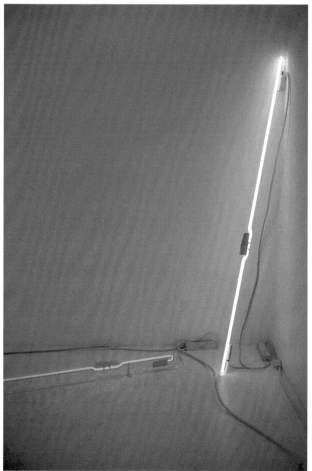

itchy palm trees standing/leaning on the tribune HOW LONG DO YOU THINK ONE CAN LOOK AT
NEONS? 4 MINS?

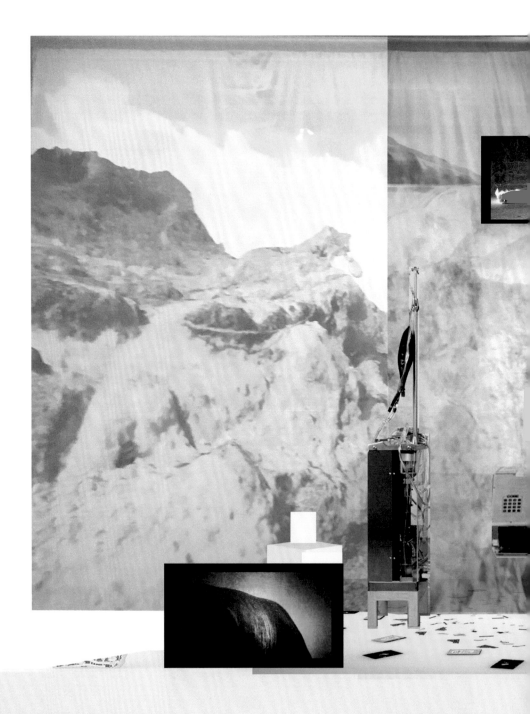

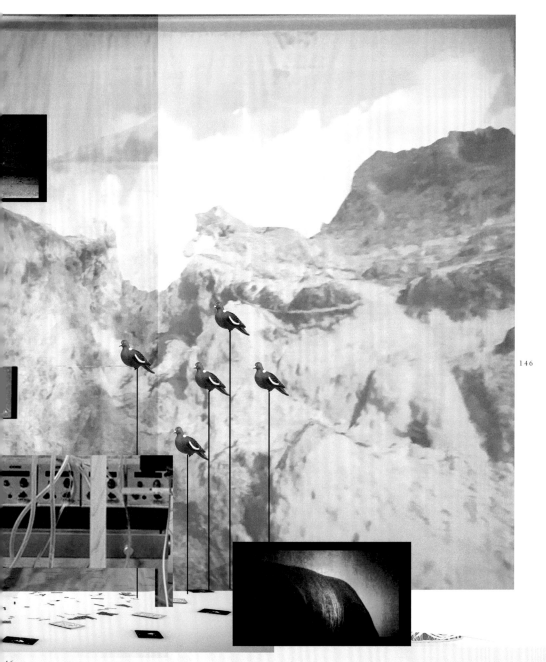

46
hite Horse / Twin Horse 2017
ehearsal 1: *Index*
Digital sketch for installation
Constellation 6: *Everything you
draw is always floating in the air.*

White Horse / Twin Horse 2017

White Horse / Twin Horse makes use
of the Brakke Grond's theater infrastructure
to rehearse forms of exhibition in which
research, process, and outcome cannot be
meaningfully distinguished.

The artists move their entire physical storage
and digital archive to the theater space
and unpack the work in collaboration with
two curators, a fellow artist, and a theater
director. The theater's technicians, used to
building and unbuilding productions every
night, reinstall the exhibition every ten days,
activating and deactivating different parts.
A writer in residence captures each iteration
with a text that remains in the space, her
writing accumulates as the exhibition
transforms. Rehearsing the exhibition in this
way questions the conditions surrounding
the production of the artwork and its pres-
entation.

Rehearsal 1: *Index*
by Revital Cohen & Tuur Van Balen
Opening December 9, 2017, 4:00 p.m.

Rehearsal 2: *Moonbouncing*
by Samuel Saelemakers
Opening December 21, 5:00 p.m.

Rehearsal 3: *Walkthrough*
by Tyler Coburn
Opening January 7, 2018, 4:00 p.m.

Rehearsal 4: *Dormant Remains*
by Christina Li
Opening January 13, 5:00 p.m.

Rehearsal 5: *To be Continued*
by Anne Breure
Opening January 23, 5:00 p.m.

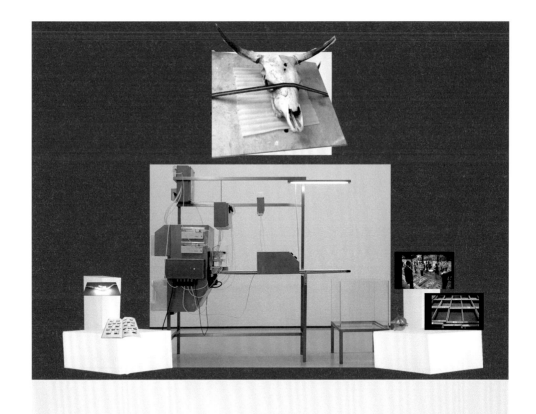

147

White Horse / Twin Horse 2017
Rehearsal 1: *Index*
Digital sketch for installation
Constellation 4: *I think it is a very*
interesting (biologically, of course) and
enjoyable experience to take care of
a baby and young child. Please enjoy
your experiences, especially during
lactation. Of course, I know it is
laborious for women as mothers.

- The skull of a Heck cattle, a breed that originated from an attempt to breed the extinct aurochs back to life in 1930s Germany as part of a de-domestication project in search of the animal's "true form." Shot in the head by an English farmer and used as a model for a mould, used to make another mould, to make another mould, etc.
- The sound of a hare's mating call bounced off the surface of the moon.
- A machine for reproducing sterile goldfish. Or, the reproductive organ of sterile goldfish. A reenactment of Dr Yamaha's fish making process.
- A curve from the neck of a neon leopard reproduced around a piece of mammoth ivory.
- A mould from a Sega lightgun, enhancing a tiny gesture of metallic connection with plastic.
- A catalogue of the winners and losers in a fish body form competition from 2014.
- Study for an artificial biological clock.
- Footage of the ceremonies, economies, and cultures through which Japanese goldfish are transformed into objects.

Audio guide, Rehearsal 1

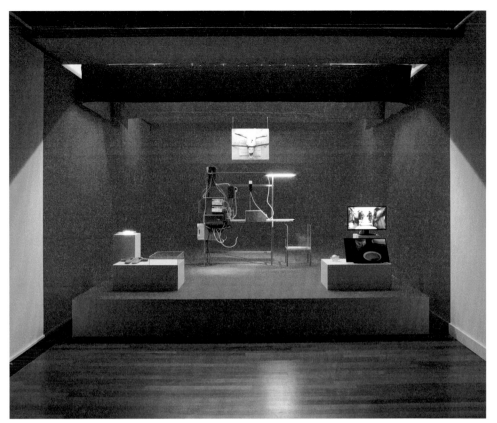

148

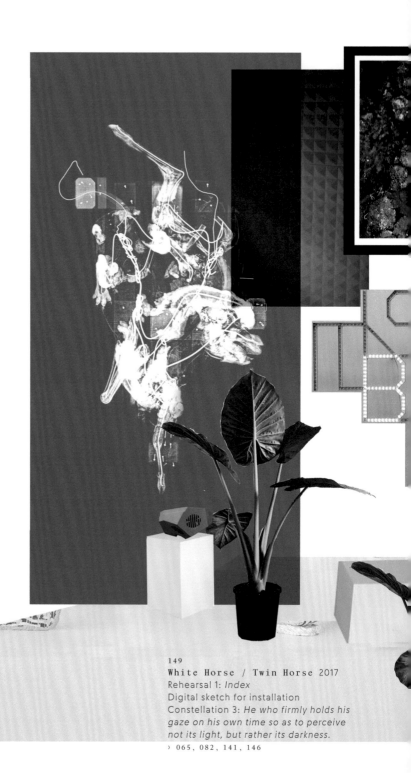

149

149
White Horse / Twin Horse 2017
Rehearsal 1: *Index*
Digital sketch for installation
Constellation 3: *He who firmly holds his gaze on his own time so as to perceive not its light, but rather its darkness.*
› 065, 082, 141, 146

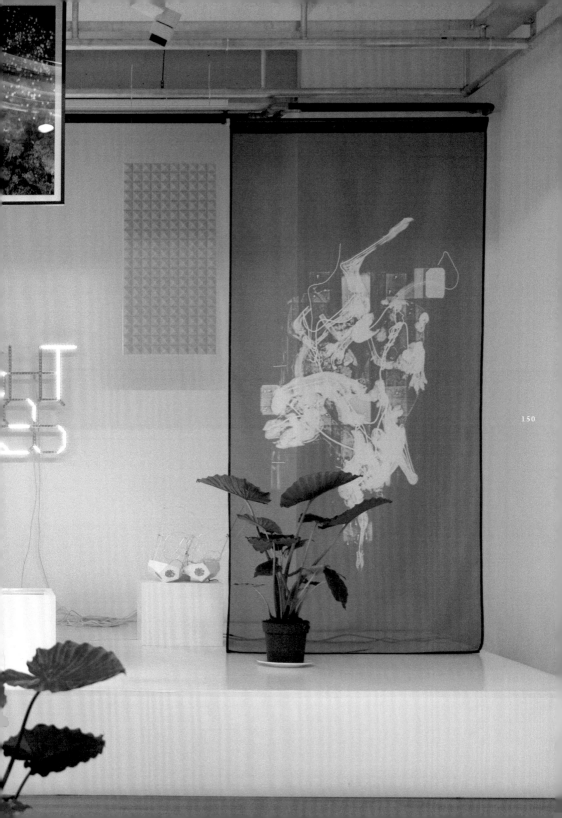

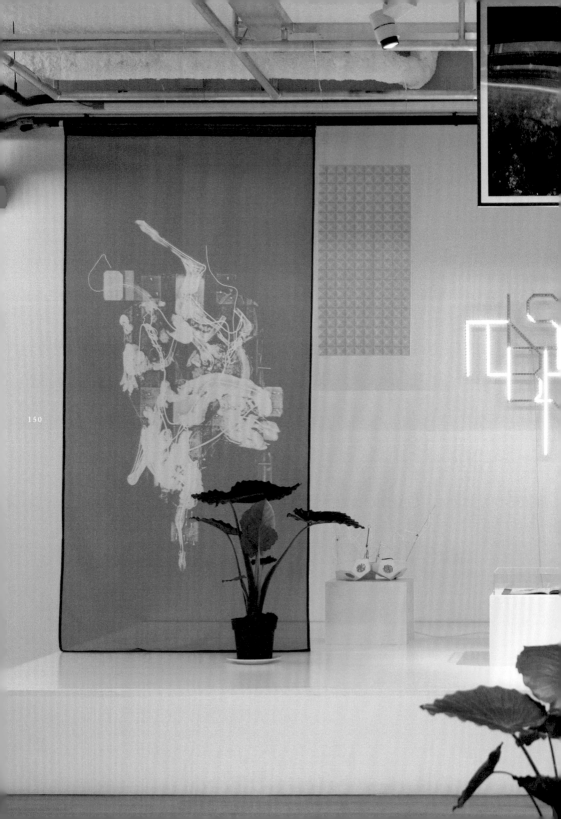

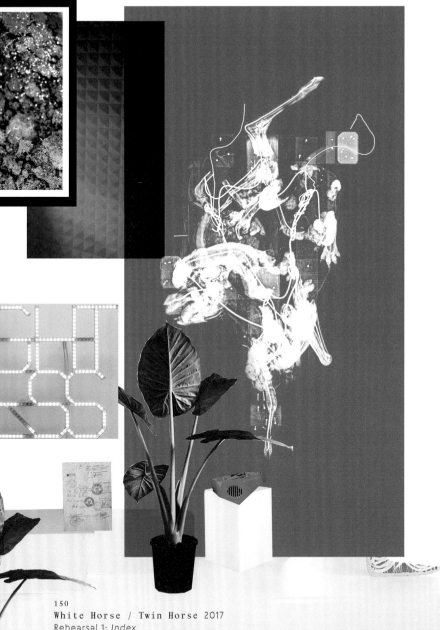

150
White Horse / Twin Horse 2017
Rehearsal 1: *Index*
Constellation 3: *He who firmly holds his gaze on his own time so as to perceive not its light, but rather its darkness.*
Installation view
De Brakke Grond, Amsterdam
› 065, 082, 141, 146

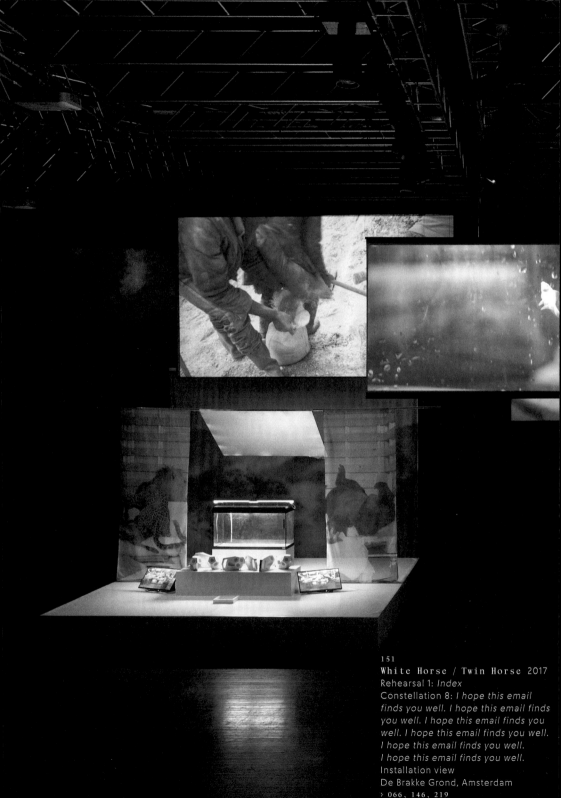

151
White Horse / Twin Horse 2017
Rehearsal 1: *Index*
Constellation 8: *I hope this email*
finds you well. I hope this email finds
you well. I hope this email finds you
well. I hope this email finds you well.
I hope this email finds you well.
I hope this email finds you well.
Installation view
De Brakke Grond, Amsterdam
> 066, 146, 219

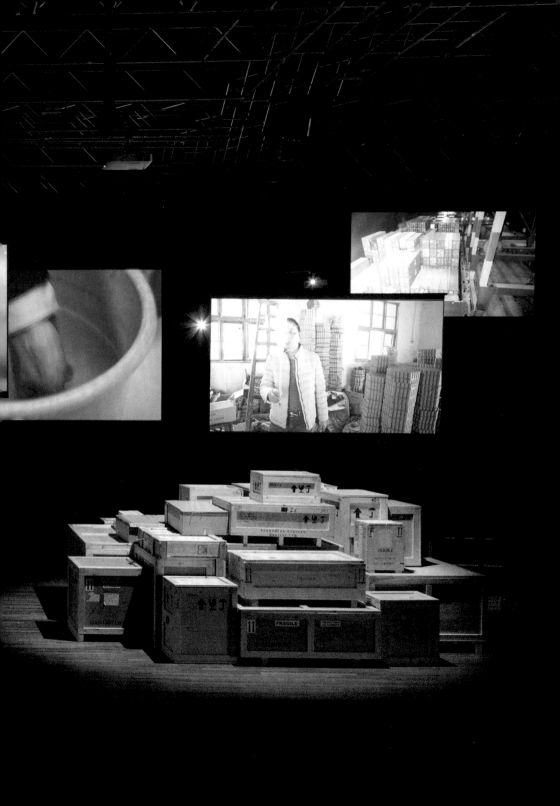

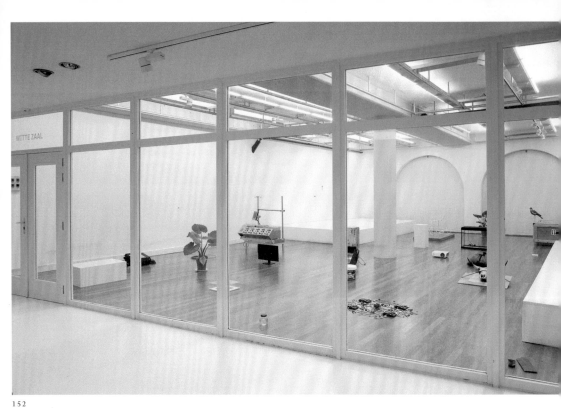

152

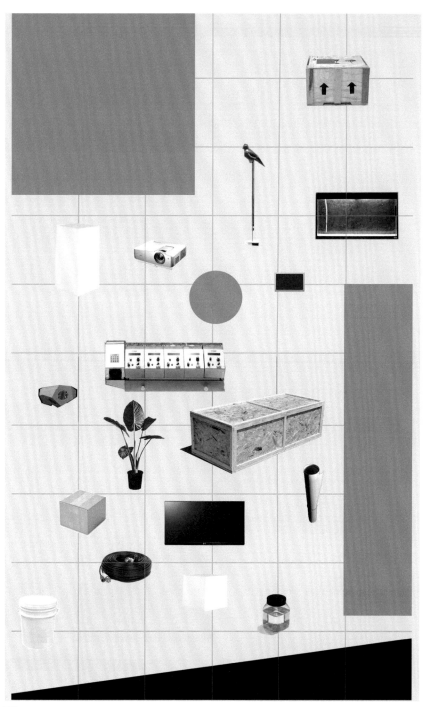

September 20th

An image by Agence France Presse shows protes[...]
Goma against President Joseph Kabila and his re[...]
resign. The[...]ke the leftov[...]
our produc[...]lphe, our fix[...]
check wit[...]

It is a [...]
I sit in [...]
snorin[...]
know [...]
through a shaky co[...]

54
White Horse / Twin Horse 2017
Rehearsal 4: *Dormant Remains,*
by Christina Li
Digital sketch for cluster 2
126, 132, 141, 146

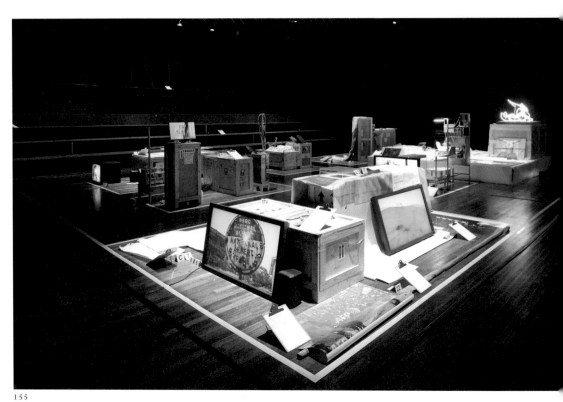

155

156

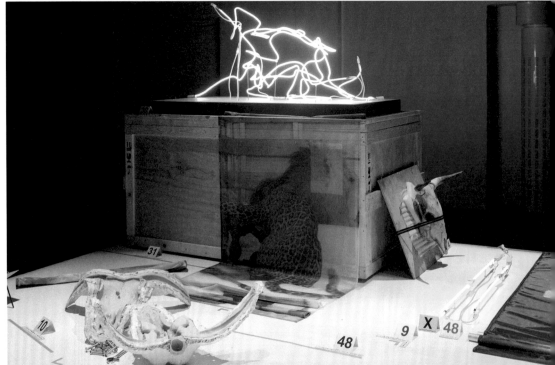

155-157

White Horse / Twin Horse 2017
Rehearsal 4: *Dormant Remains*,
by Christina Li
Installation views
De Brakke Grond, Amsterdam
Photographs by Ernst van Deursen
011, 146, 201

Tuur:
While talking to Anne I was very self-aware of what I was saying,
a self-awareness which I also pronounced: I don't like catching
myself saying things in a way that I've already said before. So
when I give talks, doing the spiel; the spiel being the thing where
you explain a work in a way that you've already done before, or
even explaining the process or even making the same joke…
That's the worst: when I catch myself making a joke that works.

Revital:
You don't like performing.

Tuur:
No, I don't like the rehearsal, I don't like it being rehearsed.
Maybe that's my rehearsal; to say something in a way I've said
before. Sometimes I do it but while I was talking to Anne I really
tried to avoid it because I felt that conversation would be more
earnest if I didn't. When I feel that I need to perform, I obviously
grab back to answers that are rehearsed. For example, on the
same day as the interview with Anne, when I was talking to
the students of de Appel about the exhibition, I used rehearsed
answers because I knew I had very little time, I was installing
a show…

Revital:
Don't you think that has its own charm?

Tuur:
No it doesn't just have its own charm. I think through these
rehearsals something can evolve into a very good explanation.
So that's the point. It doesn't have its charm, it has its function,
an important function. But my fear is that we continuously
rehearse so much that we end up being some kind of cruise ship
entertainer with a Madonna mic.

58
White Horse / Twin Horse 2017
Rehearsal 5: *To Be Continued,*
by Anne Breure
Installation view
De Brakke Grond, Amsterdam
Photograph by Ernst van Deursen
001, 090, 146

White Horse / Twin Horse 201
Rehearsal 5: *To Be Continued,*
by Anne Breure

(Final scene)

› 146, 169

scene 5
*"after this conversation
with Anne"*
7.20 minutes

Anne:
Hi Tuur, one last
question. What is your
favorite dance
performance music?

Tuur:
an amazing scene in
Jerome Bel's 'The Show
Must Go On' comes to
mind:

the stage is completely
dark and the technician
puts on a single spotlight
shining straight down in
the middle of the stage

and he walks out of his
booth, which is in the
middle of the tribune
and makes his way to
the stage

and starts dancing in that
one spotlight
and he's really the
technician, not some
dancer pretending to be
a technician

and Tina Turner start's
playing

Private Dancer

Anne:
Tuur - how did you know it was
not a dancer that rehearsed to
dance as a technician?

Tuur:
:)
Trust?

Rehearsal 05

To be continued
-
The End

Surviving the dream

don't know, back then, there were also a lot of things that I did not understand, but I was never embarrassed to say. We would meet brilliant, important scientists, philosophers, academics, but I never felt like I had to apologize if I didn't understand exactly what they did. But when it's my work and I don't understand part of my work, that's a very different story.

That's also a super interesting question: To what extent do we have to represent our work individually? Because I also feel sometimes that there are things I cannot explain or justify or represent in the work we make, which might be because you wanted to do it that way. And I like that. Maybe instead of trying to represent that and asking you to explain and me learning to be able to represent it, perhaps we shouldn't. Sometimes we're doing it because you want to do it, and sometimes we're doing it because I want to do it. Perhaps that's a way to keep some individuality in this practice. Do you feel like you need to represent all of the work that we do?

feel like for me there is a really strong sense that work has to be autobiographical, always has been. And that is something that's a lot harder to do with two people. And I've been really trying. I've gone as far as taking on your childhood memories and really follow-

ing this Congo storyline, which is really not in my autobiography at all. I feel like it always makes for better work. It's just a question of how to do that within a collaboration. And you know what I mean, the autobiographical angle should never be explicit, but it needs to be at the bottom of it for some kind of heart, and I feel like our best work always has that.

But don't you think it's kind of a way of approaching it? A way of twisting things and looking for doubt—

I feel that if there's not some sort of connection running deep in it, you can't force it, it just doesn't work.

I'm sorry, but this Congo personal history has never been that significant to me. And I know you're saying it is very significant.

You've been talking about it for years. I didn't even know the place existed.

Of course, I grew up with it, I saw images of it, but I never feel like it's such a huge part of who I am. I don't necessarily feel like it's the thing I have to dig into.

But that's not what I mean with something being autobiographical; it's not necessarily a kind of toxic thing that one has to dig into. I don't know… Doing this work in Congo, I felt it was justified or more relevant because of

that, rather than if we now chose to do some

work in India or—

What about China?

Well, I think as well for China, it's been very

much connected to industrial design and to

our long involvement in that. If we were to just

go to China and do something about Chinese

theater or whatever that would be a bit weird.

This still felt very personal. And it doesn't

have to be the country, it can be other things,

like *Sterile* for me was very much my feelings

about my body and the future of our lack of

children. These works are just better that way,

I don't even know why. And it doesn't always

make me happy; I wish I could flow more. But

Yeah, although I also feel like you can make

I feel that if we're just following our head, it

subjects your own. This is also something that

just doesn't have this kind of magic.

frustrates me in our practice, which comes

from the same point—this mode where we

switch to a different project, and we don't

have that much time to really make something

our own. I see other artists who have a very

clear process, and it is very "reasonable" but

But that's exactly what I'm talking about,

also feels very calculated.

about not following reason—and I feel like

when we do start something, something that

hits a personal nerve, it feels very relevant to

our lives in another way.

What about the gambling proposal we've just written, this new area we want to play around in?

For me, this is the source of a lot of my anxieties at the moment. Years ago, I was really occupied with the body and reproduction, and that's resolved for me. At least for now. But one day the thought suddenly entered my head—and hasn't left, actually—that this can just end in nothing, that this doesn't have to work. I don't know, I never saw that reality as an option. But once I did, I realized that, while I thought I was building something, actually we were just rolling a massive dice.

Yes, but that's the joke I made to Matthew a long time ago. We were walking through Berlin and he said everything seems to go so well for us, with having that show and living off our work, la la la. And I mentioned that we're barely living off this, just about surviving.

Surviving the dream.

Exactly. And he said: well, this is the stage of investment, you're building up something, you're investing. And I literally told him: it's more the stage of gambling. Investing is just gambling when the odds are stacked against it.

That's why I feel like, I don't know where this work will go, but it resonates, because, at the

moment, it has a strong autobiographical un-

dercurrent, something we're both very occu-

pied with.

So maybe autobiographical isn't the right

term. Maybe "personal" is a better term.

There's a personal thing at stake.

We're here again. Do you want to walk more?

Yes, a little more. Where are we?

That leads to the main road.

Let's go there. I think they're shooting over

there or something.

It's interesting, this question of representa-

tion. Because the question, "Why did you want

to make a [fill in the blank]?" still sometimes

comes up. And I don't think either of us should

be able to answer this, neither of us should be

able to describe this choice. You should be

able to say, "It felt right," and I should be able

to say, "It felt right"—even if I didn't even feel it.

"It felt vicariously right."

How do you give space to this thing that

is personal and just feels right, in our pro-

cess which is heavily based on—arguments?

[Laughs.]

No, that's not…

Not arguments but in a collaboration where you have to defend choices.

I think that's more of the question: How can something feel right between two people? Feeling right or gut or instinct is a very personal thing, and how do you keep that when you work with someone?

But don't you think that when it does become personal between two people, it's kind of magical?

Yeah… I do, but also, I think that as the woman among those two people, I feel like it often can be seen like it was less of me. That's not something you ever create, it's the reality of it. Maybe what I fear is that as a woman working alone I had full autonomy, and if anyone liked my work, they had to accept it came from me, whereas as half of us, I often feel very marginalized. Not by you. But it feels like I lost a hell of a lot of weight, I lost a lot of autonomy over my own work, which is really weird. I feel sometimes when people meet you without me in a work thing, when they meet me later—I feel like they're almost surprised by how opinionated I am, and strong-willed. They almost like… they did not expect this, they thought I'm just, like, your babysitter.

I don't know if it's even a woman thing. Even
if I was to collaborate with another woman,
there is something in this self-splitting which
makes you have to re-prove yourself.

But I don't really feel that way. Is that just
because I'm too dominant and your fears are
right and I am just walking all over you? I
doubt!

You're not walking all over me. [Laughs.] I
wouldn't really let it happen.

I'd like to believe that I'm also sensible
enough not to.

But can I just say that we do walk all over each
other, and that's something that I also tried to
say in that therapist meeting—when we walk
all over each other in a professional manner,
at least, there are residues of this behavior.

I think that's a super interesting question, but
I think we have to dig that up another time.

I'm just saying it brings up a lot of insecurities
because we are continuously shining a light
on each other's failures. Working together al-
lows me to escape a lot of things I cannot deal
with—maybe I spoil myself and then I have to
pay for it. This division of labor between us…
When I don't want to do something and you
do it instead of me, it's an instant gratifica-
tion, but it has long term consequences.

16

"How dare you?" asks the lady in the audience, "Who are you to
go to China and make factory workers dance?" "Yes, you're right.
But don't I make factory workers dance every time I buy something
that's produced in China? I mean, I edited this film on a Macbook Pro
assembled at Foxconn."

161

162
75 Watt 2013
Resin, aluminum, electronics
35 × 17 × 18cm (edition of 40)
HD video with sound
10:00 minutes

In **75 Watt** a group of factory workers on an assembly line constructs identical objects in a series of elaborate movements. Designed in collaboration with a choreographer, the objects' only function is to dictate the laborers' movements, putting into question the nature of mass-manufacturing from the geopolitical context of hyper-fragmented labor to the biopolitical condition of the human body on the assembly line.

We see design and manufacturing as political in nature, regardless of the objects produced. The division of labor has been a dominant force in shaping contemporary society and culture. In the United Kingdom, the 20 pound note reminds the nation of Adam Smith—"The division of labour in pin manufacturing: (and the great increase in the quantity of work that results)"—while Marx describes how that division of labor can lead to workers' alienation, leaving them "depressed spiritually and physically to the condition of a machine." * But perhaps it is the laborer in the condition of a machine who best suits the engineering logic that facilitates the increasing complexity of industrialization processes.

By shifting the laborer's actions from the efficient production of objects to the performance of choreographed acts, mechanical movement was reinterpreted into dance. We wanted to question the value of an artefact that only exists to support the performance of its own creation. And if the product dictates the movement, does it become the subject, rendering the worker the object?

› 021, 086, 088–094, 264

Karl Marx, "Wages of Labor," in *Economic and Philosophic Manuscripts of 1844* (1844;

*

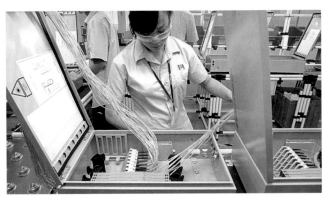

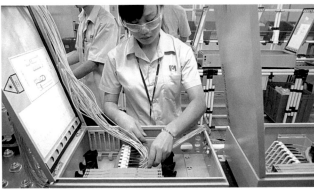

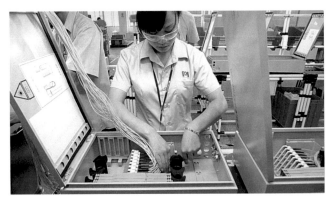

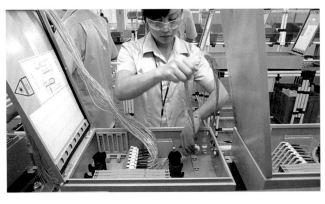

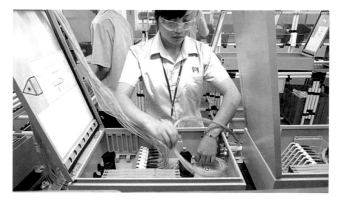

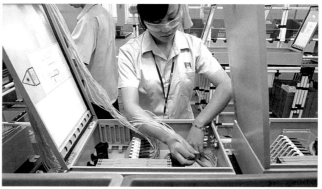

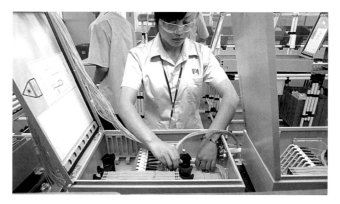

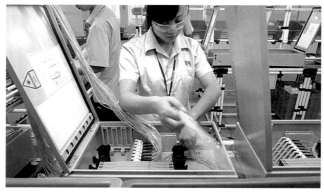

63

Footage from research trip to
Guangzhou and Shenzhen, 2011.

Glass fiber cables cannot be
bent at sharp angles as that
would cause the fibers to break.
Instead, workers have to gently
weave the cables.

040, 092, 162

At the time (2012), the Pearl River Delta in China
was the center of global production and manufacturing.
The work was to be made at the source of this global
supply chain, where minerals become everyday objects,
hotels keep packing tape and shipping scales in their
corridors, and market traders manually paint the little
red dot on dial buttons.

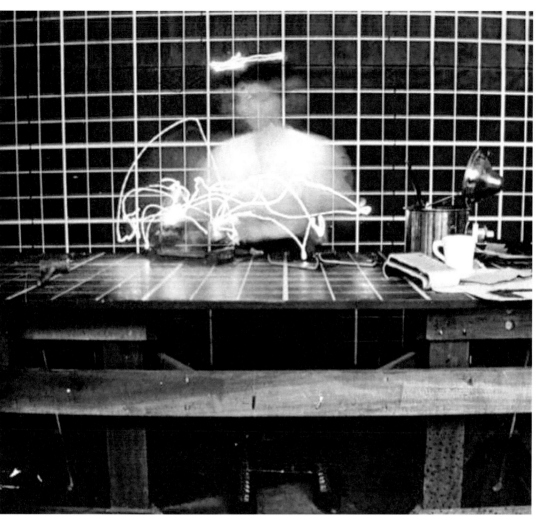

165

We chose to work at the White Horse Electric Factory in Zhongshan
because we were looking for a fair working environment, i.e.
somewhere not imposing sweatshop conditions. As often when
working in a specific context, we managed to forge a relationship
with the factory owner, who turned out to be an art lover.
For the first meeting we brought him a bottle of whiskey and
an Arsenal scarf, which seemed to land well.

The factory was originally called White Horse, but when it
opened to the international market, they discovered that there
was another company with that name, so it was rebranded as
Twin Horse. However, they could never quite give up on the
White Horse title and always used both in a strange and beautiful
inconsistency.* So the factory operates under both names—
a schizophrenic brand identity.

This dual or split identity inspired the name
of our exhibition, White Horse / Twin Horse,
at De Brakke Grond five years later.

About halfway down the assembly line, a young female
worker carefully weaves an electroluminescent wire through
the product. As her hands move on to the next point of
attachment, the glowing wire traces her motions in the air.

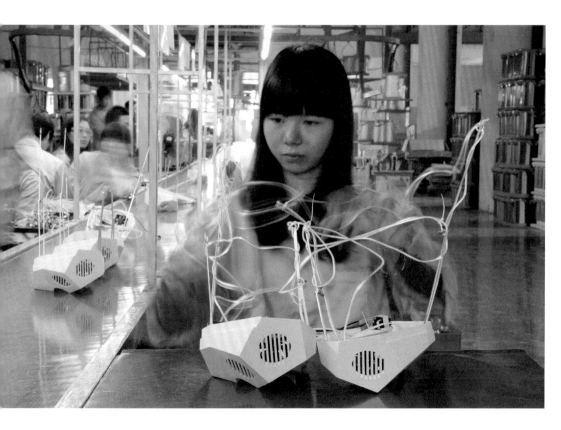

After attaching the arm to the outside of the object,
he tests the joints with a quick succession of movements
and places the product back on the assembly line to
be packed.

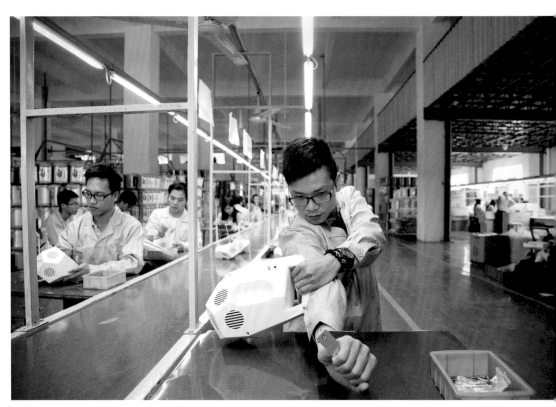

At the end of the assembly line, the final movement is
created by testing the object's electronics. At the flick of a
switch the worker's long black hair rises in the wind created
by six small fans, a small wink at Pina Bausch induced
by electronics testing.

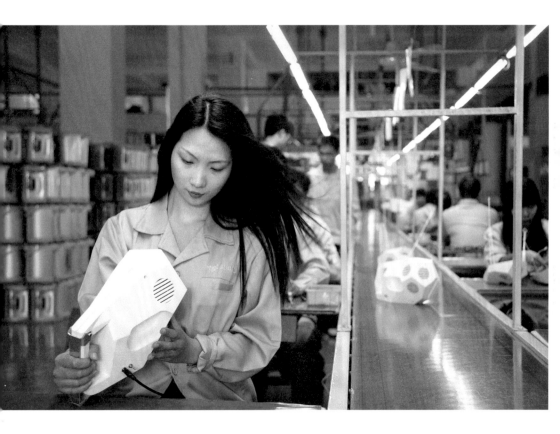

75 Watt 2013
Film still
› 090, 162

According to *Marks' Standard Handbook for Mechanical Engineers*, a laborer over the course of an 8-hour day can sustain an average output of about 75 watts.*

The theory was the start of the work; it reflects the way engineering logic reduces the factory laborer to a man-machine through the scientific management of every single movement (going back to F.W. Taylor's *The Principles of Scientific Management*, and Frank and Lillian Gilbreth's use of time-lapse photography to study the inefficiencies in workers' motions).

Engineering logic provides the abstraction and hierarchy necessary to design for increasingly complex industrial processes as the designer/engineer isolates what they don't (need to) understand as a "black box." Given consistent standards, this abstraction allows for the design of ever more complex products in ever more complex processes and encourages the belief that there is very little we cannot engineer. However, it also creates multiple layers of disconnection: disconnection between designer and maker, disconnection between producers and suppliers, disconnection between technology and people, disconnection between head and pin.

This "black box" logic only works when everything is meticulously characterized: every part in the process must behave in a predictable manner. And within the huge complexity of industrial manufacturing processes, the human bodies on the assembly line are not always predictable enough to fit.

* Eugene A. Avallone, Theodore Baumeister, and Ali Sadegh (eds.), *Marks' Standard Handbook for Mechanical Engineers*, 11th Edition (New York: McGraw Hill, 2007), 94.

In the end we were only granted three days for rehearsal
and filming in the actual factory, which meant we
relied on the factory workers to help us refine the stages
of assembly, divide the tasks, and figure out how to keep
the line running smoothly based on their own expertise.

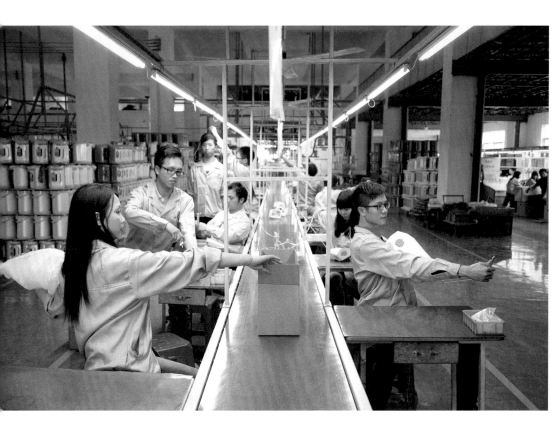

75 Watt 2013
Film still
» 087, 162

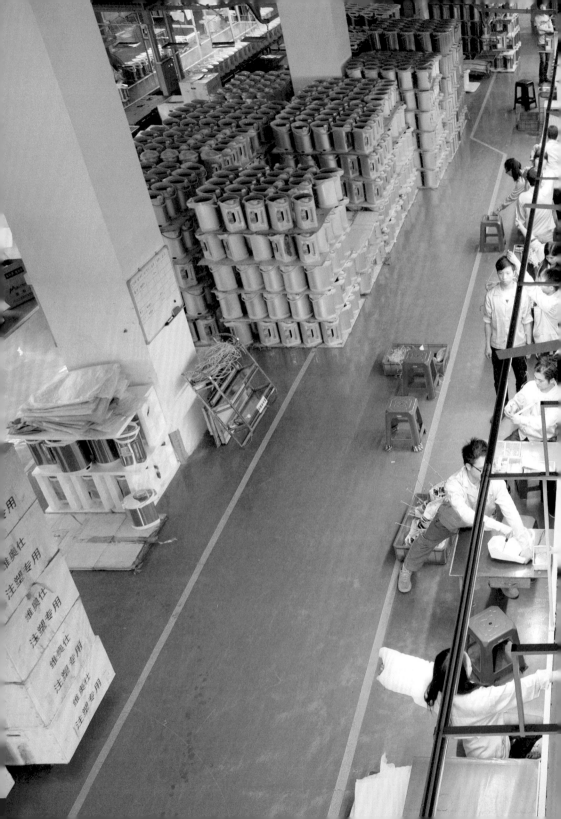

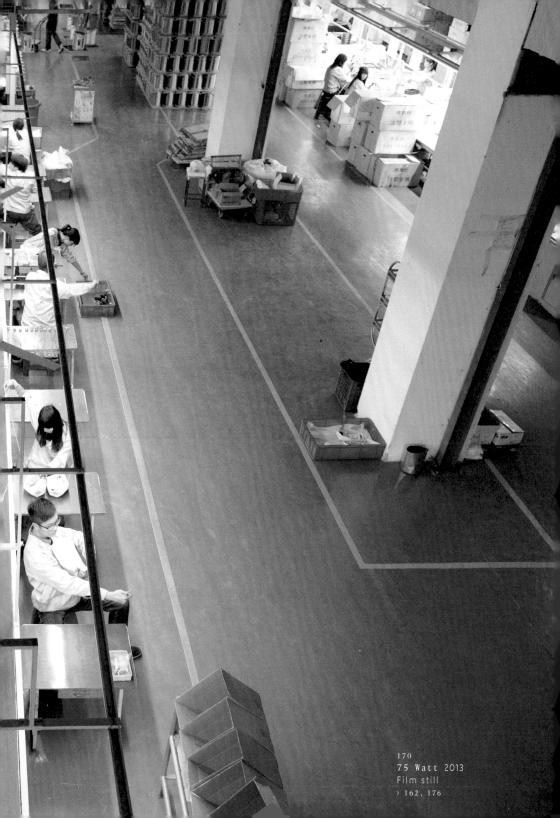

Giving form is one of the hardest things there is, especially form
that follows function and is somehow reflective of it. This thing
could have been any thing. I tried to work it out from the inside
out, using the open carcass of a handheld vacuum cleaner as
a start. Once all the parts of the movements (wire and supports
for looming, electronics, hair-blowing fan, hinged arm for testing
sequence) were clustered, we just wrapped that volume in a
resin skin. But when I held the thing in my hand (first in card
then resin), I suddenly saw echoes of a Ranchu goldfish.

he invisible landscapes inside
onsumer products dictate a
ance of fingers during their
ssembly.

173
Automatic Hog-Weighing
Apparatus for Use in Packing
Houses, Cincinnati, 1869.
(U.S. Patent 92,083).

The first assembly line was
a disassembly line (after
Giedion's *Mechanization
Takes Command*).

› 047, 162, 247

174
The Immortal 2012
Production documentation

(*Automata vs. humidity*)

› 175, 176

START UP

1. Disconnect all machines except Heart-Lung Machine.
2. Disconnect incoming tube dark grey (incoming water via
 pump number 5) and submerge into a bucket of water with
 a splash of bleach.
3. Turn on brain > HLM pump number 5.
4. If the water doesn't get sucked in tighten the pump using
 the screw on top.
5. Follow the water's journey as it travels through the circuit,
 when it reaches a new tube / area, turn on the corresponding
 HLM pump and tighten / turn speed up as needed.
6. Slowly go through the circuit following the path of the
 water and stopping for amendments whenever there's a
 leak. The most leak-prone areas are all sides of the dialysis
 machine (check dialyser is well connected), points of tubing
 connections, cell-saver reservoir, and black bag. Use bucket
 filled with water and a splash of bleach.

ALARMS !

Turn off alarms on Ventilator—small button to the left
(press again and again and again until quiet).
HLM monitor – button on the right
EKG – button under drawing of a bell
(better: dials at the back of the machine /
best: switch off all alarms in menu)

Hi Revital

Spoke to a hospital engineer in Newcastle yesterday
who will be replacing 3 heart lung machines in
March (possibly), also have sent out a request to
our NHS engineer clients (approx. 900 contacts
covering most of the hospitals in the UK) so that
might bring something. We have a number of
dialysis machines here that are available, you just
need to let us know which ones you need.

Could you use an Iron lung! very old bit of kit but it
looks great! One coming out of an old hospital in
Liverpool.

Revital

All is under control! There are no Gambro machines
in the sale tomorrow, but we do have a clutch of
them in store ready for the next sale, you can either
have a green or blue one. The Heart lung machine
came in too late for the sale and is also in store
and will be in the May sale, should get all you
need in May.
Mike

The Immortal 2012
Detail
Life support machines, stainless steel,
acrylic, wood, tubing
Dimensions variable

A Heart-Lung Machine, Dialysis
Machine, Infant Incubator, Mechanical
Ventilator, and an Intraoperative Cell
Salvage Machine are connected to each
other, circulating liquids and air in an
attempt to mimic a biological structure.
When turned on, these organ replace-
ment machines operate in orchestrated
loops, keeping each other alive through
the circulation of electrical impulses,
oxygen, and artificial blood. Salt water
acts as a blood replacement: throughout
the artificial circulatory system minerals
are added and filtered out again, the
"blood" is oxygenated, and an ECG
device monitors the system's heartbeat.

› 165, 176

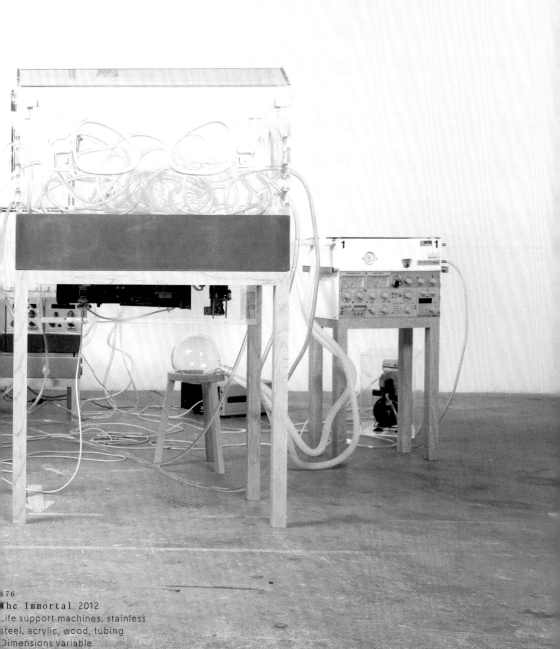

The Immortal 2012
Life support machines, stainless
steel, acrylic, wood, tubing
Dimensions variable
Production documentation
175, 178

As fluid pumps around the room in a meditative pulse, the sound of mechanical breath and the slow humming of motors resonates in a comforting yet disquieting soundscape.

Life support machines are extraordinary devices: computers designed to activate our bodies when anatomy fails, hidden away in hospital wards. Although they are designed as the ultimate utilitarian appliances, they are extremely meaningful and carry a complex social, cultural, and ethical subtext. Life-prolonging technologies are emergency measures to combat or delay death, but we can also consider these devices to be a human-enhancement strategy. The patient is a cyborg, negotiating the relationship between medicine and techno-fantasies of mechanical bodies, hyper-abilities, and posthumanism.

Defining the body as a machine—where dysfunctional parts can be replaced by mechanics—speaks of how we understand life. The medical machine—whether in use or not—is an object which transcends its materiality. Designed and created to perform a single, crucial function, we rarely critically investigate these devices as industrial products.

The installation is a Frankenstein-esque system built from advanced medical equipment. Making the machines work without a body required defining this creature as its own species—from interpreting mechanical "blood" and establishing brain function replacement to prioritizing and mapping functions of cleaning, pumping, and oxygenation—in order to construct a coherent circuit. Most of the machines were reconfigured or hacked, "dumbed down" in order to operate without biological matter. All machines were given new casings that expose their inner workings and visually unify them as organs of the same body.

The existing technology illustrates the Western view of the lungs and heart as the center of our being, avoiding confrontation with the denigrated digestive system, which is conceptually unappealing yet biologically vital. Similarly, the Cell Salvage machine, developed in response to Jehovah's Witnesses' refusal to accept blood transfusions (believed to be in defiance of God's will), is an industrial artefact that blurs the boundary between technocracy and the metaphysical. Social meanings can also be found within the complex practices and hierarchies surrounding the trade and donation of advanced medical equipment. Medical devices in decline have clear migration patterns: they travel from the Global North to the Global South to veterinary practices. Migration trails indicate which types of machines are in demand in which parts of the world, telling whose body is a priority and when.

The compelling and discomforting nature of these objects is a product of our attempts to conquer biology with engineering. The absence of the body belies the fact that the machines filling the room are inherently biological.

The Immortal 2012
Detail

(Cell saver black bag)

› 175, 234

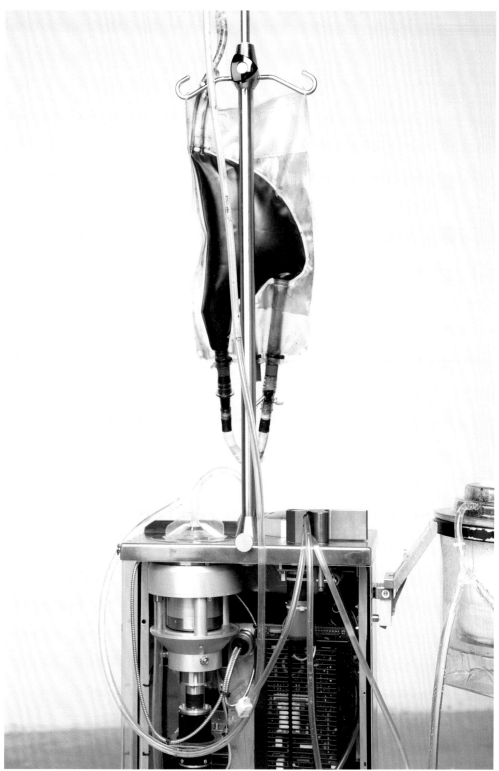

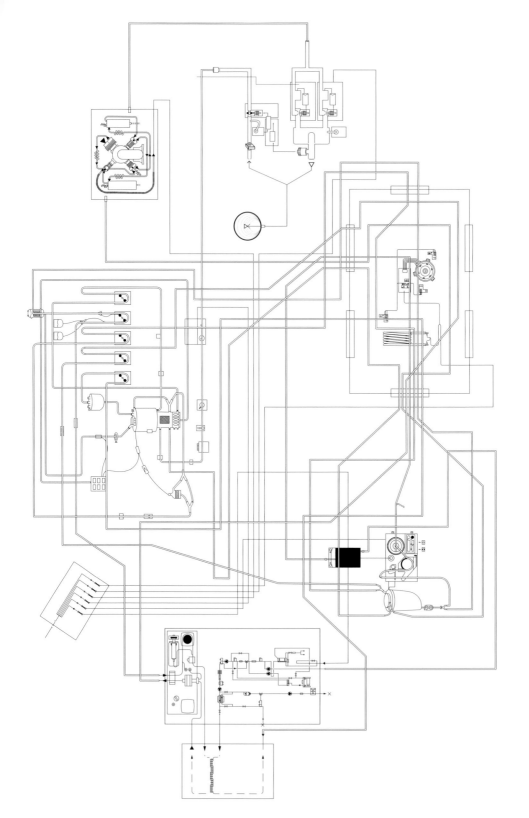

"Barometer Uses Shark Oil," Tripoint Gift News (blog). July 16, 2010, http://wwwtripointgiftnews.blogspot.com/ 2010/07/barometer-uses-shark-oil.html.

*

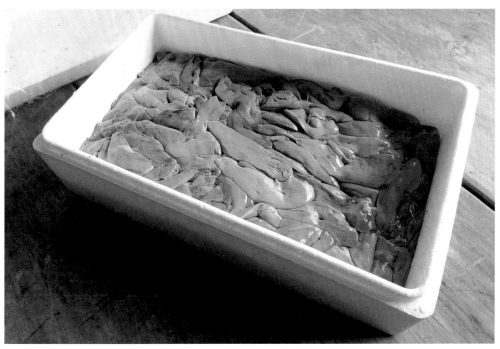

179

179
The Quiet 2015
Production documentation

Not 100% Scientific – Shark oil barometer.

The shark oil is extracted from the liver of the shark. The remainder of the liver that is left over for use in the shark hash is hung in the sun to allow for the heat to melt the liver and the pure shark oil drips into a collector and then placed into the bottle or vial. This is the only way that the shark oil will work properly.

Roger Barton might be able to provide a shark liver. He sells at the Billingsgate Fish Market and can be reached at xxxxxxxxxxxx.

Note from studio assistant Ben Ditzen, who spent a long hot August day melting shark livers

› 004, 241

178
The Immortal 2012
Anatomical drawing from
operation manuals
Digital drawing on paper
59 × 84 cm
› 175, 176

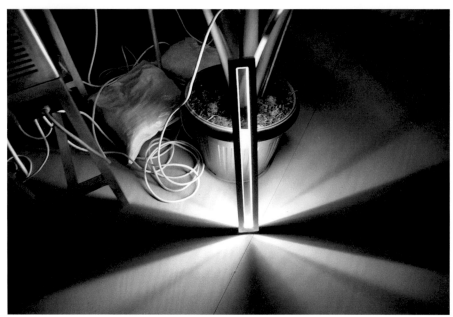

180

181

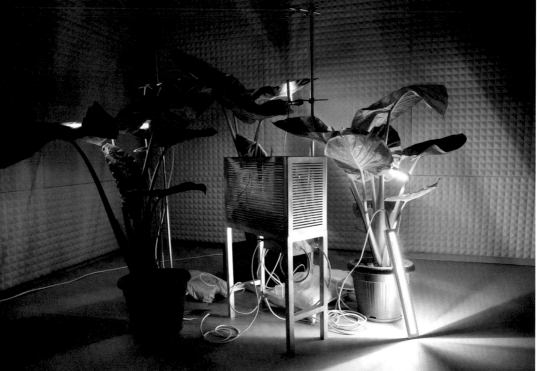

180-182
The Quiet 2015
Aluminum, electronics,
VOC chemicals, plants,
acoustic foam
Dimensions variable

Humidity increases; temperature
decreases/increases; positive ion
emission increases; volatile organic
compounds become more perceptible;
pressure drops; electromagnetic waves
change; noise decreases. These are
just some of the scientific conditions
responsible for the phenomenon known
as "the quiet before the storm."
For their installation The Quiet, the
artists assembled all of these invisi-
ble conditions, and many others, in
a small room, in an attempt to recreate
this natural, scientific, cultural,
historical, and, above all, elusive
phenomenon.*
Keren Goldberg, *The Invisible Aesthetics of Perception*

› 082, 150, 179

*

183

184

183–185
Rusty Knives 2013
Glass, steel, vinyl, hormones,
raspberry plants
200 × 60 × 200 cm

Stress and fear in animals that are
about to be slaughtered can change
the taste and color of their meat.
Cortisol, adrenaline, and lemon juice
slowly drip into ripening raspberries,
in a chemical reenactment of the
biological experience of violence.
By infusing berries with these stress
hormones, the installation attempts
to distill the taste of fear.

› 047, 181

Oil covers all surfaces. Oil slides down
my stomach, black grease rubs on everything
I touch. The dolphins play in the vessel's waves
at dusk, in 50,000 years their fossilized bones
will be buried in the depth, about to be turned
to oil. In the Captain's office I sit through
a slideshow of black-and-white photos of his
grandfather in Odessa standing in the mouth
of a dead whale. Oil everywhere.*

"I Know Nothing" in Christine Shaw, ed. *Logics of
Sense 2: Implications* (2016; Toronto: Blackwood Gallery,
University of Toronto 2020) 10-12

186
A crew member scarecrow
made to deter pirates,
on board the Dignity
container ship, 2016.
› 019, 189

A tick. The steel whale glides through the bay of Bengal, dissolved
gold pools on a sheet of stainless steel. Soil rolls down the side
of a mine and foam gathers at the bottom of the ship. A white horse
is grazing in the middle of a landscape that doesn't exist. Whale
again. The living quarters of a factory in Zhongshan, a red party
windmill spins in the breeze. A stray dog walks by the sign (White
Horse in Chinese). Factory floor techno. A worker is testing optic
fibers, another tests joysticks, LEDs blink in unison, a pile of Coltan
is spooned into a test tube. Green smoke demo in the middle of the
Hunan countryside, a miner hacks into the wall of a rock with a steel
rod. Machines push red soil into the bottom of cardboard tubes, in
preparation for gunpowder. On a conveyor belt firecracker cakes
are being pressed. The mouth of a volcano. Rumba starts to play.
Sunlight is playing in the bullet holes that pierce a sign directing to
the national Albert park, Virunga. A firecracker factory display for
potential customers. Children dancing in a colonial catholic school
performance. Fireworks explode in the quality control testing grounds
/ the flag waving vigorously in the boat's wind. LEDs blink on the
ship's deck, liquid silver glides on the steel. Stage effects are tested
in a parking lot and under a bridge, a map of East Kivu. LEDs flicker
in a phone charging shop in Numbi, gold particles flow in the wind.
Smoke tests in pink, yellow, green, purple and white. A mining town
of dust and steel / a priest leads two local boys up a mountain.
A boy stops in the street. The children perform in white clothes,
rubbing their eyes. The ship's stairs glow in changing colours,
a man is dressed as a ghost. Houses are reflected in the lake, the
boat passes a ship corroded by entropy. An unidentified phone call.
Children are dressed as mushrooms, now my father is the priest.
A glitch in Lake Kivu's water, liquid silver glides on stainless sheet.**

The super 8 films had been digitized by a hobbyist who offered this service to people in the neighborhood. A basic setup allowed the old man to film the projections and return the footage on a DVD, filtered by an occasional smoke cloud from his cigarette, his unhealthy coughing providing a strange soundtrack to the scenes of children playing in what would prove to be the last years of the colony. I had seen the films before, projected by my grand-father in the living room of their house in Antwerp, bringing to life the surrounding masks and carpets. Later in my life and remediated on DVD through a coughing smoke screen, the scenes elicit a different reading.

issolution (I Know Nothing) 2016
wo-channel video with sound
0:00 minutes
ilm still

Jnknown white horse in
R Congo, circa 1950s)

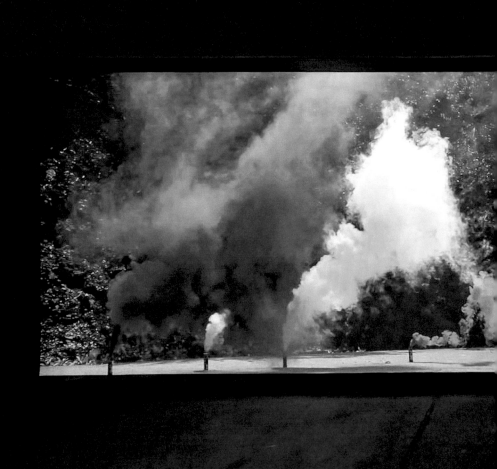

188
Dissolution (I Know Nothing) 2016
Installation view
The Blackwood Gallery, Toronto, 2019
Photograph by Toni Hafkenscheid
› 126, 189, 213

189

189–195
Dissolution (I Know Nothing) 2016
Two-channel video with sound
10:00 minutes

The footage used in Dissolution
(I Know Nothing) composes a form
of seascape, assembling fragmented
connections between material and
time from Congo, Rwanda, and across
the Indian Ocean on a containership
to China. Gunpowder, dissolved minerals,
blinking LEDs, personal and colonial
histories.

› 133, 137, 139

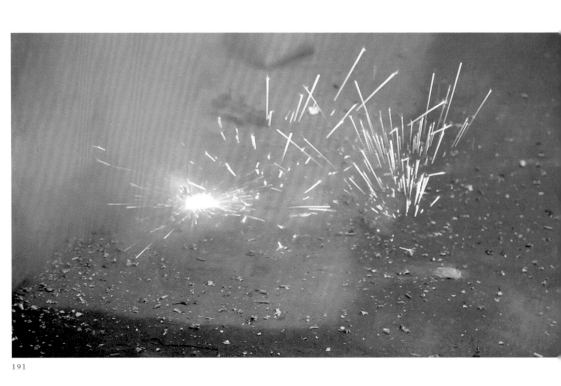

191

195

Both in Lingala and in local Swahili
"nguanzu" is slang for something of bad
quality, something that doesn't last,
named after Guangzhou, the city in
Southeast China where all the fake stuff
comes from. The ubiquitous clothes
and phones aren't the most concerning
of counterfeits: electrical supplies,
baby formula, and medicines (malaria,
even Ebola) wreak more havoc. My
phone is a "Samsung" and so I make
a new gmail address: nguanzu2000@
gmail.com.
› 092, 162, 189

196
New Donfranc Hotel,
Guangzhou, April, 2016.
› 089, 189

Roberto Castillo, a researcher of the African Diaspora in China, weaves his way through the narrow alleys and hallways of Chungking Mansions, a complex made up of three buildings in the centre of Hong Kong. Dirt cheap guesthouses are spread over the top 14 floors while the shopping arcades on the bottom mostly house import/export businesses dealing in parallel goods. The building is notorious for its lawlessness but drugs and sex are only the footnotes to the real business of mobile phones and cheap textiles. Quoting the anthropologist Gordon Mathews, Roberto speaks of Chungking Mansions as "a central node in low-end globalisation." Consisting of multiple informal supply chains, this form of globalisation arises when a product is cheaper in one country than in another or when there is no "official" distribution, creating a parallel market.

The market is always moving and now many Africans go to China for wholesale purchases, mostly in Dengfeng Cun, a sub-district of Guangzhou dubbed by locals as "Chocolate City." We stay at the New Donfranc hotel, more cheap rooms on top of a shopping centre dedicated to African trade. There are commercial scales in the hallways, a packing-tape shop in the lobby and piles of boxes everywhere. A business card holder is glued to the door of room 4001, advertising cargo shipping to Gabon. Downstairs, an endless display of mobile phones, LEDs and generators, TV monitors arranged in Droste effect, moulds for casting pseudo-Corinthian columns, and rooms filled with curtains of black hair.*

196

197

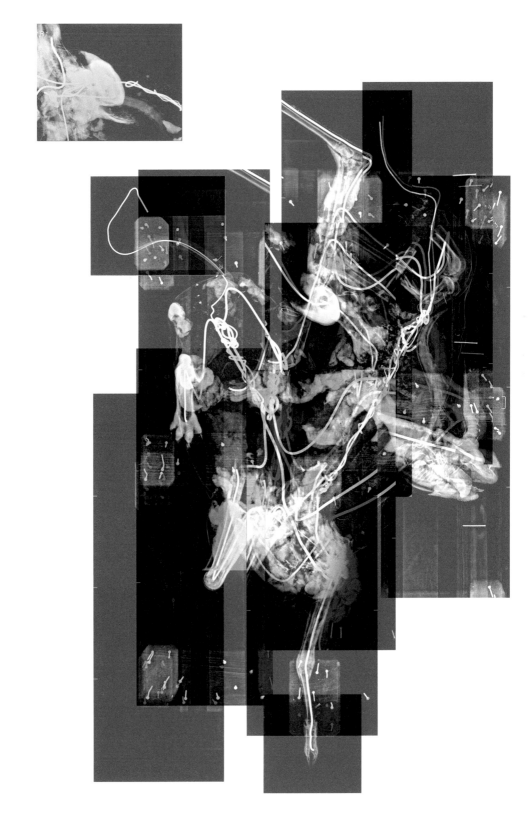

X-Ray Style
(*See also* Heart Line)

• Anthropomorph with bones and internal organs showing

Petroglyph, Reindeer, Eastern Siberia, and (below) pottery decoration, Pueblo Indians, North America

The X-ray style is without doubt an expression of the shamanistic view current among the early hunters that animals could be brought back to life from certain vitally important parts of the body. The mere portrayal of these vitally important parts or of the life line—a single line running from the mouth to the heart region—brought about the resuscitation or increase of animals . . . (the artists) no longer remembered the original meaning of the lines inside the outline, but gradually abstracted them; thus the drawing of the intestines became concentric circles or spirals (above) . . . the X-ray style . . . finds its dying echo in the ornamental art of the Pueblo Indians (below).
[Lommel 1967:129-132]

(Right) Petroglyphs, West Creek Canyon, Glen Canyon area, Utah

Style 2. . . . Heart is drawn on this (sheep) as it was on deer and antelope petroglyphs around Oraibi (Hopi Mesas, Arizona).
[Turner1963:48]

Petroglyphs, Washington State

Anthropomorph (with skeleton body) formerly located 10 miles from The Dalles on the Columbia River, has been destroyed by vandals. . . . Strong (1959:120) identifies this common stylistic element as the exposed rib motif.
[Ritter and Ritter 1972:102, 106-107]

Comment on X-ray style in rock art

A common theme in shamanism is the death, dismemberment, and rebirth that the shaman experiences in the initial trance states that occur when he is "called" by the supernatural powers. The experience sometimes is horrendous. The shaman, in his vision, may see himself reduced to bones, which are then reassembled and transformed into a new body. In this way the shaman is reborn into his new role as intermediary between his people and the spirit world. The skeletal motif is common in worldwide shamanic art and shamanic beings often are represented with their skeletons exposed. Contrary to common belief these are not death images, but symbols of shamanic rebirth.
[Hedges 1983:56]

214

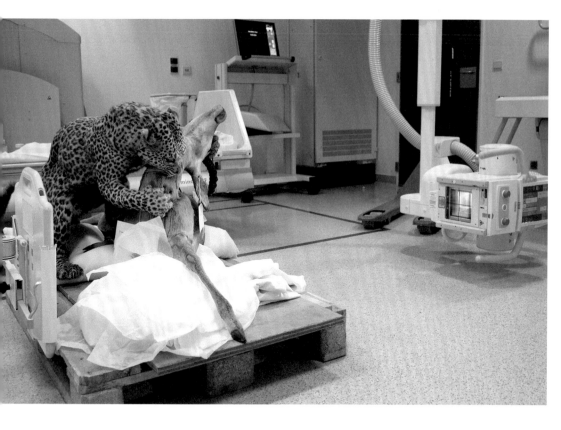

Leopard, Impala 2016
Rare earth neon, mammoth ivory,
natural rubber
152 × 84 × 63 cm

The steel structures uncovered inside
a diorama of a leopard killing an
impala are recreated in rare earth neon,
mammoth ivory, and natural rubber,
reconstructing an imagined choreo-
graphy between two animal skins in
the materials of contemporary mining
practices. Mining plays an important
role in maintaining a postcolonial
reality (and vice versa), where resources
are extracted from deep in the
Congolese soil to be distributed
throughout the world. The act of
mining for Siberian mammoth ivory
(a matter that exists between animal
and mineral) or rare earth phosphates
echoes the X-ray process: extraction
from below the surface—the surface
of the earth or the surface of the body.

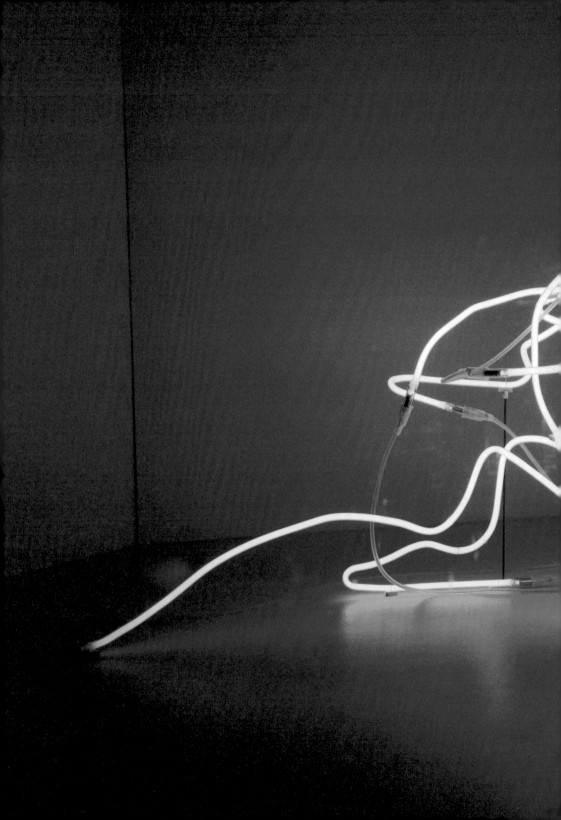

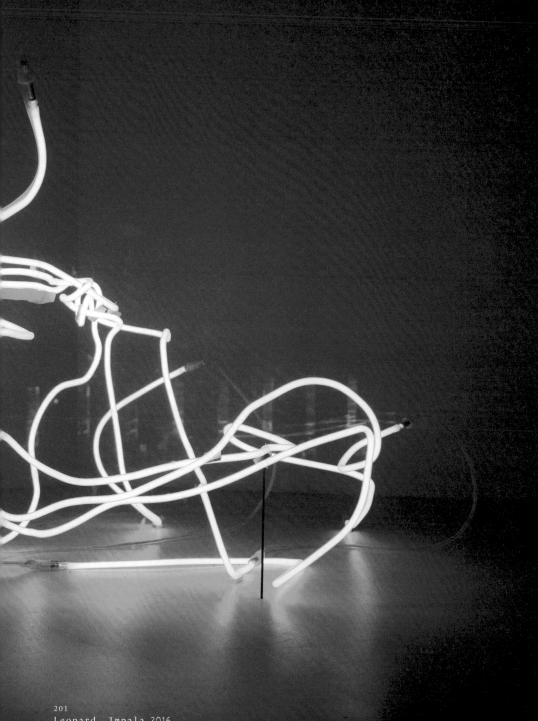

201
Leopard, Impala 2016
Rare earth neon, mammoth ivory,
natural rubber
152 × 84 × 63 cm
› 006, 061

Sunday morning, a pallet covered in a white bedsheet is silently
wheeled through a hospital corridor. A tiny black hoof peeks below
the fabric edge. The slow red line scans softly down the half
lion's frozen expression, a tag dangling from its jaw and spinning
in the air conditioning. The scene of slaughter glides on the
radiographic table, images of its internal scaffolding flick on
a side screen. Six men lift a gorilla that died in the 1900 onto
a floating platform, a telescope adjusts its angle, the room is
silent except for mechanical clicks and automatic gears.

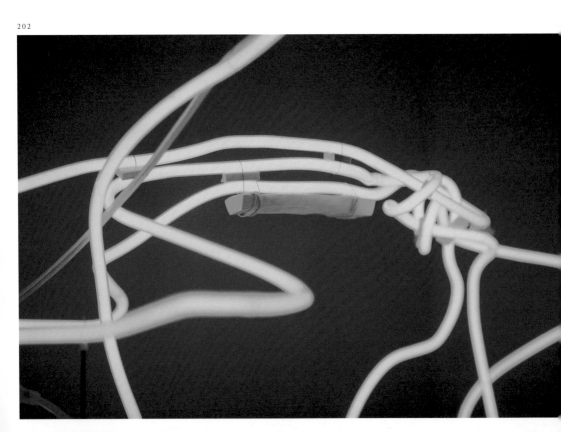

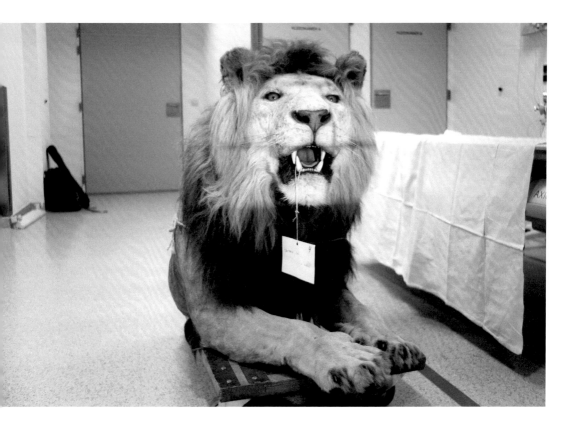

02
Leopard, Impala 2016
Detail
Rare earth neon, mammoth ivory,
natural rubber
52 × 84 × 63 cm
006, 199

03
Heart Lines 2016
Production documentation

(Museum tag spinning in
the hospital's AC)

061, 063

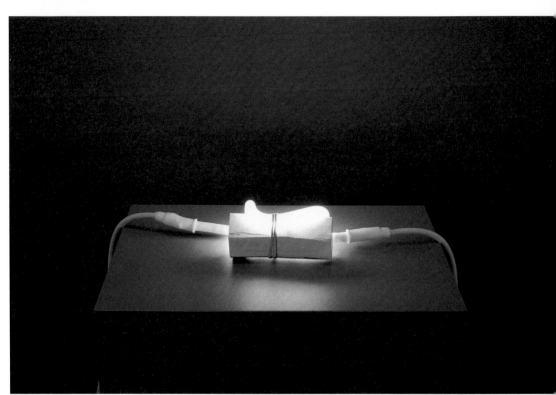

204

204
Vertebra (Neck) 2017
Rare earth neon, mammoth ivory,
natural rubber
19 × 8 × 6 cm

This material trinity—rare earth neon,
natural rubber, and mammoth ivory
—keeps coming back. All existing
somewhere between the organic and
the industrial, they carry a strange glow
of infatuation and greed. Rare earth
neon: glass tubes coated in metallic
elements that are neither rare nor earth
but become precious through politically
motivated, artificially produced scarcity.
Natural rubber: embodying a forest,
mass production, and the start of
exploitation. Mammoth ivory: a material
of the climate crisis, of warm inanimate
body parts that are revealed as the
snow in Siberia melts. I think of these
together as a core sample of sorts.

› 200 , 240

205
Trapped in the Dream
of the Other 2017
4k video with sound
20:00 minutes
Installation view
Mu.ZEE, Ostend, 2018
> 133, 220-228

a case of gunpowder apophenia
(or: where does this even start and why was
it meant to be?)

> Thinking of the soil in which virtual matter resides

> Then came the question of what a physical
 manifestation of a virtual environment can be
 (explosions seemed to resonate and be instantly
 recognized as a basic / early interactions with
 a screen-based environment (SEGA duck hunt?)

> Then, going into the manufacturing process of
 performative explosions (fireworks) and discovering
 there was soil used within them, a circuit was closed.
 (Soil, coltan, explosion, dipping in and out of a
 screen, alternating between virtual and material.)
 [The gunpowder can also be seen as a sort of
 protagonist of the supply chain connecting the two
 sites (DRC and China c. 2016): Containers would
 carry the minerals from DRC directly to China

> We asked what comes back in the containers
 coming back? Well, things, probably food, but also
 ammunition (bullets made in China to fit the old
 AK47s still present in the region).]

So: Soil, gunpowder, distance, connection.
 I know this all somehow makes sense.

206
Untitled (Almost Rubaya) 2016
Copper, nickel, gold, and tin on bronze
20 × 20 cm
> 129, 139

Enter the ring. The vans drive up the dirt road into the wide empty field. Standing on the tribune, managers wait armed with checklists on clipboards. As soon as dawn creeps in pyrotechnics start shooting from all vans, rapidly, chaotically, relentlessly. In this daily ritual hundreds of fireworks are tested simultaneously, staging an industrial spectacle that looks and sounds like a festive war zone.*

209

209
Numbi Coltan mine
South Kivu, DR Congo,
November, 2016.
› 133, 206

210
Gunpowder stars drum,
fireworks factory, Liuyang,
China, October 2014.
› 127, 133

Going up the mountain, the process of turning gunpowder
into stars unveils in reverse. Every stage in the assembly line
is performed under concrete canopies at least 20 meters apart
alongside the spiraling trail so if an accident happens the
whole operation doesn't vanish in a rapid series of explosions.
Liuyang city is loud, polluted, and grey, while in the silent
green mountainside open air mixers turn soil and chemicals
into industrial spectacles.

Going down the mountain daily, we catch a few minutes of
internet connection on the highest point that can carry a video
stream. Numbi mining town fades into the distance as we climb
the grassy green hills, following the men with shovels on their
way to the source. The image is pixelated and slow, the sound
robotic. From the other side this landscape is a broken
simulation, forever incomplete. *

210

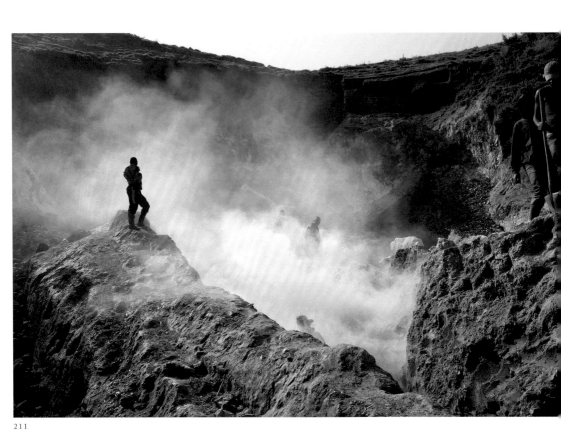

211

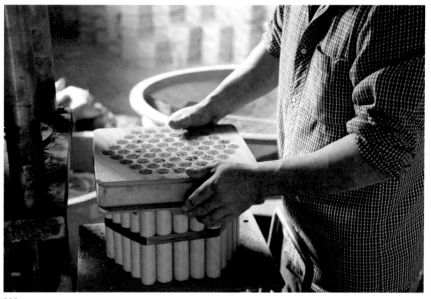

212

213

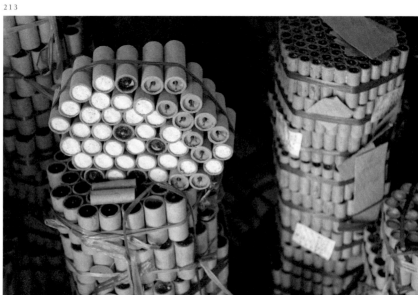

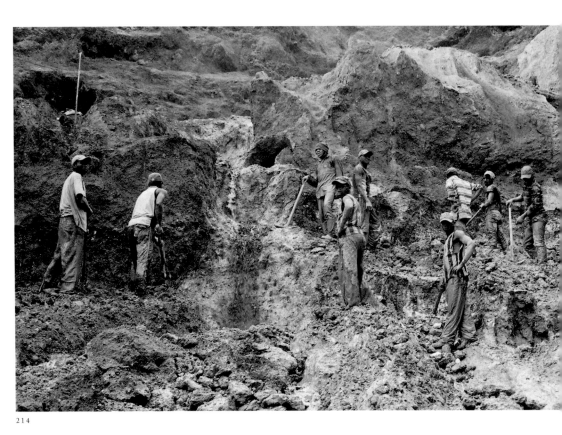

214

Artisanal mining in the DRC dates back to
colonial times, but has grown significantly
in the eastern part of the country since the
1970s, with the volume and value of artisanal
production exceeding that of industrial
production by the 1990s. The economy is
largely informal: very few miners and traders
are officially registered. Opaque conditions
make state oversight near impossible, leaving
armed groups (including state security
services) to profit from the region's mineral
wealth. Militias control some of the mines,
oversee collecting stations, run smuggling
networks, or simply put up roadblocks
charging trucks to pass. Digging down the
murky mineral supply chain, we find at its
source hundreds of thousands of 'creuseurs,'
extracting ores with rudimentary tools and
physical force under difficult working
conditions.

214
Artisanal coltan mine near
Numbi, South Kivu, DR Congo,
July, 2015.
› 133, 163

215-216
Fireworks factory, Liuyang, 2016.
› 127, 133

215

216

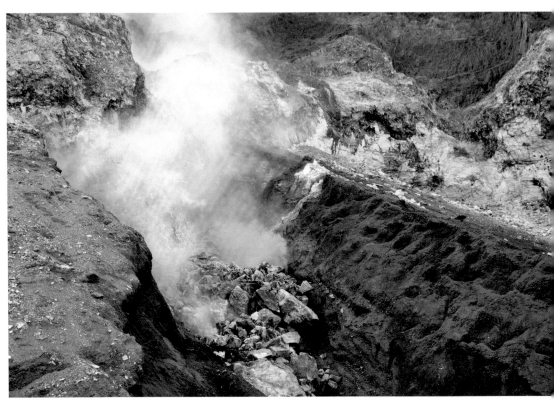

217

218

219

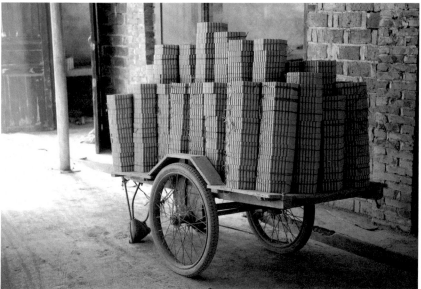

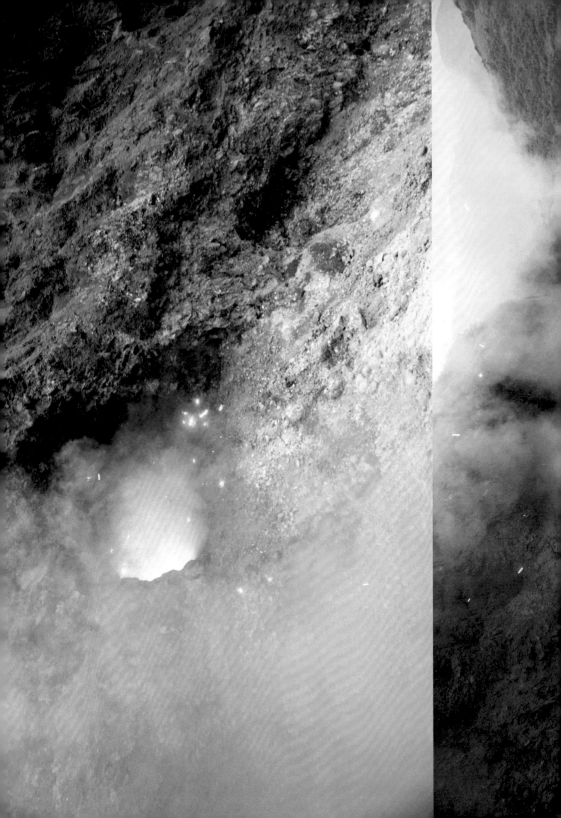

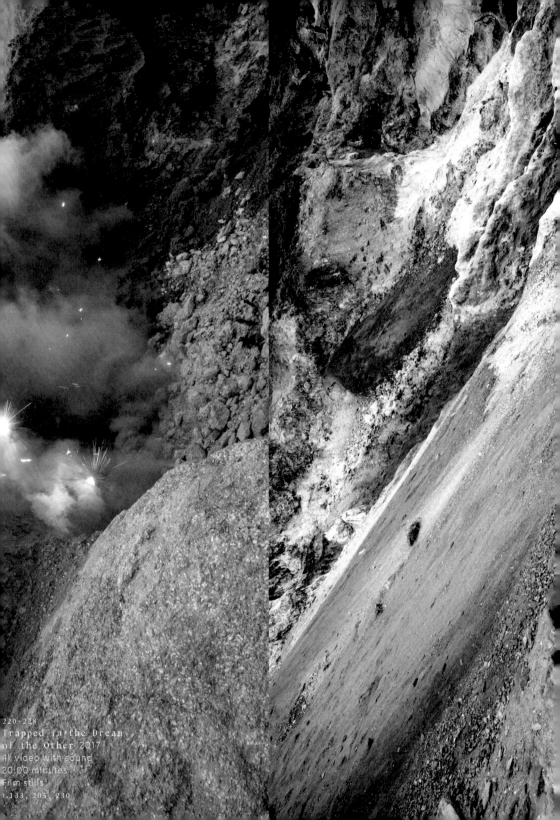

220-228
Trapped in the Dream
of the Other 2017
4K video with sound
20:00 minutes
Film stills
p.133, 205, 230

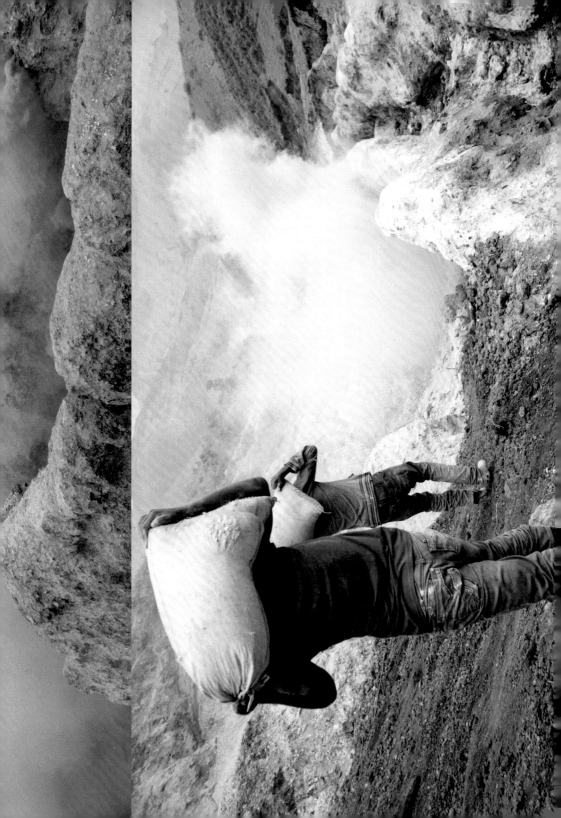

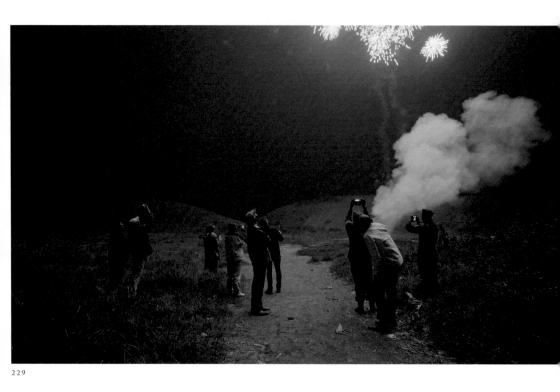

229

Trapped in the Dream
of the Other 2017
Production documentation
› 126, 133

That evening, after a long day of filming, it starts raining. Still unsure if a fireworks spectacle in a war-torn area is a good idea, we set up some flares just outside the village. The invitation clearly didn't travel much beyond the authorities whose initiative this was and the small crowd gathered makes it look more like a VIP event. Fire one arrow and the people will come, we're told. Or run away. It starts raining more and the only response to our first arrow is a gunshot in the hills. We're being rushed to shoot the remaining fireworks but the situation doesn't get better. More shots, a drunk soldier shows up waving his AK47 while we're trying to clear up and make our way back to the village.

It's the possibility of a problem that turns out more attractive than fireworks. We're soon surrounded by men, some drunk, some armed, who try to make the problem both bigger and theirs. There's an elaborate economy of problems here: problems are opportunities, they can be monetized through fines, taxes, bribes – the difference between which is often unclear.*

September 20th, 2016, an image by Agence
France Presse shows protests in Goma against
President Joseph Kabile and his refusal to resign.
The pink smoke looks a lot like the leftovers
from our production. I left them with Adolphe,
our fixer, so I check with him on WhatsApp.

"Goma is in the news today, with pink smoke.
Is it ours?"

"No, it is not ours. It cannot be, because I sold it." *

230
Photograph by
Mustafa Mulopwe/AFP
via Getty Images.
› 133, 134

Daisy Hildyard

When I was growing up in the rural north of England there was a quarry between my village and the nearest large town. Sometimes I walked out to the quarry to look at the view—the ground suddenly drops away, the path spirals downwards, sand martins make their homes in the loose walls. I had the sense there was a whole world inside this bowl: the space created where the land had been blasted away contained, in the negative, the presence of the globe. One day at school I was told that the gravel from local quarries was sent all over the world. It was being used to build a brand new city in China.

I was familiar, of course, with the words "Made in China." If I upended an ordinary household object—a pencil-case or broom—this acknowledgement would often appear, in relief, on the underside. The wording became so familiar, in fact, that I no longer noticed it. It was hiding in plain sight, and so I took it for granted, as I did with my other relative supports and privileges, like free healthcare or my parents. Sometimes something is so immediate that it becomes invisible. If there was a relationship between the new city built in China on top of my gravel and these imported objects in the kitchen and the bathroom, this wasn't a connection I knew how to make. It is only in the last few years that I have started to perceive how these things—the surface and its underside, the foreground and the background—might contain one another. In a recent work, the anthropologist Eduardo Kohn defines what he calls constitutive absence: the way living processes create one another in absence, "life grows in relationship to that which it is not."[1] The stakes of these mutual dependencies are critical: Kohn is talking of survival, super + vivre, "to live beyond life."[2] To survive is to continue after the death of another—survival defines itself by what it leaves behind. This is a form of self-definition that underpins all life processes and underwrites all our relationships of production, sustenance, and consumption. Co-creation, then, is not necessarily benign.

When I first saw Trapped in the Dream of the Other (2017), I was disturbed by the way it articulated this experience of connection that had been stuck in my throat for decades. The images, shot in painful definition from slightly below ground level, within the rushes of an open coltan mine in Kivu, DR Congo, mangled my sense of scale, flipped my stomach. I felt that I was inside a cut or scar on some massive body—green hills are visible all around, only the immediate foreground is bare earth—until, nearby, something explodes. The explosion

Eduardo Kohn, How Forests Think: Toward an Anthropology Beyond the Human (Berkeley, University of California Press, 2013), 217.
Kohn, How Forests Think, 217.

recurs, again and again, showering sparks, then colored smoke. At the end of the film, this smoke dissipates gradually, drifting away to reveal a wide landscape that had been all but obscured: river, hills, a person moving, a goat climbing deftly towards running water. The background is full of life.

The fireworks that created the explosions contained rare earth materials that had originated in the coltan mines of Kivu and were then sent to Liuyang, China, where they were used to manufacture the fireworks. *Trapped in the Dream of the Other* returns this earth to the earth— that is, the coltan was sent from Kivu to China, and the artists brought it home again, in its transformed state, to the ground from which it had been mined. Each firework's journey home will involve an absurd comedy of obstacles. Rubber stamps, email chains, dollar bills, shipping containers, walkie-talkies, polystyrene coffee-cups, Avtomat Kalashnikovas, thumbed bibles. Letting off fireworks in a war-zone, of course, is not a joke. Everything has its own resonance, more or less literally, in every local place. The laborious and weird odyssey of the fireworks to get "back" to their Ithaca made me see what objects and bodies go through when they are put through industrial processes. We all go through these processes, in our differently situated and local ways. What the film looks like to me is a form of negative portraiture—a life that is created through its relationships to that which it is not. I know, of course, about the rare earth metals that are inside my own smartphone, and I know, more or less, how they got there. I know that these materials are inside my phone in a different way from the other things that are inside it: my emails, my notes, pictures of my children.

Revital and Tuur and I happened to be in Cambridge on the same day this year. It was early spring. I was there to give a talk to architecture students, and the artists were visiting the national stud farm for horses at Newmarket. They had hoped to film thoroughbred inseminations but couldn't because there were not, the breeders said, enough good mares. The stud farm, in fact, had already been their second choice; their original plan was to travel to Macau for another new film, but this had been cancelled because of a virus that had spread from a bat to a pangolin to a live animal market in the Chinese city of Wuhan, to the human population of Hubei province. From there it moved through China and into South Korea and Iran; the first cases in Europe

had recently been confirmed, and it had arrived inside the café we were in: the people at the next table were talking about it. New phrases made themselves audible above the general murmur. Pre-existing conditions; viral load; daily deaths. I spooned loose-leaf tea into a silk strainer.

Revital and Tuur and I discussed their ongoing work. We talked about the dancers at the Macau casino and the casino owner's investments in Israel and the USA, about gambling in the political process, about the afterlives of the albino goldfish that the artists had created for *Sterile* (2014), about dioramas of Congolese animals in the natural history museum in Brussels. It's never really possible to separate a work from its environment, and so we also talked, of course, about circumstances: not only the virus but also the ongoing university strikes, awkward childcare arrangements, the situation of workers in Kivu, about Revital's experience of watching Tuur and his brother filming in Kivu from home in London—she was pregnant and unable to travel—working where possible through a stuttering livestream that connected them to each other through satellite.

One thing that seems vital to their process is this commitment to a various and sometimes bewildering reality. The real world pours out of their work, not as some resolved subject that has been sculpted into the artist's vision but as something more willful and troubling. Their subjects—a goldfish, a machine, a mine, a factory floor full of dancing workers—exceed my perception of them, and the excess is practically infinite. Previously, I thought of the blind spot as some narrow parameter of my visual field. Here, it becomes apparent that many of our blind spots effectively eclipse most of the world. Reality is queerer and more psychedelic than the diminished or narrative version that is the inevitable outcome of any artist's attempt to dream up the other in their own image.

There is an assumption that runs through many aspects of life, though, that this wild reality is more than the human mind can cope with. It is manifested not only in those places that lie at the peripheries of vision—the background, the distance—but is also inscribed on the most intimate parts of every human body. In Cambridge we talked about Caesarian sections, and how the mother is unable to look into her own body as she gives birth because a small cloth screen is placed between

her eyes and her womb. The assumption is that seeing the inside of her body is more than a woman's mind can cope with. Tuur described the Caesarian operation as a well-rehearsed choreography: the screen is raised and lowered in such a way as to reveal the baby while simultaneously concealing where the baby comes from. He compared this process to the black box logic of engineering, which disconnects each phase of production from its history.

There is an association between these two forms of disconnection: they both conceal bloody origins from human eyes. What Tuur said reminded me of Anna Tsing's writing on the global circulation of goods—that each circulated object, as it moves away from its connections in a particular and local way of life, has "to be disembedded from those connections in a messy process of translation." "There is room here," writes Tsing, "for imagining other worlds."[3] I couldn't think of a better description for what is happening in Revital's and Tuur's work than this: moving within connections and translations to create new room—to imagine new worlds. This creation is always also a form of negation, a stepping back, allowing a process, rather than a product, to come into being. It is a pointed reversal of the way the world usually works, like the act of putting minerals back into the ground they came from or creating an object whose only purpose is to point back to the process of its own creation. One of the last of their works I saw was one of their earliest, *75 Watt* (2013), in which workers on a factory floor transform, bodily, into a dance of production for a mysterious technological object whose function is only to choreograph that dance. The human bodies shape themselves around the technology they create and the technology's functionality is a process of relating to their movements. What I noticed here was this attention, which runs throughout the artists' work, to the grace and violence of living machinery—what it takes to dance, mine, conceive, or engineer something, and what these processes take back. This concern for these specifics looks like a new form of love.

Sensei Ichi-gō 2014
Technical drawing
178 , 233

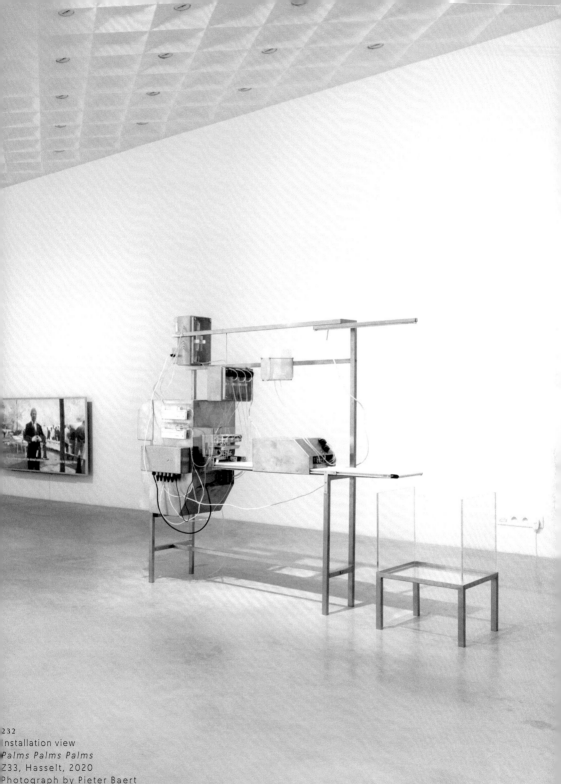

Installation view
Palms Palms Palms
Z33, Hasselt, 2020
Photograph by Pieter Baert
→ 051, 117, 233

- 1 – collect sperm and eggs
- keep male and female fish
- feed fish
- ? induce ovulation
- take male fish out of water
- collect sperm
- dilute sperm
- take female fish out of water
- collect eggs
- 2 – fertilize eggs
- add sperm to eggs
- mix sperm and egg
- transfer fertilized eggs into petri-dish
- ? rinse fertilized eggs
- dechorionate fertilized eggs
- 3 – incubate
- (opt.) get egg white
- (opt.) make egg-white solution
- transfer dechorionated eggs to egg-white solution
- store in Incubator at 20°C
- 4 – inject morpholinos
- transfer eggs to injection-plate / petri-dish with embryos (under microscope)
- (opt.) making needles for injecting
- load morpholinos into eppendorf celltram
- insert morpholino into PGC (Primordial Germ Cells)
- 5 – raise embryos
- check rodamine fluorescence
- transfer successful embryos to culture plate
- incubate
- transfer to culture plate
- incubate
- hatching
- transfer to small glass aquarium after 2-3 days
- transfer to larger aquarium
- Extra
- Kimura system
- growth phases and durations

233
Sensei Ichi-gō 2014
Detail
Stainless steel, electronics, acrylic,
glass, vinyl, nylon
200 × 170 × 450 cm

A machine capable of producing sterile
goldfish in an automated reenactment
of Professor Yamaha's movements and
actions. A contraption with its own
(dormant) choreography, the machine
acts as a potential reproductive organ.

The machine is built to automate and
run a linear process of extracting sperm
and eggs from parent fish, fertilizing
and rinsing them, injecting them with
morpholinos, and incubating the eggs
until they hatch. We plan to design and
build it to work but have no intentions
to turn it on or actually use it to
manufacture more fish. As such, the
machine aims to give form and physical
substance to this conceptual and
technological potential, rather than
to act upon it.

› 051, 055, 176

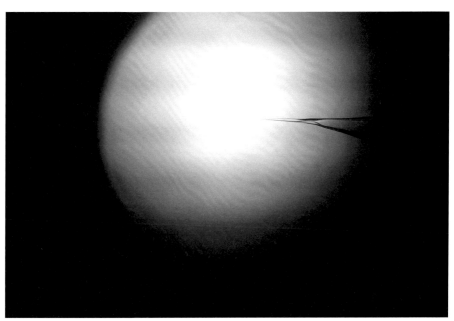

235

Dear Mis Revital Cohen,
First of all, I would like to apologise for my delayed
reply. Actually, after last e-mail, I send your e-mail
some my Ph.D members and discussed your real
intention about your project. Because, we wonder
at your project as we Japanese know that your royal
family hate Living Modified Organisms. Although
they were interested in your arts, I could not
get good answer from my PD about your request.
My first question is "why goldfish?" and the second
is "why sterile?" Let's start.

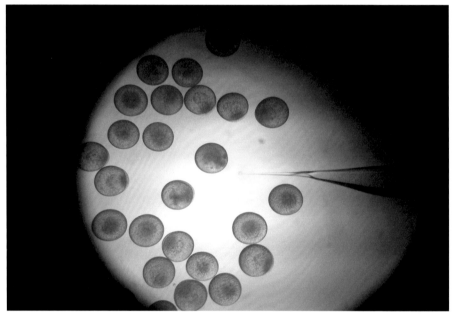

7

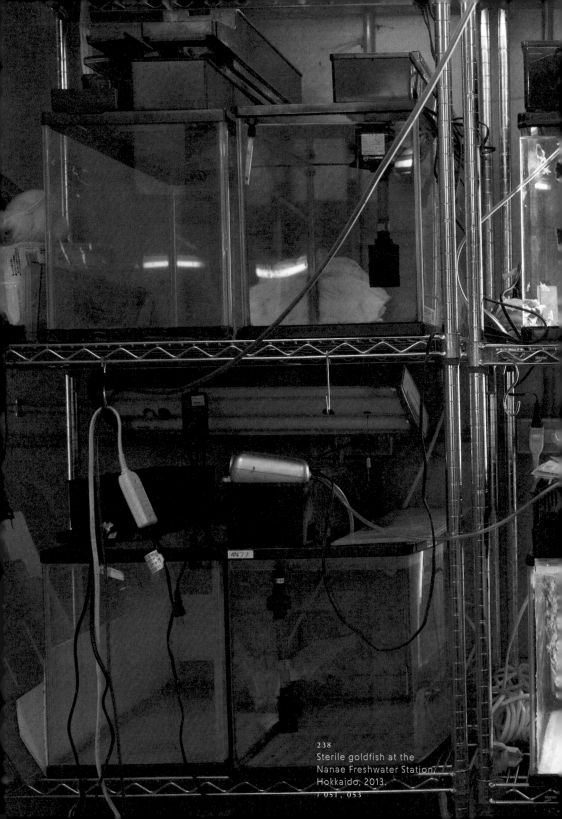

238
Sterile goldfish at the
Nanae Freshwater Station,
Hokkaido, 2013.
> 051, 053

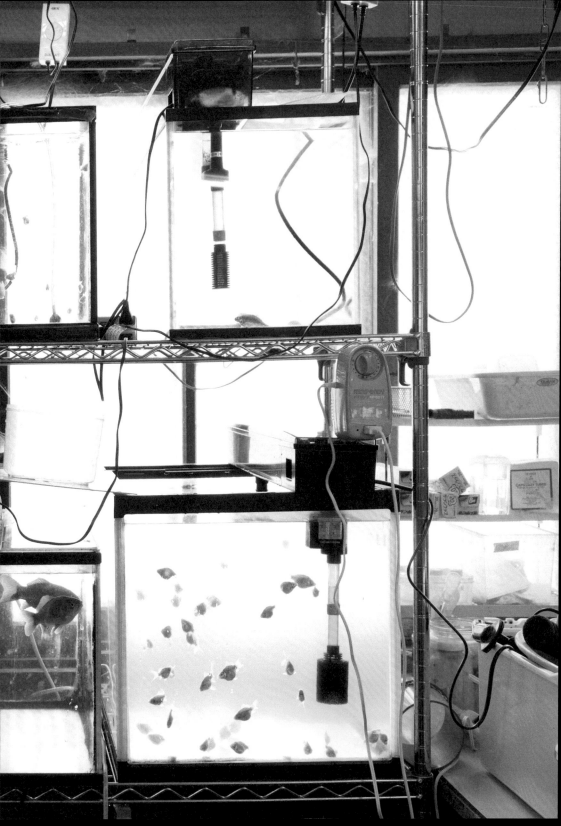

Date: December 12, 2011
Subject: Sterile Carassius auratus
From: Revital

Dear Dr. Yamaha,
山羽博士

Thank you very much for your reply! I am so
very happy and grateful that you agree to start a
conversation about this project. Apologies for
the delayed response, I wanted to make sure I can
explain myself well.
お返事、大変ありがとうございます。私のプロジェクトについて、お話を
進めていただける旨、大変うれしく存じます。お返事遅れて大変申し訳あ
りません、きちんとしたお返事を書くのに時間がかかってしまいました。

The real intention about the project is to question
the changing definitions of nature and product.
I am very curious by the pet industry and the way
domestic animals have been designed through
breeding. I was wondering why people are afraid
of genetic modification in a laboratory but not of
modification through selective breeding? From the
many product-animals, pets are most interesting
to me because they are animals modified mostly
for aesthetic reasons.
このプロジェクトの本当の目的は、自然と製品の変わりゆく定義に問いか
ける、というものです。私はペット業界、そして家畜ペットが繁殖によ
ってデザインされていくことにとても興味があります。どうして私達人
間は研究室で行われる遺伝子操作には恐れるのに、品種改良のための繁
殖は平気なんだろう。このようなたくさんの製品動物の中でも、私にとっ
ては、外見のためだけに改良されたペットに一番の興味を抱いています。

"why goldfish?"
なぜ金魚なのか?

I want to make a goldfish (and not Meduka or
zebrafish which are available in UK laboratories)
because goldfish have a true relationship with
people.
のようなイギリスで改良されている種ではなく、人間とのかかわり合い
が深い、金魚をプロジェクトの焦点にしたいと思っております。

They are already living modified organisms – bred
over generations to be beautiful, and we keep them
as pets, love them and invite them to live in our
homes. Goldfish also appear in legends and beliefs,
and are symbolic and significant culturally. Goldfish
can easily fall into the category of cheap consuma-
bles, and I think they are a perfect example of an
organism which can be defined both as a designed
product and an animal. They also tell the story of
fish domestication, of designing animals through
breeding a genetic mutation and of domestic
amateur biotechnology.

金魚は既に遺伝子操作された生物です。美しくするため何世代も改良され、私達はペットとして飼い、愛し、そして私達の家族の一部として扱います。金魚は伝説や信仰などにも登場し、シンボルとなり、また文化の一部になっています。金魚は安価な日常品に容易く劣化することもあり、私にとって、金魚は、”デザインされた製品”と”動物”という両方の定義を持った生物の完璧な例だと思います。また金魚は遺伝子操作と家庭でのアマチュアバイオテクノロジーを通してデザインされた、”魚の家畜化”というストーリーを伝えます。

"why sterile?"
なぜ 無菌なのか?

Most pets designed through selective breeding
are sterilized after birth. This is an important stage
of turning an animal into a product (stopping
uncontrolled reproduction = protecting copyright).
I want to highlight this logic through the design
and creation of an animal born without reproductive
organs at all, a biological product in essence.
By doing so I hope to explore the meaning of
infertility, the classification and perception of an
organism which is not a link in a chain but a being
which encapsulates both the beginning and the
end of its existence.
選抜育種によって設計されたほとんどのペットは、出生後に滅菌されています。これは動物を製品に変えるという観点の上で大切な過程です(制御不能な複製を停止＝著作権の保護)。私は生殖機能なして産まれた、さらに生物学上の製品である動物のデザイン、創作を通してこの過程を焦点に当てたいのです。そうすることによって、私は不妊、分類および、生命存在の始まりと終わりの両方を持っている有機体の知覚の意味について探求したいと思っております。

I also wonder if a species that does not depend
on sexual reproduction is in some way protected
from extinction. Maybe a breed has better chances
of survival if it enjoys a commercial success and
is reproduced according to rules of supply and
demand? I wonder if the evolution of the animals
of the future would rely on a good business plan,
free from the uncertain dependency on the complex
networks of nature?
もしある種が有性生殖に頼らなかったら、絶滅の危機から守られているのだろうか。未来の動物の進化は、複雑な自然から解放され、需要と供給のルールに従ってできたビジネスプランに頼ることになるのであろうか?

I would love to hear what you think, and be happy
to answer more questions or explain
things further.

I hope to hear from you soon!
Best wishes

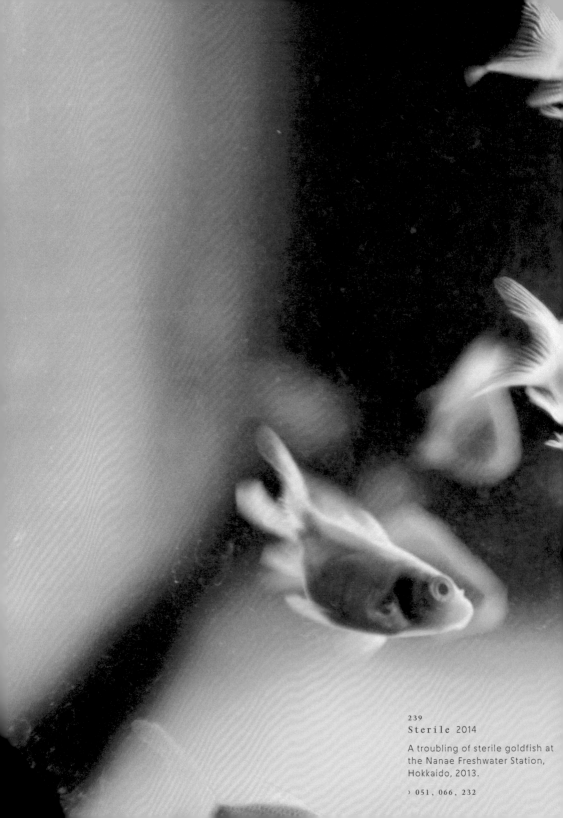

239
Sterile 2014

A troubling of sterile goldfish at
the Nanae Freshwater Station,
Hokkaido, 2013.

> 051, 066, 232

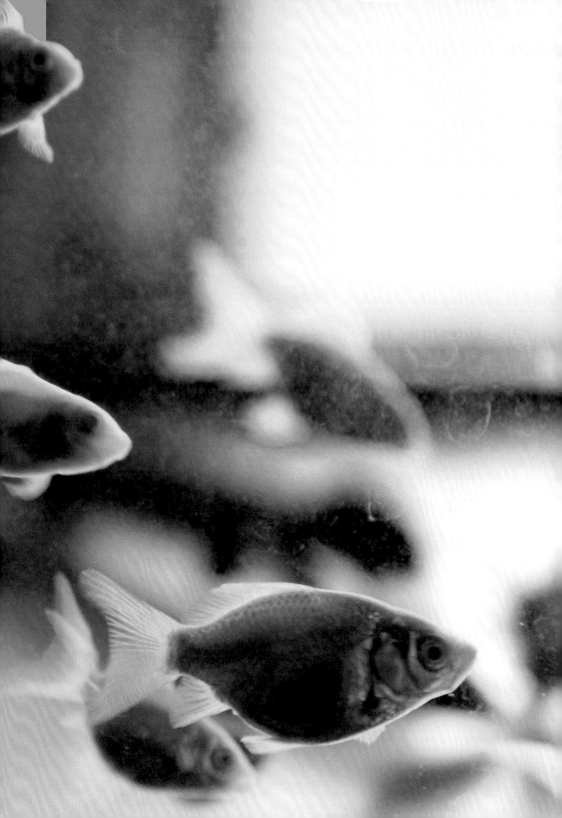

The tusk rush is driven not by ancient callings
but by powerful modern forces: the collapse of the
Soviet Union and the ensuing frenzy of frontier
capitalism, the international ban on trading
elephant ivory and the search for alternatives,
even the advent of global warming. Rising tempera-
tures helped seal the mammoths' fate near the end
of the last ice age by shrinking and drowning their
grassland habitats, leaving herds stranded on
the isolated islands where Gorokhov now hunts.
Today the thawing and erosion of the mammoth's
permafrost graveyard—and the rush of tusk hunters
—are helping bring them back.*

Brook Larmer, "Of Mammoths and Men"

Daniel Stiles, an ivory analyst, believes that,
in recent years, the ivory market in China has
been driven not by the upwardly mobile middle class
but by speculators betting on the extinction of
elephants, which would drive prices still higher.**

Peter Canby, "China and the Closing of the Ivory Trade"

Brook Larmer, "Of Mammoths and Men," *National Geographic* 223, no. 4 (April 2003): 45–46.

Peter Canby, "China and the Closing of the Ivory Trade," *New Yorker*, June 13, 2017

*

241

ANTVERPIA – LIBERTY Ltd
Service Centre for Domestic Animals
Crematorium for Pet Animals
Herentalsebaan 170
B-2240 VIERSEL – ZANDHOVEN
Tel. 03/484.42.38 www.antverpialiberty.be
BNP Paribas Fortis BE22230022497047
BIC GEBABEBB TVA BE447.833.360
OVAM 41219-1/108 VO 1069/2009

Mr Van Balen
26 Eagle Mansions Salcombe Road
N 168 Au London

Dear Family,

Re: Cremation of *elephant tusk*

Antverpia-Liberty, the Crematorium for Domestic Animals, has received your request for the cremation of your pet animal.

With this letter we confirm that we effectuated the cremation on *28th April 2017*

We thank you for your confidence in our company and wish you a lot of courage in these difficult days.

Yours sincerely,

Antverpia-Liberty
Mrs Schrijvers-Penninck

Viersel, *28-04-2017*

Huisdierencrematorium
ANTVERPIA - LIBERTY bvba
Herentalsebaan 170
2240 Zandhoven - Viersel
Tel: 03 / 484 42 38 Fax: 03 / 385 04 39
www.antverpialiberty.be

242

Costs: *done*

242
Pet crematorium certificate.

(Wish you a lot of courage in these difficult days)

› 129, 246

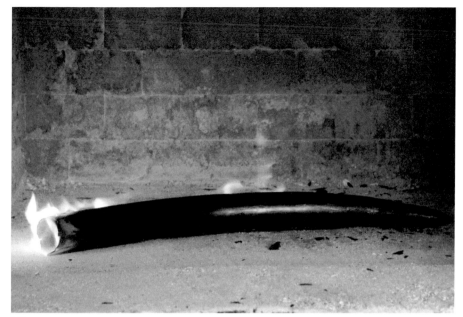

243

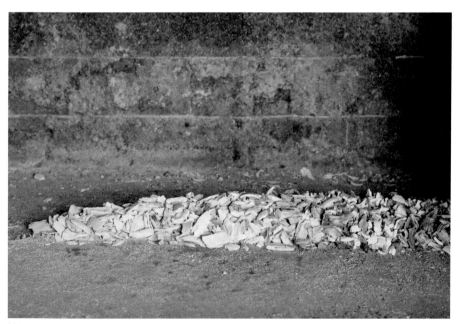

244

243–244
Forevers 2017
Production documentation
> 146, 204, 246

GIA®

GIA SYNTHETIC DIAMOND REPORT

August 09, 2017

Report Type Grading Report

GIA Report Number 2185661158

Identification Laboratory Grown*

Shape and Cutting Style Round Brilliant

Measurements 5.85 - 5.92 x 3.64 mm

Carat Weight 0.78 carat

Color Grade Near Colorless

Clarity Grade Very Slightly Included

Cut Grade Excellent

Polish .. Very Good

Symmetry Very Good

Fluorescence None

Inscription(s): GIA 2185661158. LABORATORY GROWN.
ALX0517UKLG04380-1

Comments: Additional growth remnants are not shown.

Surface graining is not shown.

*This is a man-made diamond and has been produced in a laboratory.

GIA REPORT
2185661158

ADDITIONAL INFORMATION

PROPORTIONS

50%
58%
medium - slightly thick 3.5%
15.0%
35.0%
61.9%
43.5%
41.0%
80%
none

Profile to actual proportions

CLARITY CHARACTERISTICS

KEY TO SYMBOLS*

○ Growth Remnant
\ Growth Remnant

GIA SYNTHETIC COLOR SCALE	GIA SYNTHETIC CLARITY SCALE	GIA CUT SCALE
COLORLESS	FLAWLESS	EXCELLENT
	INTERNALLY FLAWLESS	
NEAR COLORLESS	VERY VERY SLIGHTLY INCLUDED	VERY GOOD
FAINT	VERY SLIGHTLY INCLUDED	GOOD
VERY LIGHT	SLIGHTLY INCLUDED	FAIR
LIGHT	INCLUDED	POOR

reportcheck.gia.edu

3000509647

SYN

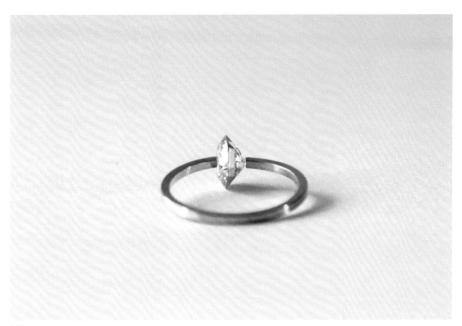

246

246
Forevers 2017
Artificial diamond from
elephant tusk, gold
17 × 19 × 5 mm

The ivory tusk of a Congolese baby
elephant, one half of a set from a
Belgian family heirloom, was burnt at a
pet crematorium. The tusk is a relic from
a region still torn by the desire for
diamonds, gold, and other natural
resources.

From the ashes of the ivory an artificial
diamond was made, turning the carbon
into a form of fossil. The impending
extinction of elephants—intentionally
accelerated in order to increase the
value of ivory—contrasts with the
promise of eternity in the ring, reflecting
practices of artificial scarcity at the
root of the diamond industry.

The diamond is set as an ouroboros in
a mass-produced gold ring, echoing the
historical role of ivory as the matter that
initiated the colonization of Congo and
the alchemical symbol of eternal unity
of all things.

245
Forevers 2017
GIA report.

› 246

› 098, 133

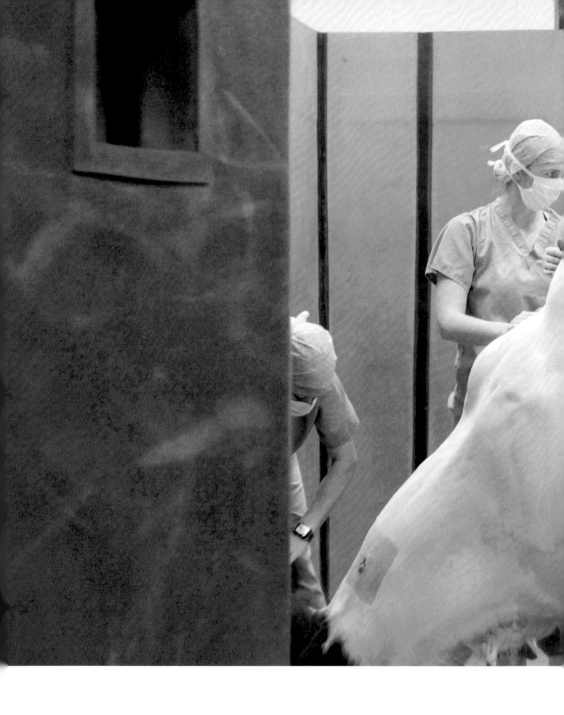

247
Knockdown box, Newmarket,
UK, 2018.

(*K / Special K / Super K /
Vitamin K / Donkey Dust*)

› 023, 036–044

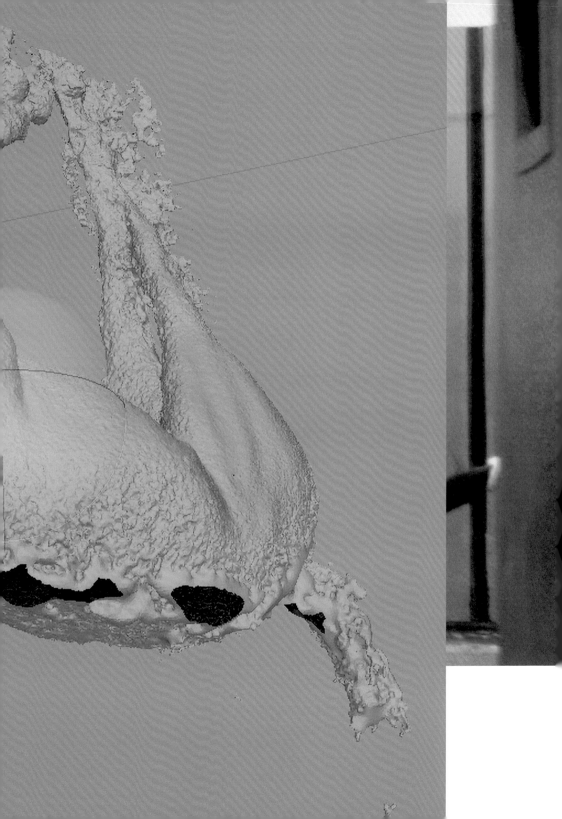

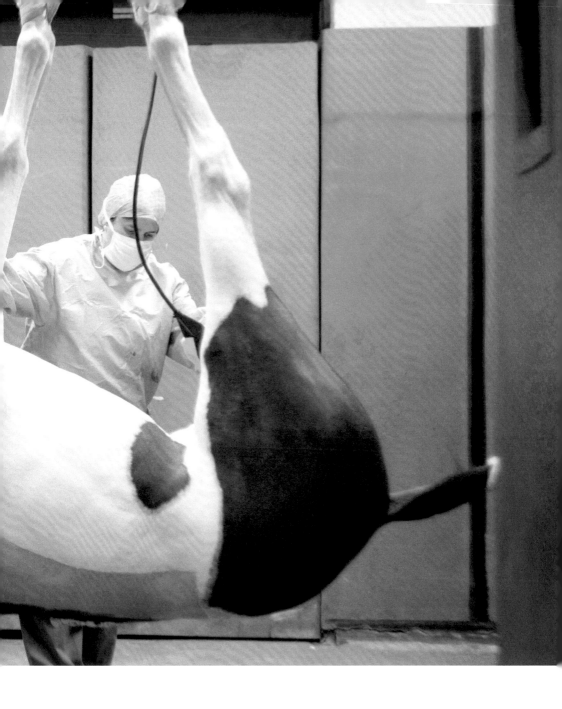

248
The Fall 2019
3D model from scan

(*AKA the sugar cube*)

› 023, 026, 257

…as a symptom of the contemporary condition
(or perhaps, gambling is the contemporary condition);
a state of mind, a prominent gesture, practice and
ideology in both contemporary politics and art.
A manifestation of delusion, grandeur and the belief
of fantasy materialising. Why do times of uncertainty
call for irrational behaviour. Why is every other
shop in our street for betting, why did 52% of this
country prefer to jump into the unknown rather than
stay in the union, why do we trust our future to… *

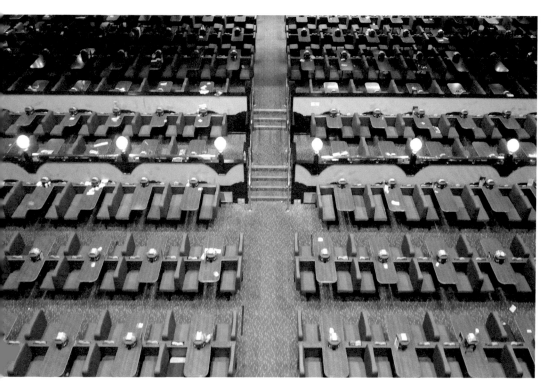

49
The Odds (Part 1) 2019
Film still

Desk bells are ringing)

023, 031–034

Revised Version

Welcome to Kensal Green. Welcome everyone! Please take your
seats as we are just about to start! We are going to begin tonight's
session with some quick party Xtra Games! Love to have you
involved. It would be a crappy £150 fee. I'm sorry! But you can
do what you like.

So there's the first number. 150 is your first number out on this
game. We are looking for a full house and don't forget that the red
lines are absolutely free on this game. 150 pounds to imagine
socialism.

150 is your first number and the next number is (pause...) 11 – 1
and 1 – 11 – legs! Eleven pounds for two E-Goal Super Bright Red
LED strips. 1 and 1, two lines, two red lines on this game.

11 is the number. And here's your next number... 49, 4, and 9 for a
professional bingo caller. 49 pounds to hire a professional bingo
caller from Gala Bingo to come and read at your game. Gala Bingo,
the happy makers to the nation. 4 and 9 for a professional bingo
caller. 49, almost a bull's eye! A professional bingo caller to call
your enemy. Do we have a claim? Board 356 on your A card?
The lucky winner, freed of everything that upsets you.

We are playing for two lines now. Two lines. First number was 150.
150 pounds. Next number 11 pounds for the two red lines. Followed
by 4 and 9, 49 for the bingo caller. 150 – 11 – 49

That leaves us with your final number. Your final number is... 90!
Top of the Shop! Put your money where your mouth is, put your
money where your heart is! What else can art do for politics?
9 and 0, 90 pounds donation to xxxxxxxxxxxxxx, a new kind
of politics. Imagine socialism. 9 and 0 to ask yourself who then
would be really upset.*

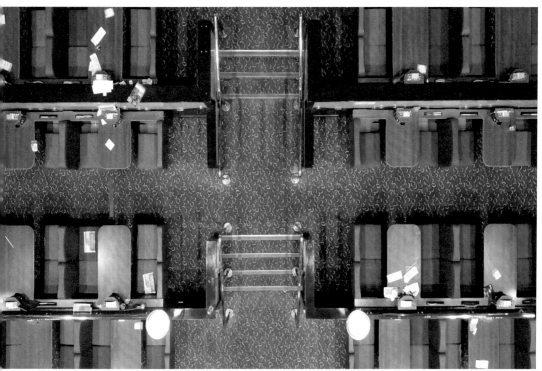

250
The Odds (Part 1) 2019
Film still

*Integrated mirage)

023, 031-034

A trance-like soundscape hangs in the air, oxygen
levels are raised as the lights occasionally break
into blinking patterns echoing the "siren song"
of a slot machine display (The Dancefloor, 2019).
A scent commissioned from a marketing company
(The Restraint, 2019) overlays musk with synthetic
molecules that mimic human pheromones and
the stress-like smell of the Dead Horse Arum Lily.*

Taking inspiration from Brown and Venturi's
Learning from Las Vegas as much as Brian
O'Doherty's *Inside the White Cube*—both examining
how spaces are conferred symbolic meaning and
structures—the exhibition is arranged as a space
in which the lighting, sound, scent and atmosphere
all follow subliminal strategies devised by the
gambling industry.

*

51

The Odds (Part 1) 2019
Film still

(Indoor palms, chlorine canals)

023, 031-034

252
The Rise 2020
Holy water, haze machine
720 minutes

The Dancefloor 2019
Programmed gallery striplights
Dimensions variable

In **The Dancefloor**, exhibition
lights are programmed to
occasionally break into blinking
patterns echoing the "siren song"
of a slot machine display.

Installation view
Palms Palms Palms
Z33 Hasselt, 2020
Photograph by Pieter Baert

› 023, 047, 254

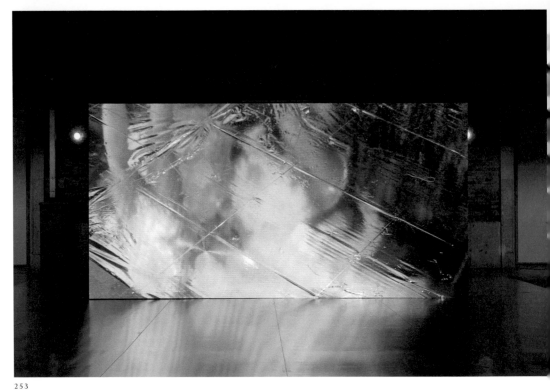

253

The Odds (Part 1) 2019
Installation view
re-creatures
Mattatoio, Rome
› 023, 047

Sensory Atmospherics:

Memory formation

This specific feeling of abnormal meaningfulness.

They know they will lose

 Dead horse arum lily for a faint smell of the sea.

Full-length mirrors reflecting the foyer

columns and creating an illusion of endless space.

It seems clear that consciousness is not required for a conditioned response.

 Iso E Super for a pheromone-like effect.

The player is not constantly losing but constantly nearly winning.

Do not vary in volume and rhythm to orchestrate action.

 Touch me not to add naturalness for soothing and lingering.

Remain below the threshold of consciousness.

Forgive us we are high on small luxuries.*

Brief for **The Restraint**:

The fragrance is for an art exhibition. It should be unique, restrained, complex, light, not sweet or with a recognisable source.

The fragrance should smell clean, subtle, intriguing, it should feel addictive but not quite recognisable, with animal and sea undertones.

Ingredients we would like to have:

- Dimethyl Sulphide (dead horse arum) – must be included – for a faint smell of the sea
- Iso E Super – must be included – for a pheromone-like effect
- musk – would like to but can discuss – for smelling 'white'
- a light floral note – Jasmin? – for a touch of indole (sex)

From the samples we received: perhaps somewhere between *Stone* and *Animalic*. Definitely not *Powder*.

Date: April 17, 2019
Subject: Re: Exhibition scent
From: Aromaco

This new version has seen a decrease in musk + ingredients that connotate cold + empty emotions. I am hoping this fits your brief. When wafted I envisage an empty white gallery, that when diffused I think will be perfect for your needs.

Look forward to feedback

Sasha

The Restraint 2019
Scent
200 hours

A scent commissioned from a marketing company for a gallery space.

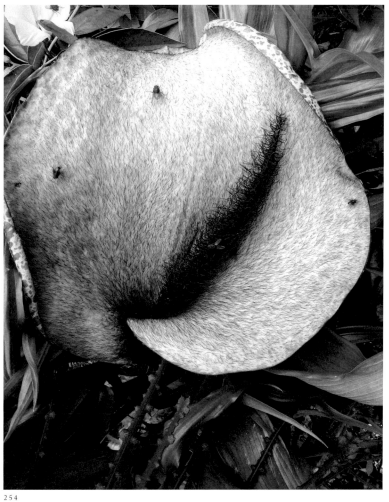

254

254
Dead horse arum lily.
Photograph by Tom Ballinger.
› 023, 252

When fragrances were first used in casinos
more than a few decades back, it was
primarily to mask the foul odor of smoke,
but today all that has changed and scents
play a very complex and vital role in
increasing casino revenue and visits…

According to scenting experts, it's smart
to emphasize cleanliness in the development
of casino scents because it has an effect
on perception, especially in casinos where
patrons spend days not hours within the
service environment. Signature casino
scents are all different as often each hotel
is trying to invoke a different region of the
world; The Mirage is Polynesian; Mandalay
Bay is Southeast Asian and the Bellagio
whispers of Northern Italy.*

"How Casinos Use Scent Marketing to Attract and
Retain Gamblers," Air-Scent International

"How Casinos Use Scent Marketing to Attract
and Retain Gamblers," Air-Scent International.
January 3, 2017. www.airscent.com/how-casi
no-brands-use-scent-marketing-to-attract-
retain-gamblers.-324.

*

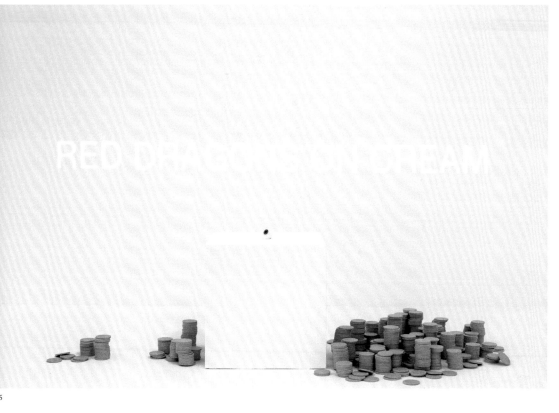

RED D[RAGON]...[D]REAM

255
The Circuit 2019
Jerusalem clay and resin
Dimensions variable
Installation view
Luna Eclipse, Oasis Dream
Stanley Picker Gallery, Kingston
Photograph by Lewis Roland

Casino chips manufactured in China,
using clay dug in Jerusalem.

The Sands Macao casino made its owner
richer faster than anyone ever—a fortune
that was then used to make its owner
the world's biggest political donor.
In spaces masquerading as "Venice,"
"Paris," or "London," Chinese baccarat
players sponsor the move of the US
embassy to Jerusalem, slot machines
materialize buildings in the occupied
West Bank, and showgirls promote
a wall between the US and Mexico.

› 010, 023

Siren Song
BY MARGARET ATWOOD

This is the one song everyone
would like to learn: the song
that is irresistible:

the song that forces men
to leap overboard in squadrons
even though they see the beached skulls

the song nobody knows
because anyone who has heard it
is dead, and the others can't remember.

Shall I tell you the secret
and if I do, will you get me
out of this bird suit?

I don't enjoy it here
squatting on this island
looking picturesque and mythical

with these two feathery maniacs,
I don't enjoy singing
this trio, fatal and valuable.

I will tell the secret to you,
to you, only to you.
Come closer. This song

is a cry for help: Help me!
Only you, only you can,
you are unique

at last. Alas
it is a boring song
but it works every time.

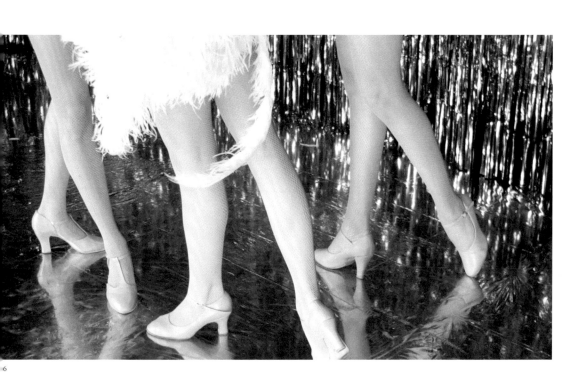

256
The Odds (Part 1) 2019
Film still

(Deep breath)

› 023, 169

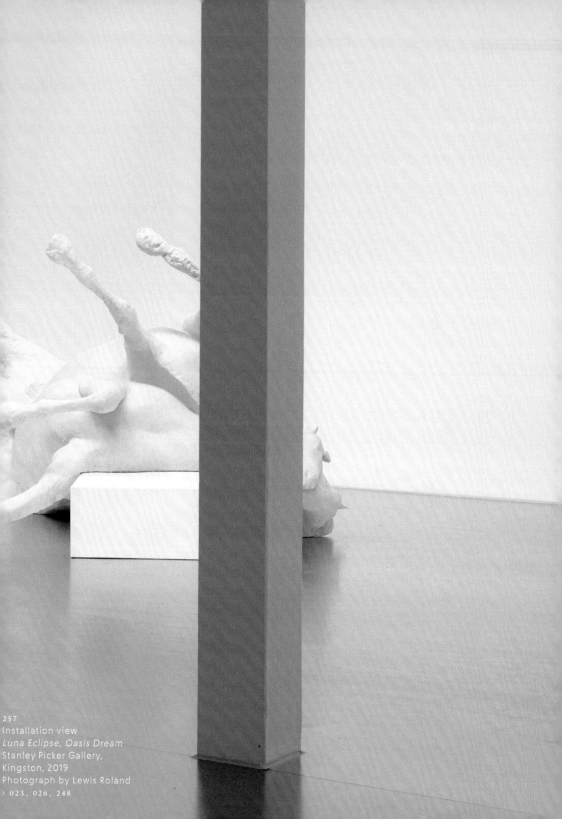

257
Installation view
Luna Eclipse, Oasis Dream
Stanley Picker Gallery,
Kingston, 2019
Photograph by Lewis Roland
→ 023, 026, 248

You dance in your own room. There's no mirror and you've never seen yourself dance, so you have no visual representation of your dancing and yet you are just dancing. In a sense it's expressive, but it's not representational. Not only because most dance is not representational in the sense that it's non-figurative, but it's not representational in the sense that you're not required to imagine an Other… You don't have to have a sense of yourself, to have a representation of yourself to do this expressive thing.

Just below the surface of your skin lie many thousands of colour-changing cells. These chromatophores, alongside other cells, form a system that allows you to change your colour across space and time into complex colourful displays. Yet like all cephalopods you are believed to be colourblind.

You dance in the middle of a rave. You sweat with thousands of others in a badly lit space. A loud beat synchronises your body with that of the others and you know they are there but you don't see them. There's expression without perception. It's ecstasy. There's no meaning, there's no figure.*

"Spots Stars Tunnel Vision"

*

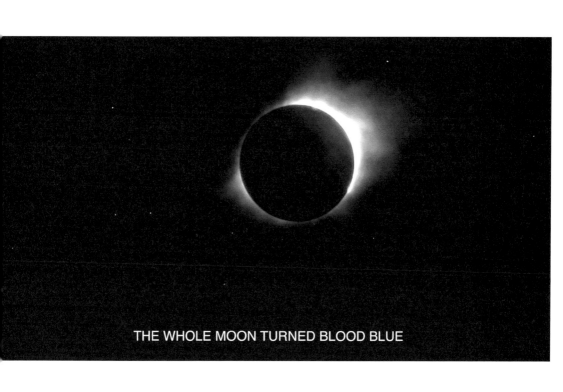

THE WHOLE MOON TURNED BLOOD BLUE

258
Study for Heavens (2020), film still.
009, 142

RAPID HEART BEAT

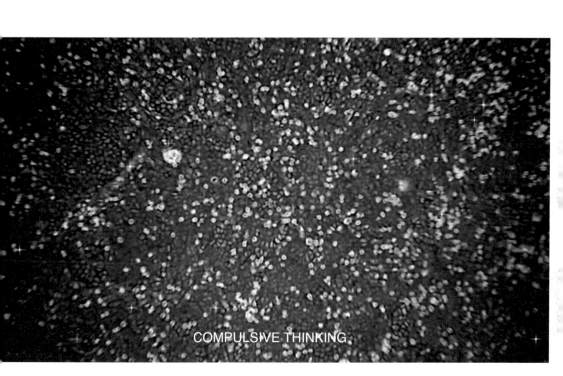

COMPULSIVE THINKING

Study for **Heavens** (2020), film still.
004, 009, 022

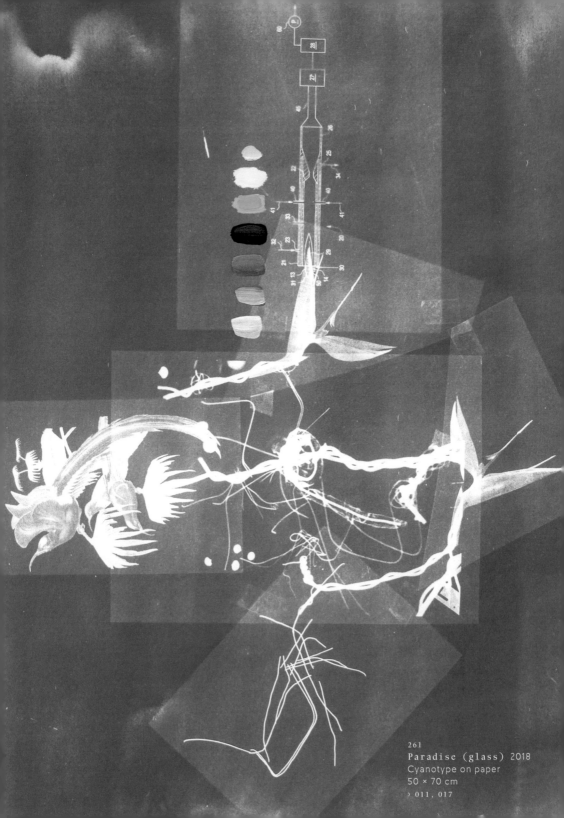

261
Paradise (glass) 2018
Cyanotype on paper
50 × 70 cm
> 011, 017

Advances 2015
HD projection on silver screen
10:00 minutes

A herd of Heck cattle moves across a green screen. The breed was the result of an attempt to bring extinct aurochs back to life in 1930s Germany: a de-domestication project in search of an animal's "true form." The remaining cattle are now self-replicating sculptural objects, inspired by an ideo-logical dream of nature. In the south of England, a farmer is rearing Heck to be photo-graphed, a reflection of a post-Fordist economy where the image of an animal is more valuable than its flesh.

› 124, 125

Avant Tout, Discipline 2017
Printed voiles
500 × 300 cm (series of 7)

Coltan, a mineral used in most electronic products, such as lap-tops, smartphones, and game consoles, could be considered the material of virtuality. A coltan mine in Numbi (South Kivu, Democratic Republic of Congo) is rendered using a program for making computer games. The images are printed on theater backdrops.

› 107, 108, 016, 136

Blue Roan series 2020
Horse ash powder coat on aluminum panel
Dimensions variable

Ashes of a thoroughbred race-horse were used to make a bespoke powder coat formula. The powder particles are speci-fied to be the thickness of horse-hair and the color is mixed to match a blue roan—a rare color pattern for horse coats. The powder is then applied unevenly by hand to aluminum and steel sheets in a powder coating factory, proposing a breed of horse painting which is material rather than figurative.

› 002, 074–079, 267

B/NdAlTaAu 2015
Neodymium, aluminum, gold, tantalum
14 × 9 × 7 cm

40 Kilograms of destroyed hard drives were sourced from a data destruction service, a mountain of shiny deformed bricks that were scrapped out of the guts of computers. Mined out of soil, designed in the United States, made in China, destroyed in England. Labor starts in reverse, dissolving the virtual into the fake from the other end of the consumption chain. Metals and rare earth minerals are mined from the pile of hard drives and reconfigured back into mineral form. Neodymium (Nd) magnets are shredded with a water jet, tantalum (Ta) is filed out of capacitors and the gold (Au) recovered with acids. The aluminum (Al) platters—still holding their ones and zeros—are melted and recast in a sand mold. An artificial ore emerges from the earth, unexpectedly black.

› 098

The Circuit 2019
Jerusalem clay and resin
Dimensions variable

Casino chips manufactured in China for the artists, using clay dug up in Jerusalem.

› 010, 255

The Dancefloor 2019
Programmed gallery striplights
Dimensions variable

Exhibition lights programmed to occasionally break into blinking patterns echoing the "siren song" of a slot machine display.

› 023, 047, 254

**Dissolution
(I Know Nothing)** 2016
Two-channel video with sound
10:00 minutes

The footage used in **Dissolution (I Know Nothing)** composes a form of seascape, assembling fragmented connections between material and time from Congo, Rwanda, and across the Indian Ocean on a containership to China. Gunpowder, dissolved minerals, blinking LEDs, personal and colonial histories.

› 137, 186–196

Drawings 2015–ongoing
Gouache on cyanotype on paper
50 × 70 cm

An ongoing series of blueprints overlaying technical drawings, research, ideas, and mementos collected in the production process of works.

D/AlCuNdAu 2015
Aluminum, lava, copper, neodymium, gold
10 × 8 × 6.5 cm
Dimensions variable

An artificial ore constructed of aluminum (Al), copper (Cu), neodymium (Nd), gold (Au), and Icelandic lava rock "mined" out of hard drives from the DataCell data center in Iceland.

Every Increased Possession Loads Us with New Weariness 2017
Steel, concrete, glass, aluminum, copper, cast iron, Caithness stone
184 × 135 × 87 cm

A public sculpture for Ruskin Square—a large-scale develop-ment in Croydon—that reverses the supply chains of the complex, unmaking the building and remaking it into an artificial mineral of steel, concrete, glass, aluminum, copper, cast iron, and Caithness stone.

› 005, 109–115

**Exhaustion
(Left Front Pastern)** 2020
Patinated bronze
6 × 6.4 × 15 cm

A cast of a racehorse's fractured
leg bone, reconstructed from
a medical CT scan.

› 014, 266

Forevers 2017
Artificial diamond set in gold ring
01:00 minute video loop

The ivory tusk of a baby Congo-
lese elephant, one half of a set
from a Belgian family heirloom,
was burnt at a pet crematorium.
From the ashes of the ivory an
artificial diamond was made,
turning the carbon into a form
of fossil. The diamond is set as
an ouroboros in a gold replica of
the artist's wedding ring.

› 241–246

Frames 2014
Performance
40:00 minutes

A collaboration with Alexander
Whitley for Rambert Dance
Company. Score by Daníel
Bjarnason.

Frames presents Rambert's
dancers at work. Confronted with
a mass of material stripped away
from the conventional mecha-
nisms of the theater, they come
together, organize one another,
and are put to task at their own
production site. Objects of
numerous forms emerge between
the dancers' actions and a
system of metal structures,
growing and morphing in and out
of life as they surpass the sum
of their parts.

The dancers construct and
reconstruct familiar elements of
a dance production, the material
and immaterial, the visible and
what is seen. What does dance
itself produce if no visible artifact
is left over from the dancers'
efforts?

› 083–085, 087, 162

**Giving More to Gain More
series** 2014
Aluminum and electronics
185 × 87 × 15 cm

Aluminum structures are set
with programmable LED strips
displaying fragments of text
from conversations with LED
manufacturers. Made legible
by animated illumination,
the language that emerges is
a byproduct of global mass-
manufacturing processes:
a production-centered pidgin
prose, where Alibaba.com
becomes a source of both
material and content. Includes
**We Have To Work Hard And
Work With Our Hearts,
It Is So Brightness**, and
**Customers Are Real People
And Real Feeling.**

› 082

Grounds 2016
HD video with sound
07:00 minutes

Grounds is composed of footage
from the fireworks testing site
in Liuyang in Hunan Province,
China, where most of the world's
fireworks are produced. A daily
"performance" of product testing
unintentionally stages an indu-
strial spectacle, where mass
quantities of gunpowder mixed
with local soil explode in a
battlefield of colored smoke.

› 142

Heavens 2021
4K video with sound
30:00 minutes

A film made for planetarium
projection, juxtaposing planetary
and underwater footage to see
deep into the ocean by looking at
the sky, or perhaps the other way
around. A sound installation of
multiple voices (human and not)
forms a choir, unravelling inter-
planetary ecologies and a
creation myth based on the
hypothesis that a cosmic event
caused the Cambrian explosion.

Heart Lines series 2016
C-type print
Dimensions variable

X-ray portraits of historic
taxidermy from the collection of
the Royal Museum for Central
Africa in Tervuren, Belgium. A
gorilla, half a lion, and a leopard
killing an impala were taken from
the museum's archive and
X-rayed in a local hospital,
exposing the sculptural struc-
tures within.

› 019, 060–065, 198–200

H/AlCuTaAu 2014
Aluminum, copper, gold,
tantalum, whetstone
12 × 7 × 6 cm

Precious metals and stones
were mined out of technological
objects and transformed back
into mineral form. The artificial
ore was constructed out of gold
(Au), copper (Cu), tantalum (Ta),
aluminum (Al) and whetstone;
all taken from tools, machinery,
and computers that were sourced
from a recently bankrupt factory.

› 100–106, 162

The Immortal 2012
Life support machines, stainless
steel, acrylic, wood, tubing
Dimensions variable

A Heart-Lung Machine, Dialysis
Machine, Infant Incubator,
Mechanical Ventilator, and
an Intraoperative Cell Salvage
Machine are connected to each
other, circulating liquids and
air in an attempt to mimic a
biological structure. When turned
on, these organ replacement
machines operate in orchestrated
loops, keeping each other
alive through the circulation of
electrical impulses, oxygen, and
artificial blood. Salt water acts as
blood replacement: throughout
the artificial circulatory system
minerals are added and filtered
out again, the blood is oxygen-
ated through contact with the
oxygen cycle, and an ECG device
monitors the system's heartbeat.

› 175–177

Inlands series 2016
Copper, nickel, gold, and
tin on bronze
Dimensions variable

A series of landscapes produced
by electroplating gold, copper,
tin, and nickel onto bronze
sheets. The abstract renditions
of open mines in the Democratic
Republic of Congo are material-
ized by the elements excavated
from its soil. The titles are taken
from a travel guide to Congo
and Ruanda-Urundi from 1958
belonging to Van Balen's grand-
parents. Includes Untitled
(Almost Rubaya), A Pool of
Experience, and Where One
Can See 120 Ntore Dancers.

› 138, 139, 206

Itchy Palm Trees 2016
Rare earth neon, mammoth ivory,
natural rubber
3.5 × 110 × 2.2 cm

Neon tubes coated in rare earth
phosphate powder and shaped by
a Hong Kong neon-master were
paired with fragments of mam-
moth ivory to construct a sort
of core sample of an immaterial
geology. The phosphates
extracted from Chinese soil are
juxtaposed with tusk mined from
mammoth skeletons found deep
in the muds of Siberia and traded
predominantly in Hong Kong.

Kingyo Kingdom 2013
HD video with sound
20:00 minutes

A film following the stages
through which goldfish become
objects: a house built by a
breeder, a national competition,
a wholesale market preparing
boxes of goldfish for airfreight.

› 048–050, 116–123

Life Support 2008
C-type print on aluminum
Dimensions variable

The Life Support series
proposes the use of animals bred
commercially (for consumption
or entertainment) as companions
and providers of external organs.
The use of transgenic farm
animals or retired working dogs as
life support "devices" for renal
and respiratory patients suggests
a hospitable alternative to
machine-driven medical
therapies.

› 058, 059

Leopard, Impala 2016
Rare earth neon, mammoth ivory,
natural rubber
152 × 84 × 63 cm

In the sculptural incarnations
of Heart Lines, the steel
structures uncovered inside
a diorama of a leopard killing
an impala are recreated in rare
earth neon, mammoth ivory,
and natural rubber, recon-
structing an imagined choreo-
graphy between two animal
skins in the materials of contem-
porary mining practices. Mining
plays an important role in
maintaining a postcolonial reality
(and vice versa), where resources
are extracted from deep in the
Congolese soil to be spread
throughout the world. The act
of mining for Siberian mammoth
ivory (a matter between animal
and mineral) or rare earth
phosphates echoes the X-ray
process: extraction from below
the surface—the surface of the
earth or the surface of the body.

› 006, 201-203

Nowhere A Shadow 2013
Six-channel infrared video
07:00 minutes

Proposing entertainment as
a form of nature conservation,
a six-channel infrared video
captures a wolf inside a darkened
gallery, walking around an
installation of scaffolding,
electronics, and plants. The
invisibility of the exchange
between the plants and the wolf
is reflected in the undetectable
display, unseen by the wolf
and aimed only at the distant
spectator. By using infrared
lights, the wilderness as a
spectacle is revealed only to the
audience at a physical remove,
fusing nature documentary,
surveillance technology, and
theme park aesthetics.

› 080, 081

The Odds (Part 1) 2019
HD video with sound
16:00 minutes
LED wall, 400 × 200 cm

The Odds (Part 1) brings
together racehorses anaesthe-
tized and collapsed on ketamine
in a "knockdown box," showgirls
from a Macau casino belonging
to the world's biggest political
donor, and Steve Ignorant, from
anarcho-punk band Crass,
performing in a bingo hall
originally built as a cinema
designed to look like a church.
Produced specifically for a large
LED screen, the footage is over-
laid with pulsating light forma-
tions inspired by Las Vegas
techniques of visual seduction.
The interconnections evoked
draw logic from apophenia—
a psychiatric term describing the
tendency to perceive meaningful
connections between unrelated
things or to recognize patterns
in random information.

› 001, 004, 022-047, 247-256

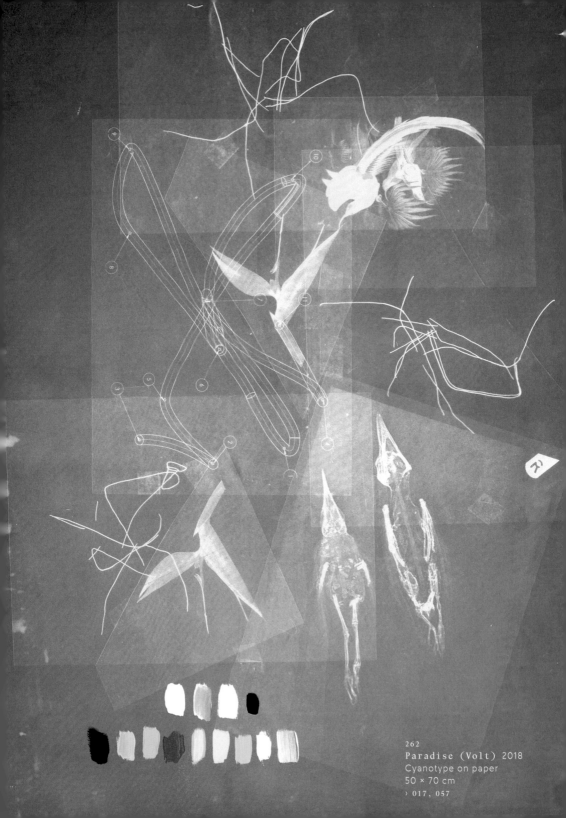

262
Paradise (Volt) 2018
Cyanotype on paper
50 × 70 cm
› 017, 057

Others 2012
Sound
01:14 minute loop

Moonbouncing (or Earth-Moon-Earth communication) allows Earth-based radio stations to communicate by reflecting radio waves off the surface of the moon. Using radio telescope antennas, a hare's mating call was sent to the moon on March 30, 2014 from Italy by I1NDP and received by team PI9CAM in the Netherlands. It was the first animal sound ever bounced off the moon's surface.

› 013

The Opening 2019
Hand blown glass
28 × 28 mm

A glass replica of one of the artists' eyes, hovering some-where between commodity and amulet.

› 007

Paradise series
2017–ongoing
Rare earth neon, mammoth ivory, copper, paint
Dimensions variable

The steel structures within taxidermy birds-of-paradise, collected by naturalist Alfred Russel Wallace while developing his theory of natural selection, were revealed by a horse veterinarian through an X-ray machine. They were then reconstructed from the radio-graphic images in rare earth neon and mammoth ivory.

› 011, 017, 261, 262

Pigeon D'or 2010
DNA code to produce lipase in bacteria
Video
10:40 minutes

Working with biochemists and pigeon fanciers, techniques from synthetic biology were used in an attempt to make a pigeon defecate soap. In order to do so, the DNA of bacteria was modified so it could metabolise soap inside the pigeon's gut.

› 056, 057

The Quiet 2015
Aluminum, electronics, chemicals, plants, foam
Various dimensions

An immersive installation simulating the atmospheric conditions of the quiet before the storm. The bright grey room is filled with acoustic panels, VOC-emitting plants, and instruments emitting ions and regulating pressure, temperature, and light. The nature of this quiet is based on folklore and meteorological research, which is itself based on folklore.

› 178–182

The Restraint 2019
Scent
200 hours

A scent commissioned by the artists from a marketing company for a gallery space. It is made of musk overlayed with synthetic molecules that mimic human pheromones and the stress-like smell of the Dead Horse Arum Lily—a flower that imitates a horse corpse to draw flies, and that is sometimes used in perfumery to add a faint smell of the sea.

› 254

Retour 2015
C-Type Print
75 × 75 cm (from series of 3)

Goldfingers from computer motherboards scattered on the soil of a Congolese gold mine.

› 140, 141, 143

The Rise 2020
Holy water, haze machine
720 minutes

› 023, 047, 254

Rusty Knives 2013
Glass, steel, vinyl, hormones, raspberry plants
200 × 60 × 200 cm

Stress and fear in animals that are about to be slaughtered can change the taste and color of their meat. Cortisol, adrenaline, and lemon juice slowly drip into ripening raspberries, in a chemical reenactment of the biological experience of violence. By infusing berries with these stress hormones, the installation attempts to distill the taste of fear.

› 183–185

Take a Good Lamp 2016
Recorded screen
03:30 minutes loop

A coltan mine in Numbi (South Kivu, DR Congo) is filmed through a distant video call, capturing a landscape mined for minerals of virtuality over an unstable connection. The footage was made during the production of Trapped in the Dream of the Other.

› 132

Sensei Ichi-gō 2014
Stainless steel, electronics,
acrylic, glass, vinyl, nylon
200 × 170 × 450 cm

A machine capable of producing
sterile goldfish in an automated
reenactment of Professor
Yamaha's movements and
actions. A contraption with its
own (dormant) choreography,
the machine acts as a potential
reproductive organ.

› 231-237

Sterile 2014
Goldfish
Dimensions variable

An edition of goldfish engineered
to hatch without reproductive
organs. The fish were produced
for the artists by Professor Etsuru
Yamaha, from Hokkaido Univer-
sity in Japan, in a single edition
of 45. The fish went on to live
in the artists' studio and their
bodies were eventually
preserved as a memorial.

› 003, 018, 051-055, 066-073,
 238, 239, 265

Trapped in the Dream
of the Other 2017
4k video with sound
20:00 minutes

A camera navigates through
what the artists themselves
have called a performance:
in the summer of 2016, bespoke
fireworks were set off in an
open-air coltan mine near
Numbi, in the eastern region of
DR Congo. The fireworks had
been imported from Liuyang in
Hunan Province, the epicenter of
China's fireworks manufacturing
industry, and set off remotely
over an unstable connection.

› 008, 020, 126-135, 197,
 205-230

Vertebra (Neck) 2017
Rare earth neon, mammoth
ivory, natural rubber
19 × 8 × 6 cm

A fragment of Leopard, Impala.

White Horse / Twin Horse
2018
Exhibition in five rehearsals

White Horse / Twin Horse
makes use of Brakke Grond's
theater infrastructure to rehearse
forms of exhibition in which
research, process, and outcome
cannot be meaningfully
distinguished.

The artists move their entire
physical storage and digital
archive to the theater space and
unpack the work into a series of
repetitions in collaboration with
two curators, a fellow artist, and
a theater director. The theater's
technicians, used to building
and unbuilding productions every
night, reinstall the exhibition
every ten days, activating and
deactivating different parts. A
writer in residence captures each
iteration with a text that remains
in the space, her writing accu-
mulates as the exhibition trans-
forms. Rehearsing the exhibition
allows to question and expose
conditions surrounding the
production of the artwork
and its presentation.

› 001, 144-159, 125, 243

75 Watt 2013
Resin, aluminum, electronics
35 × 17 × 18cm
HD video with sound
10:00 minutes

A product is designed to be
made in China. The object's only
function is to choreograph the
movements performed by the
laborers manufacturing it.
The assembly/dance took place at
the White Horse Electric Factory
in Zhongshan, China between
March 10 and 19, 2013 and
resulted in 40 objects and
a film documenting the choreo-
graphy of their assembly.

› 021, 088-094, 160-173, 264

Heavens was commissioned by the
Serpentine Galleries and supported
by Malevich.io.

The Odds (Part 1) was co-commis-
sioned by Stanley Picker Gallery, The
Philadelphia Museum of Art, Walker Art
Center, and The Art Institute of Chicago.

White Horse / Twin Horse was made
in collaboration between De Brakke
Grond and Z33. Supported by
Amsterdams Fonds voor de Kunst
and Mondriaan Fonds.

Forevers was commissioned by
The Museum of Modern Art, New York.
Collection MoMA, New York.

Trapped in the Dream of the Other
was supported by the Flemish Authorities,
MU Artspace, Dominator Fireworks,
and Starburst Pyro.

Avant Tout, Discipline was
commissioned by Mu Artspace and
Fotomuseum Winterthur.

Paradise was commissioned for the
exhibition Verschwindende Vermächt-
nisse: Die Welt als Wald, at the
Zoological Museum Hamburg.

Every Increased Possession
Loads Us With New Weariness was
commissioned by muf architecture/
art and Stanhope Schroders.

Dissolution (I Know Nothing)
was commissioned by Container Artist
Residency. 8mm footage by Harrie Van
Balen. Collection Mu.Zee, Ostend.

Leopard, Impala was commissioned
by Cooking Sections for the Empire
Remains Shop.

H/AlCuTaAu was commissioned by de
Brakke Grond. Collection M+ Hong Kong.

B/NdAlTaAu was commissioned by
Thyssen-Bornemisza Art Contemporary.

Frames was commissioned by Rambert
Dance Company for Alexander Whitley.

Sterile was commissioned by
Schering Stiftung and The Arts Catalyst.

Giving More to Gain More was
commissioned by Jerwood Visual Arts.

75 Watt was Supported by Arts Council
England, The Flemish Authorities,
Ask4Me Group, Zhongshan City White
Horse Electric Company, FACT,
V2_Institute for the Unstable Media, and
workspacebrussels. Collections MoMA,
New York, M+, Hong-Kong, De Collectie
van de Vlaamse Gemeenschap.

Nowhere A Shadow was Commissioned
by Lisbon Architecture Triennale.
Supported by The Physics and Astronomy
Machine Shop and The Bridge Residency,
Michigan State University.

Kingyo Kingdom was commissioned
by The Arts Catalyst and John Hansard
Gallery. Collections MoMA, New York,
Region of Skåne, Malmo.

The Immortal was supported by
a Wellcome Trust Arts Award.

Pigeon d'Or was supported by
the Flemish Authorities.

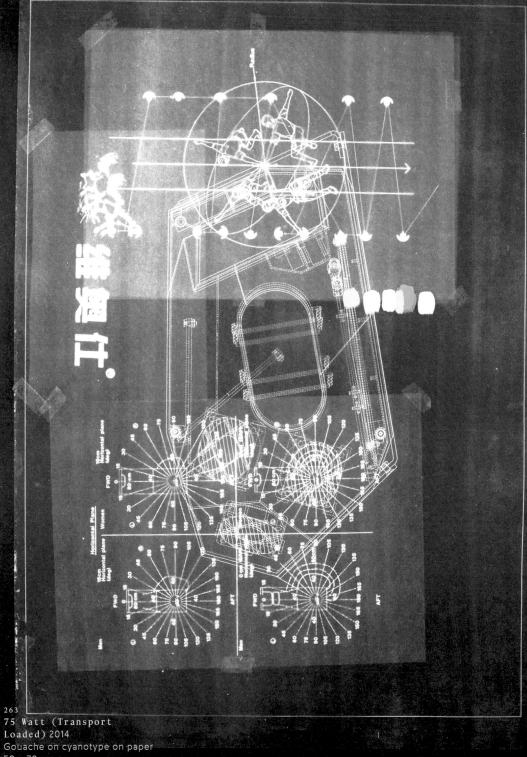

75 Watt (Transport
Loaded) 2014
Gouache on cyanotype on paper
50 × 70 cm
> 162, 171

264

264
75 Watt, 2013
Production documentation
Shunde, Guangdong
March, 2013
› 162, 169

265
Animal as other animal,
animal as fictional animal
Photograph courtesy of
WENN Rights Ltd/Alamy
Stock Photo.
› 051, 203

Barad, Karen. "Quantum Entanglements and Hauntological Relations of Inheritance: Dis/continuities, SpaceTime Enfoldings, and Justice-to-Come." *Derrida Today* 3, no. 2 (2010): 240–268.

"Barometer Uses Shark Oil." *Tripoint Gift News* (blog), July 16, 2010. http://wwwtripointgiftnews.blogspot.com/2010/07/barometer-uses-shark-oil.html.

Benjamin, Walter. "One-Way Street." In *One-Way Street and Other Writings*, translated by Edmund Jephcott and Kingsley Shorter. London: NLB, 1979, 103–104.

Brown, Trisha. "Interview with Emmanuelle Huynh." In *Histoire(s) et Lectures: Trisha Brown/Emmanuelle Huynh*, edited by Emmanuelle Huynh, Denise Luccioni, and Julie Perrin, 25–90. Dijon: Les presses du reél, 2012.

Canby, Peter. "China and the Closing of the Ivory Trade." *New Yorker*, June 12, 2017.

Cassidy, Rebecca. *Horse People: Thoroughbred Culture in Lexington and Newmarket*. Baltimore: Johns Hopkins University Press, 2007.

Cixin, Liu. "Taking Care of God." In *Invisible Planets: Contemporary Chinese Science Fiction in Translation*, edited and translated by Ken Liu, 321–358. New York: TOR, 2016.

Cohen, Muhammed. "Sands Macao: The House That Built Sheldon Adelson." *Forbes Asia*, May 15, 2014.

Cohen, Revital, and Tuur Van Balen. "I Know Nothing." In *Logics of Sense 2: Implications*, edited by Christine Shaw, 10–12. Toronto: Blackwood Gallery, 2019. Exhibition catalog.

　Source book for Palms Palms Palms. Hasselt: Z33, 2020. Published in conjunction with an exhibition of the same title at Z33, October 4, 2020–January 3, 2021.

　"Particles (an Epilogue) / Epilogue (a Particle)." In *Unthought Environments*, edited by Karsten Lund, 144–157. Chicago: Renaissance Society, 2019. Published in conjunction with an exhibition of the same title at the Renaissance Society, February 17–April 8, 2019.

　"Let the Games." *DUE*, Architectural Association, May 25, 2018.

　"Mine." In *Rare Earth*, edited by Boris Ondreička and Nadim Samman, 54–61. Berlin: Thyssen-Bornemisza Art Contemporary and Sternberg Press, 2015. Published in conjunction with an exhibition of the same title at Thyssen-Bornemisza Art Contemporary, Vienna, February 19–May 31, 2015.

　"Spit on the Carpet." Seminar text for Columbia University Graduate School of Architecture, Planning and Preservation, New York, 2019.

　"Spots, Stars, Tunnel Vision." London: Serpentine Galleries, 2020.

"Synthetic Blood on Leopard Skin." In *The Empire Remains Shop*, by Cooking Sections (Daniel Fernández Pascual and Alon Schwabe), 75–90. New York: Columbia Books on Architecture and the City, 2018.

"Take A Good Lamp." In "Mediated Geologies," edited by Jussi Parikka. Special section, *Cultural Politics* 12, no. 3 (November 2016): 332–338.

"The Immortal." In *Are We Human? The Design of the Species: 2 seconds, 2 days, 2 years, 200 years, 200,000 years*, edited by Beatriz Colomina and Mark Wigley, 480–478. Istanbul: Istanbul Foundation for Culture and Arts (IKSV), 2016. Published in conjunction with the 3rd Istanbul Design Biennial of the same title, October 22–November 20, 2016.

Conrad, Klaus. *Die beginnende Schizophrenie. Versuch einer Gestalt-analyse des Wahns*. Stuttgart: Thieme, 1958.

DeLanda, Manuel. *Philosophy and Simulation*. London: Continuum, 2011.

Fishbase. "3 Families of Chimaeras." *Fish Identification: Find Family*. Last modified June 29, 2012. https://www.fishbase.se/identification/familieslist.php?ordnum=3&areacode=&classnum=3&ccode=.

Gilbreth, Frank. *Motion Study: A Method for Increasing the Efficiency of the Workman*. New York: D. Van Nostrand, 1921.

Goldberg, Keren, "The Invisible Aesthetics of Perception," published in conjunction with "The Quiet," exhibited at FACT, Liverpool, February 2015.

Han, Byung-Chul. *Shanzhai: Deconstruction in Chinese*. Translated by Philippa Hurd. Cambridge, MA: MIT Press, 2017.

Hesiod. *Theogony*. Translated by Hugh G. Evelyn-White. New York: Oia Press, 2015.

"How Casinos Use Scent Marketing to Attract and Retain Gamblers." Air-Scent International, January 3, 2017. www.airscent.com/how-casino-brands-use-scent-marketing-to-attract-retaingamblers.

Hui, Yuk. "Anamnesis and Re-Orientation: A Discourse on Matter and Time." In *30 Years after Les Immatêriaux*, edited by Yuk Hui and Andreas Broeckmann, 179–202. Lüneburg: meson press, 2015.

Kohn, Eduardo. *How Forests Think: Toward an Anthropology Beyond the Human*. Berkeley: University of California Press, 2013.

Larmer, Brook. "Of Mammoths and Men." *National Geographic* 223, no. 4 (April 2003): 45–46, 49–51, 53–56, 59, 61–63.

Lyotard, Jean-François. "After Six Months of Work... (1984)." Translated by Robin Mackay. In *30 Years after Les Immatêriaux: Art, Science, and Theory*, edited by Yuk Hui and Andreas Broeckmann, 29–66. Lüneburg: meson press, 2015.

Lyotard, Jean-François. "Logos and Techne, or Telegraphy." In *The Inhuman: Reflections on Time*, translated by Geoffrey Bennington and Rachel Bowlby, 47–57. Cambridge: Polity Press, 1991.

Lyotard, Jean-François. *Que Peindre?/ What to Paint?: Adami, Arakawa, Buren*. Edited by Herman Parret. Translated by Vlad Ionescu. Leuven: Leuven University Press, 2012.

Mallarmé, Stéphane. "A Throw of the Dice Never Will Abolish Chance." Translated by Basil Cleveland (UbuWeb, 2005).

Marx, Karl "Wages of Labor" (1844). In *Economic and Philosophic Manuscripts of 1844*.

Parke, Jonathan, and Mark D. Griffiths. "Gambling Addiction and the Evolution of the 'Near Miss.'" *Addiction Research and Theory* 12, no. 5 (2004): 407–411.

Patterson, Alex. *A Field Guide to Rock Art Symbols of the Greater Southwest*. Boulder: Johnson Books, 1992.

Peeters, Jeroen. *Through the Back: Situating Vision Between Moving Bodies*. Helsinki: Theatre Academy of the Arts, 2014.

Rowland, Katherine. "We Are Multitudes." *Psyche*, January 11, 2018. https://aeon.co/essays/microchimerism-how-pregnancy-changes-the-mothers-very-dna.

Runciman, David. "A Pound Here, a Pound There." *London Review of Books* 36, no. 16 (2014).

Schüll, Natasha Dow. *Addiction by Design: Machine Gambling in Las Vegas*. Princeton: Princeton University Press, 2012.

Stanley Picker Gallery. "Luna Eclipse, Oasis Dream." Press release, May 15, 2019.

Steele, Edward J., Shirwan Al-Mufti, Kenneth A. Augustyn, Rohana Chandrajith, John P. Coghlan, S. G. Coulson, Sudipto Ghosh, et al. "Cause of Cambrian Explosion—Terrestrial or Cosmic?" Progress in *Biophysics and Molecular Biology* 136 (August 2018): 3–23.

Sweatman, Martin B., and Alistair Coombs. "Decoding European Palaeolithic Art: Extremely Ancient Knowledge of Precession of the Equinoxes." *Athens Journal of History* 5, no. 1 (2019): 1–30.

Taylor, Frederick Winslow. *The Principles of Scientific Management*. New York: Harper & Brothers, 1915.

Traveller's Guide to Belgian Congo and Rwanda Urundi, 3rd ed. Brussels: Tourist Bureau for the Belgian Congo und Ruanda-Urundi, 1958.

Tsing, Anna Lowenhaupt. *The Mushroom at the End of the World: On the Possibility of Life in Capitalist Ruins*. Princeton: Princeton University Press, 2015.

Vlaams Cultuurhuis de Brakke Grond. "Revital Cohen & Tuur Van Balen: *White Horse / Twin Horse (rehearsing an exhibition)*." Press release, December 6, 2017.

Wilson, Eva. "Trapped in the Dream of the Other." In *The Work of Wind: Land*, edited by Christine Shaw and Etienne Turpin, 115–137. Berlin: K. Verlag, 2018.

Biographies

Daisy Hildyard
is a British author. Her first novel, Hunters in the Snow, won the Somerset Maugham Award at the Society of Authors (UK), and a "5 Under 35" honorarium at the National Book Awards (USA). Her most recent book, The Second Body, is an essay on how the porous boundaries of the Anthropocene shape human experiences. A new novel, Emergency, is due in 2022.

Andrés Jaque
is the founder of the Office for Political Innovation, an architectural agency working in the intersection of design, research, and activism. The office's work explores architecture as a political practice that negotiates its agency through trans-scalar expression. The Office for Political Innovation has been awarded the 2016 Frederick Kiesler Prize from the City of Vienna, the SILVER LION at the fourteenth Venice Biennale, and the Dionisio Hernández Gil Award, among others. Andrés Jaque is also the director of the Advanced Architectural Design Program at Columbia University Graduate School of Architecture, Planning, and Preservation. His books include Superpowers of Scale (2020), Mies y la gata Niebla: Ensayos sobre arquitectura y cosmopolítica (2019), More-Than-Human (with Marina Otero and Lucia Pietroiusti, 2020) Transmaterial Politics (2017), Calculable (2016), PHANTOM. Mies as Rendered Society (2013), Different Kinds of Water Pouring into a Swimming Pool (2013), Dulces Arenas Cotidianas (2013), Everyday Politics (2011), and Melnikov. 1000 Autos Garage in Paris 1929 (2004). His research has been published in Perspecta, Log, Thresholds, and Volume, among other publications.

Lucia Pietroiusti
is a curator working at the intersection of art, ecology and systems, usually outside of the gallery format. She is the founder of the General Ecology project at the Serpentine Galleries, London, and of a forthcoming Institute for General Ecology. Pietroiusti is the curator of Sun & Sea (Marina), the Lithuanian Pavilion at the 58th International Art Exhibition – La Biennale di Venezia, a co-curator of the 13th Shanghai Biennale, Bodies of Water, and co-curator of Back to Earth, the Serpentine's 50th anniversary program. Ongoing projects include The Shape of a Circle in the Mind of a Fish, an interdisciplinary festival, radio and publication series on consciousness and intelligence across species. In 2022, Pietroiusti will join James Bridle in curating a section of the Helsinki Festival. Her publications include More-than-Human (with Andrés Jaque and Marina Otero Verzier, Het Nieuwe Instituut, 2020) and Microhabitable (with Fernando García-Dory, Spanish edition 2020; English edition forthcoming 2021).

Xiaoyu Weng
is a curator and writer based in Toronto and New York. She is the Carol and Morton Rapp Curator, Modern and Contemporary Art at the Art Gallery of Ontario (AGO) in Toronto. Her curatorial and writing practices focus on the impact of globalization, identity, and decolonization, as well as the intersection of art, science, and technology. Previously, she was The Robert H. N. Ho Family Foundation Associate Curator at the Solomon R. Guggenheim Museum, New York, and Director of Asian Programs at Kadist Art Foundation, San Francisco/ Paris. In 2018-19, Weng served as the Curator of the 5th Ural Industrial Biennial of Contemporary Art in Yekaterinburg, Russia.

Revital Cohen and **Tuur Van Balen**
(b. 1981, based in London) work across objects, installation, and film to explore processes of production as cultural, personal, and political practices. Their work has been exhibited at the 13th Shanghai Biennale at the Power Station of Art; Palazzo delle Esposizioni, Rome; Walker Art Center, Minneapolis; Philadelphia Museum of Art; The Renaissance Society, Chicago; Serpentine Cinema, London; Fotomuseum Winterthur; Para Site, Hong Kong; Thyssen-Bornemisza Art Contemporary, Vienna; HKW, Berlin; and Congo International Film Festival, Goma, among others. Their work has been featured in many articles, catalogues, and other publications, and is included in the permanent collections of the Museum of Modern Art, New York; Mu.ZEE, Ostend; and M+, Hong Kong.

Acknowledgments

Studio Manager:
Alexander Paveley

Studio Assistants 2012–2021:
Raoni Azevedo, Stanley Bidston-Casey, Francine Chan, Lizzy Deacon, Benjamin Ditzen, Charles Duffy, Leon Eckert, Charlie Evans, Hannah Fasching, Hefin Jones, Lily McCraith, Megan Rodger, Karol Sielski, Claire Thompson, Frank Verkade, Tom Wagstaff

Collaborators

Papa Mionzima Afashamana, Jumaini Alphonse, Mwenda Pori Antoine, Adolph Basengezi, Ahmed Byuka, April Cai, James Chappell, Cici Chen, Siya Chen, Pan Daijing, Bimenya Damaceno, Cai DianFa, Naomi Esser, Issac Gihana, Tan HaiFeng, Hu HaiXin, Yasmin Hepburn, Norikatsu Ito, Koichi Ito, Xu JiaLi, Zhou JianXiong, Huang JiaWen, Nyange Justin, Bahati Justin, Fang LiFeng, Ann Lin, Kong LinXin, Jimmy Lugi, Xu MengTing, Sadiki Mugoi, Safari Mwisha, Matt Palaszynski, Chen QiuLe, Georgina Rae, Baraka Riguen, Amisi Safari, Heritier Safari, Rafiri Seba, Ye ShaoYing, Kimura Sizuo, Jan Van Balen, Michiel Van Balen, Yang WenTao, Alexander Whitley, Steve Williams, Etsuro Yamaha, Tan YongJun, Liu YuFeng, Huang YuFeng, Mogoi Zakayo, Du ZhiFeng